By MANLY BANISTER

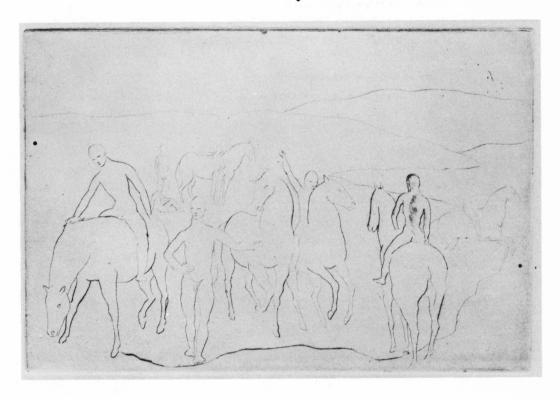

ETCHING
and other INTAGLIO TECHNIQUES

STERLING PUBLISHING CO., INC. NEW YORK

Oak Tree Press Co., Ltd.
Distributed by WARD LOCK, Ltd., London & Sydney

98930

OTHER ARTS & CRAFTS BOOKS
Prints—from Linoblocks and Woodcuts — Banister

Abstract Art

Acrylic and Other Water-Base Paints

Batik as a Hobby

Candle-Making

Cardboard Crafting

Carlson's Guide to Landscape Painting

Ceramics—and How to Decorate Them

Coloring Papers

Color in Oil Painting

Composition in Art

Constructive Anatomy

Creative Enamelling & Jewelry-Making

Creative Leathercraft

Designs—and How to Use Them

Experiments in Modern Art

Express Yourself in Drawing

Joy of Drawing

Layout

Learn Art in One Year

Making Mosaics

Metal and Wire Sculpture

Nail Sculpture

Original Creations with Papier Mâché

Painting Abstract Landscapes

Painting the Sea

Papier Mâché—and How to Use It

Sculpture for Beginners

Stained Glass Crafting

Tin-Can Crafting

Watercolor Painting for the Beginner

Weaving as a Hobby

Whittling and Wood Carving

DEDICATION
To MARJORIE
my wife

Second Printing, 1970
Copyright © 1969 by
Sterling Publishing Co., Inc.
419 Park Avenue South, New York 10016
British edition published by Oak Tree Press Co., Ltd.
Distributed in Great Britain and the Commonwealth by
Ward Lock, Ltd., 116 Baker Street, London W1
Manufactured in the United States of America
All rights reserved
Library of Congress Catalog Card No.: 69-19493
ISBN 0-8069-5136-2 UK 7061 2149 X
5137-0

CONTENTS

BEFORE YOU BEGIN. 4

1. PREPARING AND GROUNDING THE PLATE 7
Metals for Etching . . . Cutting the Plate . . . Cleaning the Plate . . . The Heater and the Jigger . . . Ball Ground . . . Transparent Ground . . . Liquid Ground . . . Grounding with the Leather Roller . . . Grounding with the Dabber . . . Smoking the Ground . . . White Ground . . . Safety Precautions

2. NEEDLING THE PLATE 19
The Drawing . . . Patching the Ground . . . Stop-Out Varnish . . . The Etching Needle . . . The Mimeograph Roulette . . . The *Échoppe* . . . The Work Table . . . Needling the Plate

3. ETCHING THE PLATE 27
Nitric Acid . . . Use of Nitric Acid with Copper . . . Use of Nitric Acid with Zinc and Steel . . . Hydrochloric Acid . . . Iron Perchloride . . . Label the Baths . . . Storing Acids . . . The Baumé Hydrometer . . . Action of the Baths . . . Etching Trays . . . The Acetic Acid Bath . . . Etching the Plate . . . Bubbling . . . Cautions in the Handling of Acids . . . The Etching Log . . . Bevelling the Plate Edges

4. FURTHER METHODS OF WORKING THE PLATE 34
Drawing the Plate in Stages . . . Etching with Stopping Out . . . Timing the Etch by "Bubblings" . . . Drawing in the Bath . . . Feathering the Plate

5. PAPER AND THE ETCHING PRESS . . . 37
Waterleaf Papers . . . Sized Papers . . . Newsprint . . . Blotters . . . Damping Waterleaf Papers . . . Damping Sized Papers . . . The Etching Press . . . The Etching Blankets . . . Dimensions of the Blankets . . . How to Buy Etching Blankets . . . Adjusting the Press

6. INK AND INKING THE PLATE 42
Etching Ink . . . Dry Pigments . . . Grinding Pigments . . . Storage of Ink . . . Inking the Plate . . . Wiping the Plate . . . Preserving Wiping Pads . . . *Retroussage*

7. PRINTING THE PLATE 51
Temperature of the Plate . . . Trial Proofing . . . Makeready . . . Storing the Plate . . . Printing the Edition . . . Flattening the Prints . . . Relief Printing . . . Prints with Margins . . . Finishing the Print . . . Cleaning Up . . . Care of the Blankets

8. REWORKING THE PLATE 56
States . . . Regrounding and Rebiting . . . Dabbing an Irregular Ground . . . Flour of Sulphur . . . Correcting the Overbitten Plate . . . Using the Scraper . . . Using the Burnisher . . . Scotch Stone . . . Snake Slip . . . The Charcoal Block . . . Polishing the Plate . . . *Crevé* . . . *Repoussage* . . . Resumé of Reworking the Plate

9. SOFT-GROUND ETCHING 67
Soft Ball Ground . . . Soft-Grounding the Plate . . . Traditional Soft-Ground Technique . . . Etching the Soft-Ground Plate . . . Printing the Soft-Ground Plate . . . Correcting the Soft-Ground Plate . . . Soft Ground as a Texture Medium

10. AQUATINT AND THE CREATION OF TONAL PASSAGES 72
Preparing the Aquatint Powder . . . The Rosin Bag . . . Dusting the Plate with the Rosin Bag . . . The Aquatint Box . . . Stopping Out Aquatint . . . Biting a Soft Edge on Aquatint . . . The Creeping Bite . . . Fading Out Aquatint with the Burnisher . . . Etching the Aquatint Plate . . . The Underbitten Aquatint . . . Correcting Aquatint . . . Sandpaper Aquatint . . . Salt Aquatint . . . Lift-Ground Aquatint . . . The Lift-Ground Solution . . . Grounding the Plate . . . The Lift Bath . . . Laying an Aquatint Ground in the Lift Areas . . . Spirit Ground . . . Pick-up Grounds . . . Deep Etch . . . Cut-Outs

11. ENGRAVING 80
The Burin . . . Sharpening the Burin . . . Using the Burin . . . Drawing on the Plate

12. DRY POINT 84
Dry Point Needles . . . Using the Dry Point . . . The Dremel Electric Engraver . . . Working the Dry Point Plate . . . Dry Point on Plastic . . . Printing the Dry Point . . . Correcting an Etched Plate with Dry Point . . . Correcting the Dry Point Plate

13. MEZZOTINT AND METAL GRAPHIC . . . 89
The Mezzotint Rocker . . . The Rocking Action . . . The Roulette . . . Rocking the Plate . . . Working the Plate . . . Inking and Printing the Mezzotint Plate . . . Metal Graphic . . . Inking and Printing the Metal-Graphic Plate

14. PRINTING THE INTAGLIO PLATE IN COLOR 94
Color Inks . . . The Color Aquatint Plate . . . Inking the Color Aquatint Plate . . . Relief Design, Aquatint Color Plates . . . The Linear Print with a Colored Background . . . Relief Inking with Stencils . . . Color Printing with Two or More Plates . . . Printing Wet-on-Wet . . . Printing Wet Ink over Dry . . . The Register Guide . . . Printing Deep-Etched or Metal-Graphic Plates in Color . . . Combination Printing of Intaglio with Wood or Linoleum Blocks . . . Offsetting the Color Design from a Block

15. MOUNTING THE PRINT FOR DISPLAY . . 102
GALLERY OF PLATES 106
MATERIALS AND TOOLS USED IN VARIOUS INTAGLIO PROCESSES 126
INDEX 128

BEFORE YOU BEGIN

Although etching was practiced as early as the 15th century, it was not until the 17th century and the Dutch etchers (of whom Rembrandt was foremost) that it really became a developed art. From the foundation laid then, etching has been evolving for nearly four centuries, until now it has assumed great stature as a form of expression.

The field of intaglio printmaking has become so broad and so intricate in its manifestations that you, the individual artist, cannot hope to master it all at once. You can, however, through learning what has been done by your predecessors, establish a firm foundation upon which to develop your own printmaking art. It is the purpose of this book to provide you with that secure ground.

The development of your skill as an artist gives you mastery over your medium. The basis of your skill is technique, founded upon knowledge of your craft.

As a serious student of etching and its related arts, you will want to learn everything you can about your materials, about the chemistry of the process, and about the metals and tools you will use. When this knowledge becomes a part of your experience, it will serve you automatically while your mind is preoccupied with the creative aspects of expression.

Nowhere in art are technicalities of no importance, and this goes double for the field of etching and its kindred techniques. You must understand the medium in its technical as well as its aesthetic features if you hope to become a successful printmaker.

Etching is, in reality, a "tool-making" operation. You do not work on the print itself, as you would on a sketch or a pen-and-ink drawing. You work instead upon a plate of copper, zinc or steel and afterward use the finished plate as a tool to produce many paper prints that are all alike.

The plate on which you work is *not* an etching. It is called "the etched plate." The surface of the plate is etched—or eaten away in a controlled process—by an acid. This results in a design bitten into the surface so that it will retain ink. The ink is then transferred by means of pressure to a sheet of paper, and this printed piece of paper is what we mean when we speak of an etching.

An etching is produced *only* by a plate that has been etched or acted upon by acid. Prints produced by engraving, dry point, or mezzotint methods are not etchings. These are known specifically as engravings, dry points and mezzotints, but generically as "intaglio" (pronounced in-tal'-yo) prints. An etching is also an intaglio print. Any plate that has lines etched, cut, incised, scratched, punched, or otherwise indented into the surface is an intaglio plate, one that has been "engraved or cut into." An intaglio plate is printed by pulling the ink out of depressions below the surface of the plate. This is the direct opposite of "relief" printing, where the ink is stamped upon the paper from the *raised* surfaces, as in woodcut, linoleum block, line-cut or halftone printing.

A third method of printing is planography, also called "lithography" from the stones originally used in the process. Lying halfway between intaglio and relief printing, lithographic printing is done from a flat surface, the printing lines and areas being neither raised nor depressed.

In order to print from an intaglio plate, the surface must first be covered all over with etching ink, which is different from regular printers' ink. The ink is forced into the cuts, then is wiped from the relief surfaces so that these will not print.

Hard ground, soft ground, aquatint and deep etch are all "wet" methods of working—that is, all require the use of acid. Engraving, dry point and mezzotint are "dry" methods, as no acid is used. The surface is cut, gouged or abraded mechanically to produce ink-retaining areas, using burins, dry points, mezzotint rockers, roulettes, and so on.

Metal graphic is a dry method that is different from any of these. It is a kind of appliqué in which pieces of metal are soldered or cemented one on top of another to form a built-up printing plate. Any or all of the methods previously discussed may be combined with metal graphic.

No one is obliged to learn *all* the techniques related to etching. To become proficient in one or two methods only is a worthwhile goal. However, the addition of other techniques in the employment of "mixed media" (the use of two or more different but related processes in the same plate) widely expands the artist's ability to communicate through the printmaking medium.

The idea of mixed media is not at all new; it was practiced by Rembrandt three centuries ago. In reworking his etched plates, he used both engraving and dry point wherever he felt the need for them.

The earliest intaglio plates were engravings. It is believed that such printing plates derived from the goldsmith's art, as engraving in precious metals for the sake of design goes back many centuries beyond the origin of printing. To keep a record of his designs, the goldsmith made a practice of filling the engraved lines with a black substance which was then transferred to a piece of paper by rubbing.

In the 15th century, production of an engraved printing plate required many hours of work spread over weeks, months and even years. It is no wonder, then, that the discovery of the etching process was welcomed with such enthusiasm that the practice swept like wildfire across the Western world. Here was a way to produce a print similar to an engraving, but requiring less skill, less work and less time. Any capable draftsman could quickly adapt his drawing technique to a facile handling of the etching point, and from there on the remainder of the process was largely a matter of chemistry.

From Daniel Hopfer, already known as an etcher on iron in the year 1500, to Rembrandt at his prime,

is a span of a century and a half. This period saw a great step forward in the comprehension of the medium and its capabilities. The use of iron was replaced by copper, a metal that makes correcting and reworking the plate much easier and quicker. Not even the 17th century development of mezzotint by the Dutch and the English, and the 18th century introduction of aquatint by the French, have had as great a bearing on the art as the techniques discovered, developed and used by Rembrandt.

Modern trends, dealing with fields of deep etch and color printing, involve tonal rather than linear expression. Some present-day etchers feel that greater vitality of expression is to be gained from these experiments in tonal reproduction. There is nothing new about this way of thinking, however, as Hercules Seghers, the Dutch artist, led the way in the 17th century with his work in tone and color.

In the following pages are described both traditional and more recently developed methods of intaglio printmaking. No book can do more than introduce you to the fundamentals of craftsmanship. You must furnish your own gift of expression, which, happily married to the techniques of printmaking, will allow you to develop your own way of saying what is on your mind.

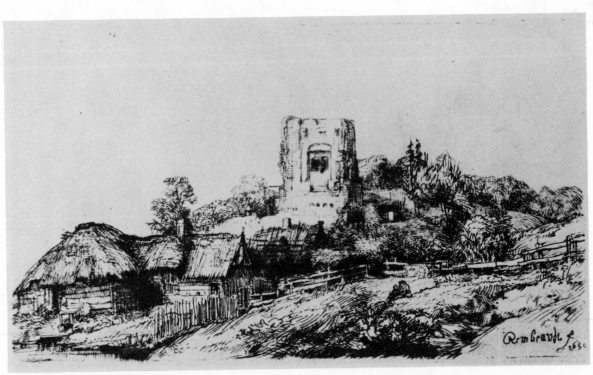

Illus. 1. LANDSCAPE WITH A SQUARE TOWER, Rembrandt (3½ × 6⅛ inches). This small plate from the artist's mature period demonstrates his skill at blending dry point with the etched line.

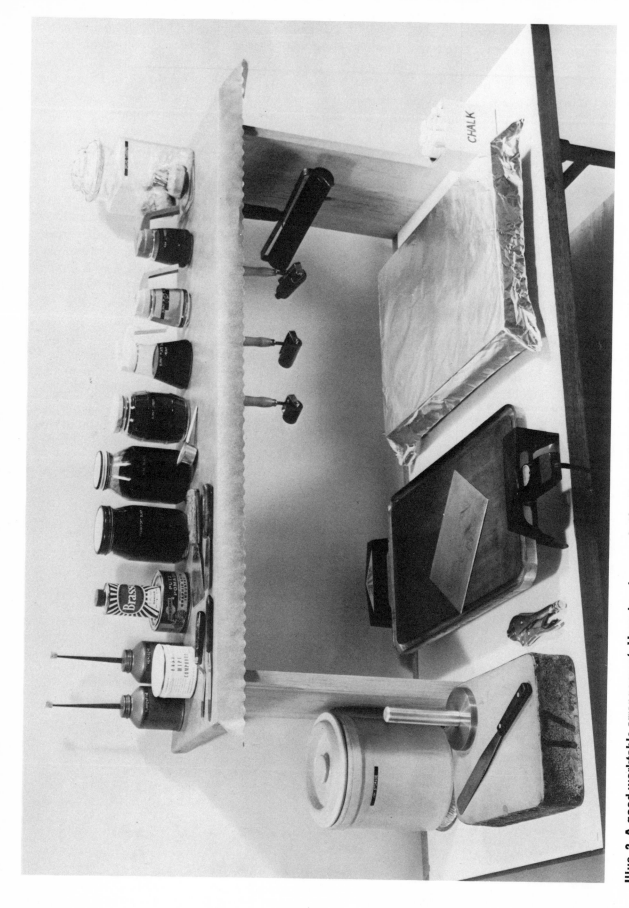

CHALK

Illus. 2. A good worktable arrangement. Have handy on a shelf: oil cans filled with kerosene and turpentine; containers of wiping compound and copper polishes; putty and palette knives; ink pigments and oils; and dabbers. On the table: Ink slab with spatula and stainless steel muller; ink storage crock; electric griddle; foil-covered jigger; chalk. Ink rollers hang under the shelf.

1. PREPARING AND GROUNDING THE PLATE

To be etched successfully, a plate must be properly prepared. This involves cleaning the plate of all dirt and grease and then laying over it a ground having a wax base. This waxy ground will serve as your drawing surface on which you will needle your design, scratching it into the ground. When the plate is etched with acid, the areas of metal exposed by your needle will be incised into the plate, while the areas that are covered by the ground will resist the action of the acid.

However, before concerning yourself with these technicalities, you should first learn something about the metals and other materials involved in the process.

Metals for Etching

The earliest etchings were made from steel or iron plates, since those first etchers were following the methods developed by the armour-makers, who had traditionally etched decorative designs on armour by using a mixture of vinegar and salt as a mordant or corrosive agent. Such a mordant was extremely slow, however, and, in casting around for a means of lending speed to the process, the early plate-makers hit upon the use of nitric acid.

Mild steel plates are still occasionally used for etchings, but steel is not as easy to work with as copper or zinc. The main advantage of steel is its resistance to wear, permitting long press runs and many prints from a plate. Steel (actually a low grade of carbon steel also called sheet iron or sheet metal) is also much less expensive than the finer metals.

Aluminium may also be used for etching; and pre-grounded plates, as well as the special mordant required to etch them, are available from a dealer in etching supplies.

The beginner, however, will do well to confine his attention to copper and/or zinc, both of which are easily obtainable as photo-engraving metals. Such plates come in standard 16-gauge ($\frac{1}{16}$ of an inch) thickness and in various plate sizes up to 24 inches × 36 inches.

The price of copper fluctuates but runs nearly four times the cost of zinc. Preference for zinc, however, should not be based on its lower cost but only on its ability to render adequately your ideas.

Copper photo-engraving plates are highly polished on the face side, while zinc possesses a fine-grained, rubbed surface. Both metals are pre-coated with an acid-resist on the back, eliminating the chore of painting the back of each plate with asphaltum before etching. Since these plates are manufactured specifically for the engraving trade, they render a better account of themselves in the acid, delivering more predictable results than ordinary sheet copper or zinc and are, therefore, to be preferred.

Zinc is appreciably softer than copper and is of a cold, bluish color as opposed to copper's warm, reddish tint. The grainy nature of zinc results in a coarser etched line, though this tendency may be mitigated to a certain extent by using slower acting or more diluted acid baths. Also, since nitric acid attacks zinc (as well as steel) more vigorously than it does copper, the weaker bath helps to keep the etching process under control.

Copper is the traditional etching metal (zinc was not well known in England until the 18th century and was not smelted on the Continent until the 19th). Copper is harder than zinc and it etches a fine, "sweet" line. It also engraves well and maintains dry point for a longer printing time, as the burr (the jagged metal turned out of the scratches by the dry point needle) does not wear away so quickly. (See Chapter 12.)

Cutting the Plate

Small plates may be purchased one or a few at a time from dealers in etching supplies, but the most economical way to buy metal is in large sheets from dealers in photo-engraving supplies (see your phone book). Though other sizes are available, a good size to buy measures 18 inches × 36 inches.

If you have workshop facilities, a bench saw or a radial-arm saw will provide clean, accurate cutting

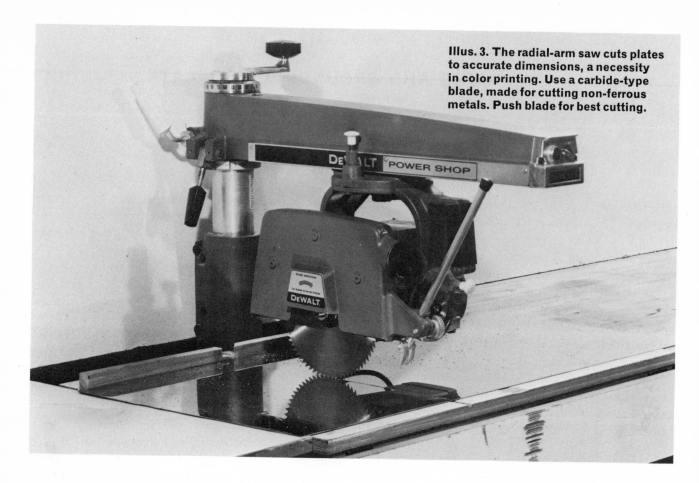

(Illus. 3). The resulting wire edge is smoothed with a file.

A metal-cutting band saw leaves a rougher cut that requires a great deal of filing to true it up. If you wish to cut the plate on a jigsaw, first clamp the metal between two larger pieces of ¼-inch plywood by nailing the wood together with brads outside the plate area. This prevents marring the plate with the hold-down foot of the jigsaw.

Where machine tools are not readily available, you can resort to slower, more arduous, but effective hand methods. A hooked tool called a "drawcutter" or "draw-type copper cutter," is used in conjunction with a steel straightedge. Lay the plate on a clean table with the line of cut near and parallel to the edge. Position the straightedge along the line, with a blotter between it and the copper to prevent scratches. Clamp the assembly to the table with a C clamp at each end of the plate. Position the clamps and blotter so as not to interfere with the cutting tool.

First score the plate with a scratch awl to guide the initial cut of the drawcutter. Go over the scored line several times with the drawcutter, until the plate is cut about halfway through. The plate can then be broken by bending and the resulting rough edge is

filed smooth. A large-size burin (engraving tool) may be used instead of the drawcutter.

To counterbalance your impatience to get started, let your first plate be a small one, not larger than about 4 inches by 5 inches. Once you have learned how to produce exemplary small prints, you will progress with greater confidence into the realm of large ones. Some of Rembrandt's exquisite portraits were composed on plates no more than 2 inches square. He etched full figures on plates measuring 1 by 2 inches. The size of a print should be of less concern to you than its quality.

Cleaning the Plate

Once you have your plate cut to the desired size, check the face in a glancing light for scratches. Very deep scratches will have to undergo treatment by scraping and smoothing as described in Chapter 3, but light ones may be removed by going over them with a tool called a burnisher and oil (Illus. 4). Burnish (rub) along the scratch, *not* across it. Apply pressure to the tool so that the metal bordering the scratch is actually pushed or moved into it, thus filling it and smoothing it over. Follow the burnisher with simple repolishing, using 4/0 emery paper.

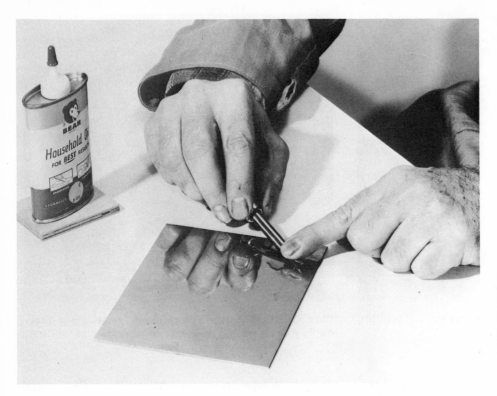

Illus. 4. The burnisher is used to polish out light scratches before grounding the plate. Lubricate with ordinary machine oil and rub the length of the scratch.

The ground with which the plate is to be covered is composed of wax and other materials that will not stick to a greasy surface. Traces of grease on the surface of the plate are not evident until the ground lets go while it is in the acid bath; this must be avoided by thoroughly cleaning the plate.

A wipe with a turpentined rag removes superficial grease. Follow this by thoroughly scrubbing the plate with ammonia and whiting (powdered chalk) (Illus. 5 to 8). You cannot tell by looking at the plate whether or not it is clean, so give it this test: Wash off all traces of whiting under the water faucet and observe the film of water remaining. If this draws itself into free-form patches and globules, the surface is still greasy. Clean the plate some more. When the film remains unbroken, the plate is clean.

Shake off the excess water and lay the plate on the hot heater (the one you will use for grounding the plate—see next paragraph). All water except distilled or rainwater has minerals or chemicals dissolved in it and these impurities precipitate out as the moisture dries. Wipe such residue from the

Illus. 5. To scrub plate, first, soak soft cloth with ammonia.

Illus. 6. Next, dip soaked cloth in whiting.

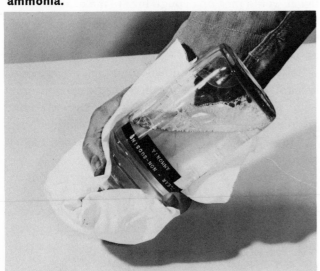

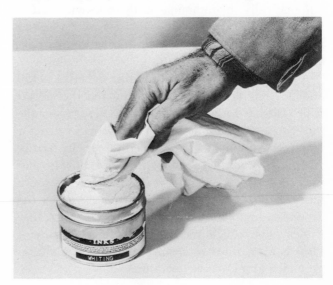

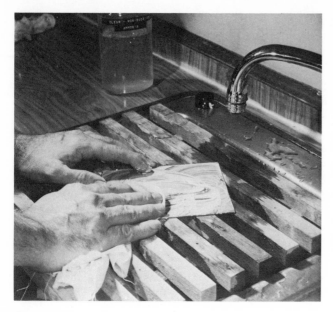

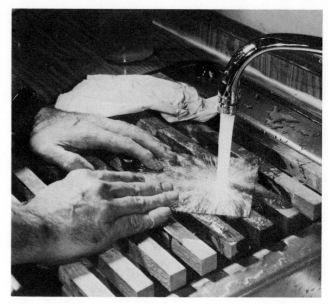

Illus. 7. Third, scrub plate with ammonia and whiting until water-test shows film unbroken.

Illus. 8. When finished scrubbing, wash plate thoroughly, face and back. Remove all traces of whiting.

plate with a piece of clean, dry chamois skin (Illus. 10), taking care not to touch the plate with bare fingers, which would leave grease spots. Always handle the clean plate by the edges only. When not in use, keep the chamois dust-free in a plastic bag. Wash it occasionally with warm water and mild soap or detergent.

The Heater and the Jigger

In early times, a charcoal brazier was used to heat the plate for grounding. Sometimes even now a gas burner, lighted under a steel plate, is used. For modern studio convenience, however, use an electric heater, either one made especially for the purpose or an electric griddle equipped with a thermostat for automatically maintaining a pre-set temperature (Illus. 2 and 9). Choose one with a level top having no raised sides to interfere with sliding the plate on and off.

A safe temperature for grounding is between 150 and 200 degrees F., as marked on the thermostat scale (Illus. 9). All thermostats may not register the same, so you should determine the correct range for your own equipment. The temperature is satisfactory when you can place your fingertips on the hot surface and just bear to leave them there for a second or so. If, when grounding a plate, you see the ground begin to bubble or smoke, you are seeing sure evidence that it is burned. A burned ground will not resist acid. It must be cleaned off and the plate re-grounded at a lower temperature.

If the temperature is a little too low, the ground will still melt, but the roller or dabber used to apply it will deposit dark blobs of solid material in the melted ground. If this happens, raise the heat until the blobs melt and return to the roller or dabber.

When the plate requires cooling, slide it off upon the jigger. The jigger is a box or raised surface placed beside and level with the heater to facilitate sliding the plate back and forth. For inking, the jigger may be covered with newspaper to keep it clean; but when grounding, unless the jigger surface is of metal or is heavily varnished so that it may easily be cleaned with turpentine, cover it with a piece of heavy-duty aluminium foil. (Illus. 2). An accidental touch of the grounded roller to a paper-covered jigger would pick up enough fuzz to make a thorough cleaning of the roller mandatory at once. This is also true for the dabber. The use of foil protects from such an accident.

To clean the roller down to its leather surface, first roll off as much as possible of the ground on a blank plate (or use an old etched plate) heated on the griddle, then finish cleaning with a turpentined rag. Let dry before using. The dabber is cleaned in the same way.

Ball Ground

Ball ground is so called because it is prepared in the shape of a ball (Illus. 11). Prepared ball ground may be purchased from suppliers of etching materials and one ball will ground many plates.

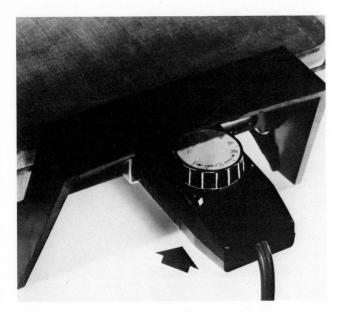

Illus. 9. Arrow points to thermostat setting (about 150 degrees F.) on electric griddle used to heat plate.

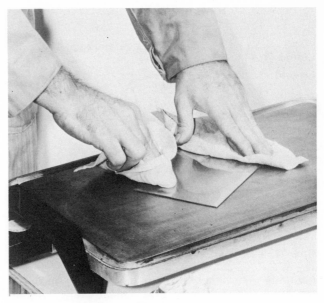

Illus. 10. When plate is dry, rub it carefully with chamois skin to remove wash-water residue.

Ground is to be had as (1) hard ground, (2) soft ground, and (3) transparent ground. Transparent ground is sometimes suggested for regrounding (Chapter 8) when it is desirable or necessary to be able to see very fine detail already bitten into the plate. For general regrounding, however, ordinary hard ground is just as efficient and makes the new work easier to see. Soft ground will be discussed in Chapter 9.

Some etchers prefer to make their own ground. The advantage of this is that you not only know what the formula contains, but you may vary the recipe to suit your immediate needs. Here is a recipe for hard ground that is standard:

2 ounces (8½ tablespoons) lump asphaltum
2 ounces (5 tablespoons) beeswax, white or yellow
1 ounce (3 tablespoons) lump rosin

Powdered materials may be used, if desired, but

Illus. 11. The leather roller in its protective box, with a ball of hard ground.

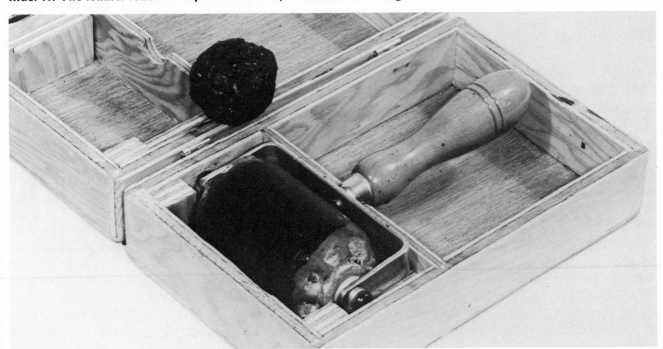

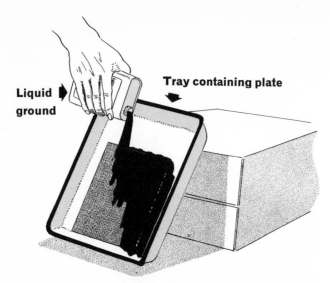

Liquid ground

Tray containing plate

Illus. 12. The best way to use liquid ground is to tilt tray at a steep angle and flood plate quickly. Remove and drain plate; stand on edge to dry. Funnel excess ground back into container immediately. Liquid ground may also be applied with a soft, wide brush.

they are more expensive. Crush the lump material to powder in a mortar, or use a heavy mug or bowl and the handle of a table knife for crushing. White beeswax has been purified of foreign materials that might scratch the plate and is therefore to be preferred. Yellow beeswax is more readily available, however, and may be used.

First melt the beeswax in an earthenware mug or bowl set in a pan of boiling water over low heat. Slowly add the asphaltum, stirring with a stick. Then stir in the rosin little by little until it is all melted.

Fill a kettle with cool water and tie several thicknesses of cheesecloth over the top. Pour the melted mixture on the cheesecloth and rub it through with the stick. Remove the cheesecloth and, as the mixture in the kettle cools, form it into balls underwater. Set the balls aside to harden, then wrap them individually in foil or plastic. Store in a glass jar with a tightly fitting lid to keep out dust.

If the ground made by this formula turns out to be too hard (it chips when lines are needled closely together or in cross-hatching), remelt it and add a little more beeswax. If it is too soft (gummy and it sticks to the needle), remelt it and add rosin. Alter the formula accordingly for future use.

Transparent Ground

Substitute 2 ounces (6 tablespoons) of damar crystals for the asphaltum in the hard-ground formula. (Damar is used to make damar varnish for use in oil painting and may be bought from an art-supply house through your local art-supply dealer. As damar melts at a higher temperature, after the beeswax and rosin have been melted, turn up the

heat until the water in the pan boils briskly, then add the well-powdered damar crystals a little at a time, stirring each bit until molten before adding the next. Or, the damar may be melted first, then the other ingredients added. Cool and form into balls as previously described.

Liquid Ground

Suppliers provide a liquid ground, the diluent of which may be benzol, ether, or something of the kind, in which the ground materials are dissolved. Illus. 12 shows how liquid ground is applied to the plate. The plate should be cleaned as usual before grounding, but no heating is required. After grounding, the plate is leaned against the wall, grounded side in, until the solvent evaporates.

Liquid ground is most often used with the "sugar lift" technique of etching (Chapter 10). It also may be used for correcting mistakes made in needling, where the patched area must be reworked with the needle. Apply to needled lines with a pointed sable or camel's-hair brush; block out larger areas with a soft, flat brush. When dry, reneedle as desired. Liquid ground is available in both hard and soft grades.

Grounding with the Leather Roller

A large, leather inking roller such as used in lithography is ideal for applying ground, as the large size makes it easier to lay on an even coating. Such rollers are expensive, however, and the usual grounding roller is either 2½ or 4 inches wide (Illus. 11).

The roller has a wooden core around which is wrapped padding of thick felt. This is covered with thick leather, so joined at the seam as not to interfere with laying the ground. The home-made box shown in Illus. 11 keeps the roller free of dust when not in use and the fittings inside hold the device centered so that the roller does not touch anything. Protection from dust is further assured by enclosing the roller in a plastic bag when putting it away. The bag alone will be enough if securely closed by cord tied around the base of the handle. Turn a screw-eye into the end of the handle for hanging the assembly under a shelf.

A roller used for hard ground must be so marked and never used for soft ground. If the formula for the ground is changed, clean the roller down to the leather before using. If you plan to work with soft ground, buy a second roller for that use alone.

Illus. 13. Ground is melted on to the heated plate by moving the ball around upon it.

Illus. 14. Levelling and smoothing out the ground is done with the leather-covered roller.

Having cleaned the plate, warm it on the heater, and you are now ready to roll on the ground. If your roller is new or just cleaned, you will have to put quite a lot more ground on the plate than if the roller were already well covered. The ground is melted on the plate by stroking it with the ball (Illus. 13). The ball may be wrapped in silk (pongee) tied around it like a bag, through which the ground is melted to strain out impurities if any should be present.

Now roll the ground out evenly over the plate, working from heavily grounded areas to areas of thinner or no ground. (Illus. 14 and 15). Do not

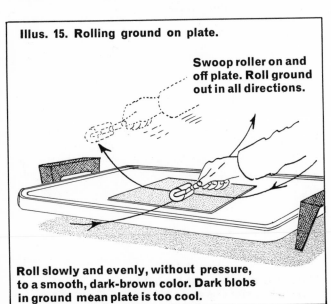

Illus. 15. Rolling ground on plate.

Swoop roller on and off plate. Roll ground out in all directions.

Roll slowly and evenly, without pressure, to a smooth, dark-brown color. Dark blobs in ground mean plate is too cool.

permit the roller to come to a stop on the plate. This will leave a mark. Swoop the roller on and off. Do not apply pressure, or the roller will skid. Roll *lightly* in all directions, and roll *slowly*. Slow rolling transfers ground from the roller to the plate. Fast rolling picks up ground from the plate and puts it on the roller.

Stated another way: Roll slowly to make the ground thicker; roll fast to make it thinner.

The color of a grounded plate should be of an even, *dark* brown, somewhat richer looking on copper than on zinc. If the tone appears light or tan, the ground is too thin and will not resist the acid. Make sure you get the ground on thickly enough; but, if it has a puckered look, it is on too thick. If it is on too thick for picking up by fast rolling, transfer the extra ground from the roller to a second plate on the heater. Just remember that it is harder to lay a ground that is too thick than one that is too thin. You are more likely to err on the thin side.

Heavy ridges of ground that may collect along the edges of the plate will not resist acid and may chip off in the acid bath. See that these are well rolled out. Keep the heat high enough to avoid depositing dark blobs in the ground.

If the ground does not roll out smoothly on the heater, transfer the plate to the foil-covered jigger and continue rolling slowly. Before the plate is quite cold, or when it becomes evident that nothing more can be accomplished, return the plate to the heater and leave it there until the ground glistens—a sign

Illus. 16. Homemade rubber-ball dabber in foreground; lathe-turned dabber cores in background.

Illus. 17. Large dabber head can be turned on lathe by experienced woodworker.

A.

1-inch dowel is glued and nailed to disc of cardboard

B. Small nail

Sponge-rubber ball sliced in two at the mould mark

C.

Disc of ¼-inch thick felt, same diameter as ball

D.

Circle of silk or chamois skin, three times diameter of ball

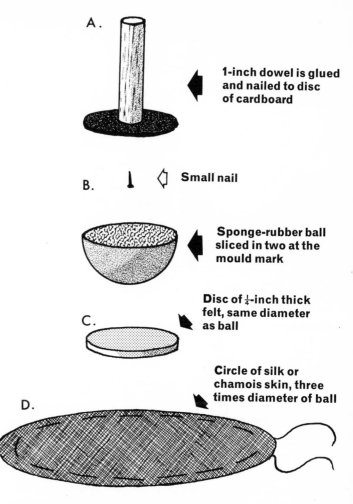

Illus. 18. To make dabbers, glue handle-disc (A) to ball (B) with white glue. Stitch a drawstring (or heavy thread) around cover (D). Draw up the cover as a pouch around the ball and the thick felt pad (C); wrap the string several times around the handle and tie. Ink dabber requires different kind of cloth for cover—see text. Dabbers (leather for grounding, cloth for inking) may also be bought at large art shops or from dealers in etching supplies.

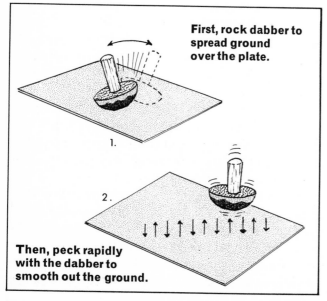

First, rock dabber to spread ground over the plate.

1.

2.

Then, peck rapidly with the dabber to smooth out the ground.

that it has melted. The plate may be transferred back and forth in this manner as often as necessary, until the ground achieves an even thickness and color throughout.

Illus. 19. Grounding with the dabber is done in two steps as shown in the diagram and as described in the text.

Illus. 20. Smoke-producing devices: Kerosene lamps, taper coil. A 6-strand twist leans on lamp base.

Illus. 21. Pick up hot, grounded plate with locking plier. Pad plier's jaws with folded blotter.

Grounding with the Dabber

The dabber (Illus. 16 to 18) is the traditional grounding tool; in former times the roller was reserved for regrounding.

Each type of ground requires a separate dabber, which should have a cover of chamois skin turned smooth side out, or one of fine silk. The inking dabber may be covered less expensively with thin felt, flannel or muslin. Illus. 15 shows a simple way of making your own dabbers from a sponge-rubber ball—one ball makes two. Store the grounding dabber away from dust in a plastic bag or glass jar.

Whereas the roller is useful for original grounding, or for regrounding when it is desired to leave the etched lines open for rebiting, the dabber is a practical necessity in regrounding where the ground must be forced into the lines to prevent further biting. As shown in Illus. 19, the ground is first spread over the plate by rocking the dabber in all directions. When the ground has been distributed evenly in this manner, slide the plate from the heater to the jigger and change the method of using the dabber.

Use the dabber now in a rapid, up-and-down pecking action that both smooths and consolidates the ground into an even, homogeneous layer. When the ground appears satisfactory, return the plate to the heater for remelting the ground. If further dabbing is required on the heater, do this, then return the plate to the jigger, and so on, back and forth as required, until the ground is satisfactory.

Smoking the Ground

Smoking incorporates a layer of soot into the melted ground, resulting in a dead-black surface upon which the needled lines show up brilliantly. Some etchers dispense with smoking the plate and work directly on an unsmoked ground.

A smoked ground shows up flaws and pinholes so that they may be patched.

The traditional smoke generator is the wax taper, which comes in a coil (Illus. 20, foreground). Six-inch lengths are cut from the coil and from three to six strands are twisted together in a group. All wicks are lighted at once to provide the smoke.

A kerosene lamp may be also used. The old-fashioned alcohol lamp with a rope-like wick, shown at the left in Illus. 20, is a splendid smoke-maker. It has a cap on a chain for snuffing the flame at the conclusion of operations.

To smoke a hot, grounded plate, pick it up from the heater with a hand vise or the easier-to-operate and more securely-gripping locking plier (Illus. 21). Pad the jaws with a small piece of folded blotter to protect the plate from scratches.

For a large plate (9 × 12 inches or larger), it will be necessary to grip the plate by two corners, as it is too heavy to be held by one. In this case, the smoke generator is placed on a table and the grounded side of the plate is passed back and forth above it.

The hot core of the flame must not linger on the ground or it might burn it. But, if the flame is too

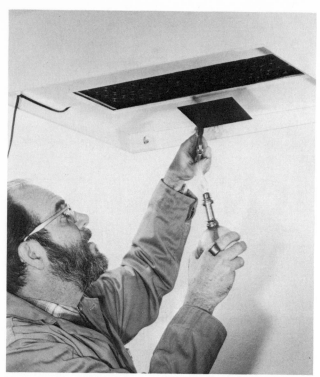

Illus. 22. Smoking a small plate with a kerosene flame. Note smoke being drawn through filter in hood.

resist acid and must be cleaned off so that a new ground may be laid. Therefore, take care with the flame and save yourself unnecessary work.

As the smoke billows over the plate, some of it is absorbed into the hot, melted ground. The remainder, in coils, strings and streamers, goes flying around the studio, settling black soot everywhere.

Such dirt may be avoided by installing a range hood with a filter and exhaust fan. Range hoods are universally available and reasonably priced. If the hood is vented to the outdoors, it may also be used over the acid bath as a fume eliminator.

If you are handy with tools, you may build your own smoke eliminator, based on Illus. 23. The small, squirrel-cage exhaust fan is inexpensive, or you may find one of the same type at a junk yard. By adding a length of flexible drier hose leading to a window board, the hood may also be used over the acid bath. It may be mounted firmly to the wall or suspended from the ceiling by chains.

The drawing shows a single furnace filter in place. Two filters, each 2 inches thick, taped together do a better job, however.

After you have passed the smoke generator back and forth and around under the plate for a few minutes, you will notice that some of the carbon is beginning to stick to the ground. Move the flame about in such a manner as to deposit a smooth, even coat upon the entire surface. After a short time longer, the ground will have turned a shiny black all over. It is shiny because the ground is melted. When this has cooled and solidified, the appearance will be flat black.

If the surface shows a granular aspect of dull-

small, not enough heat will accompany the smoke to keep the ground melted until smoking is completed and the plate will have to be reheated from time to time. So use a large enough flame and keep the plate moving briskly above it.

A small plate may be held grounded-side-down a little above eye level (Illus. 22), so that you can see what is happening. Pass the flame back and forth under the plate without stopping in order to avoid burning the ground. A burned ground will not

Illus. 23. The smoke hood.

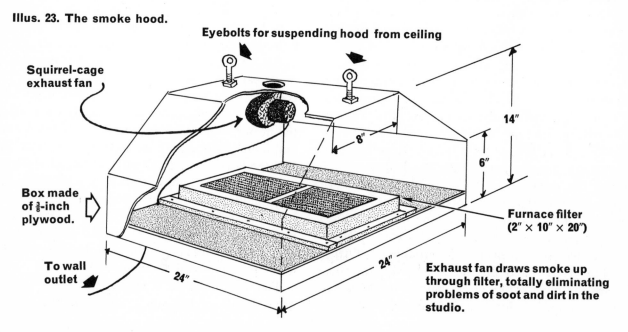

Eyebolts for suspending hood from ceiling

Squirrel-cage exhaust fan

Box made of ⅜-inch plywood.

To wall outlet

14"

8"

6"

24"

24"

Furnace filter (2" × 10" × 20")

Exhaust fan draws smoke up through filter, totally eliminating problems of soot and dirt in the studio.

looking soot, either the plate was allowed to grow cold in the process, or the ground was too thin to absorb it. Sometimes the carbon may be absorbed if the plate is returned to the heater and the ground allowed to melt. But if the ground refuses to absorb the soot, the only thing to do is clean the plate and start all over again.

The smoked plate will cool faster if laid aside on the stone ink slab or the steel press bed. As soon as the plate is cold and the ground hardened, it is ready to be worked upon, either immediately or at any time in the future. If put aside for future working, the plate should be stored in a cool place and the ground protected with a wrapping of paper to keep it from picking up scratches.

White Ground

Laying a white ground eliminates the need to smoke the plate and provides a dead-white, paper-like surface for drawing upon in a positive manner—that is, the lines show up dark on the white background, like a pencil or pen drawing on white paper. This permits you to judge the tones better and to achieve an immediate result similar to the looks of the ultimate print.

First lay a hard ground and let it cool. Patch flaws in the ground (see Chapter 2). Take a small amount of white grease-paint (obtainable from a dealer in theatrical supplies) from the tube with your

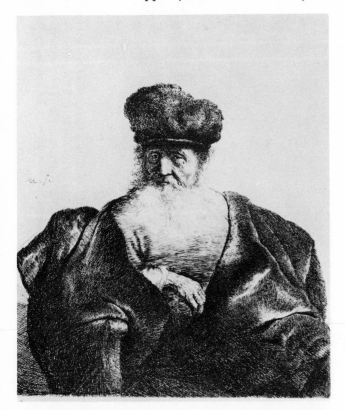

fingertip and dab it over the ground. Spread it thinly on the plate with your fingertips. Wash and dry your hands. Sprinkle some *non-chalking* titanium dioxide pigment (from a paint manufacturer) on the greased ground. (Zinc white may also be used, but *white lead* is poisonous.) With dry fingertips, gently rub the pigment until smooth and even, adding more pigment if necessary to further whiten the ground.

The white ground may be drawn upon directly with the etching needle as if it were a pencil or pen, or a drawing may be transferred to it by tracing. The drawing is transferred in reverse so it will print properly—see Chapter 2. To do this, take a piece of parchment-type tracing paper bigger than your original drawing to provide a margin at top and bottom. Trace the original drawing on this paper with pen and ink. Thoroughly blacken the *inked* side of the tracing with the flat of a 2B or softer graphite stick. Smooth the graphite out with your fingertip. The inked drawing will show plainly through the uninked side of the tracing paper.

Lay the tracing graphite-side down upon the white ground. Fold the top margin over the plate and tape it to the back. Trace the drawing upon the ground with a mimeo stylus or used-up ball-point pen and *very light pressure*. A heavy trace may cut through the ground; then, when needling, unless you hit the original line exactly, both the traced line and the needled line will bite in the bath. It is good practice, wherever the needle departs from a traced line, to paint out the latter with stop-out varnish before etching. Lift the paper occasionally to make sure the tracing is setting off properly.

Safety Precautions

Cleaning and grounding the plate make use of dangerous, volatile fluids, such as turpentine, kerosene, asphaltum, benzol and the like. It is therefore imperative that you take full safety precautions. Keep all such fluids in screw-top, metal cans and equip the area where they are used with at least one large fire extinguisher of Classification 4-B:C, carbon dioxide type. Never throw water on a fire originating in oil, volatile fluids, or defective electrical wiring.

As a further precaution, store all oily rags away in a large, metal container. A 10-gallon garbage pail, bought expressly for the purpose, is ideal.

Illus. 24. OLD MAN WITH WHITE BEARD AND FUR CAP, Rembrandt (5$\frac{3}{16}$ × 5 inches). Note the exquisite development of texture, using only the etching needle.

Illus. 25. Useful items are kept within reach at the etcher's worktable—needles, roulettes, stop-out varnish, liquid ground, brushes, gooseneck magnifying glass (partially hidden). The wood frame covered with tracing paper serves to diffuse the harsh glare of light from the table lamp. The frame is inclined at an angle. The supporting leg is held by a string to prevent it spreading too far. The leg can be folded back against the frame when the screen is to be put away.

2. NEEDLING THE PLATE

The Drawing

Before anything else, some thought must be given to the drawing you intend to make into an etching. Keep your design both simple and small—a line drawing of any subject that suits your fancy, which you may make from nature, from a photograph, or from imagination. Don't worry about making it *too* small. The self-portrait by Rembrandt (Illus. 27) reproduced on the next page in actual size shows how much can be done with a little piece of copper.

Probably the most difficult part is getting the drawing properly located in the available space. If you work directly on the plate without benefit of a preliminary drawing, you are likely to find your work badly askew in respect to the space at your disposal. Once you have started a bad drawing on the plate, the only cure is to wash off the ground with turpentine and start over.

By being neither in a hurry nor too impressed with your own infallibility, you may save yourself unnecessary work. You will gain by making a preliminary drawing—even a rough one—and transferring it to the grounded plate.

If you wish, you may make a complete drawing with pen and ink and use it as a model. This is not, however, necessary, as you may work up the drawing on the plate from a simple beginning of outlines. If you do make a preliminary drawing, trace it on parchment-type tracing paper with a 2B pencil; or, make your original drawing on layout or tracing paper.

In either case, don't go to the trouble of transferring every bit of detail and modelling. Indicate only the edges of shadows in the outline. Make the drawing the same size as the plate and leave a margin on the paper of an inch or so on each of the two long sides.

Illus. 26. Sewing needles are in jar at left; then two phonograph needles; mimeo styli; a ball-point pen; and two brushes. Behind: Jars of lampblack, liquid ground, stop-out varnish. Foreground: Roulettes, badger-hair brush, X-Acto knife.

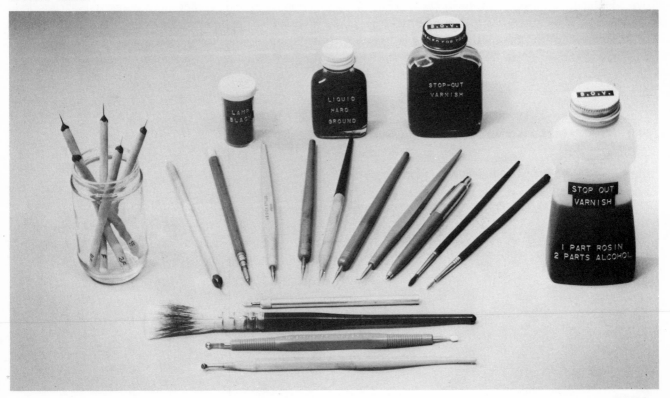

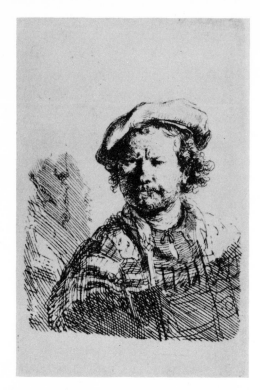

Illus. 27. SELF-PORTRAIT by Rembrandt (3¾ × 2½ inches). Note how the reflected light illuminates shadow on subject's right cheek.

Now run the plate face up through the etching press, following the set-up shown in Illus. 62 in Chapter 5, but leaving off the top blanket and the blotter over the plate. Check the transfer before stripping the drawing from the plate. If the drawing did not transfer well, run the plate through the press again with a sheet of cardboard between the roller and the blankets to increase the pressure. The transfer shows up in shiny black lines on the smoked ground.

The drawing may also be transferred without a press by burnishing with a spoon (Illus. 30) or by rolling with a hard-rubber roller (Illus. 31).

Examine the transfer. You will see that it is the reverse of your original drawing—that is, objects originally on the right side now appear on the left and vice versa. In order for the image to print the right way around it must be etched or cut into the plate in reverse and you must always keep this in mind. Therefore, when you are needling from a preliminary drawing or a photograph, prop the original up in front of you so that it faces a mirror placed in a manner that allows you to see its reflection (Illus. 32).

When needling the design on the plate, do not by any means follow inflexibly the outlines transferred to the ground. Use the transfer only as a guide and *draw again* so as not to lose the spontaneity of the original drawing.

Sometimes an etcher may make a portrait or a landscape drawing from the subject exactly as he sees it, needling the plate without benefit of an intermediate drawing. The print from such a plate is in

If the plate is smoked, the transferred drawing shows up on it better. Lay the plate grounded side down upon the face of the drawing, fold the margins over the back and tape them down (Illus. 28).

Although some authorities say to wet the drawing before attaching it to the plate, don't do it. Wetting only makes the paper stretch so that the drawing no longer fits the plate, and it has no effect on the transfer.

Illus. 28. (below). Fold margins of drawing and tape down to back of plate.

Illus. 29. (right). Transfer drawing to plate by press.

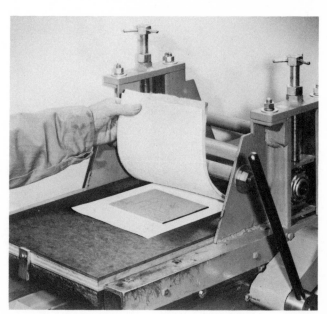

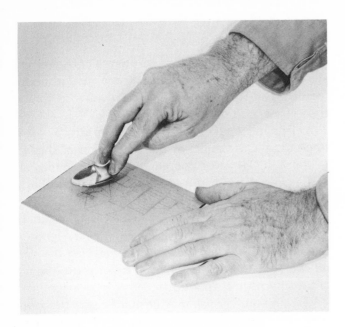

Illus. 30. Transfer drawing by burnishing.

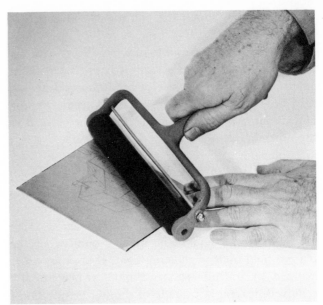

Illus. 31. Hard roller transfers drawing to plate.

reverse, a fact that does not bother an artist. However, if that print *must* be viewed the right way around, it has to be held up to a mirror.

When an etcher makes a self-portrait—and many have been made—he draws, perforce, what he sees in a mirror, which is a reversed view of himself.

Illus. 32. When working from a photo or an original drawing, view the image reflected in a mirror while needling it, thus reversing it on the plate. When printed, the image will appear the right way round.

The print then shows the subject as other people are accustomed to seeing him.

If you want to make a life drawing directly on the plate, yet have it print the right way around without having to make and transfer a preliminary drawing, turn your back on the subject and needle on the plate what you see in a small vanity mirror held in the other hand.

Patching the Ground

Smoking the ground has a particular value in making apparent every flaw and blemish in the ground. Pinholes, dust marks, scratches—all are glaringly visible against the black ground when the plate is held up to a glancing light. From the corner gripped by the pliers the ground has been totally removed, leaving a triangle of shining metal. These flaws all require patching, which should be done before the design is needled in.

Wherever the intention is to leave an area blank, patching may be carried out with stop-out varnish. Where the ground is to be needled, however, patching is done with liquid ground, or with ball ground dissolved with turpentine on a brush (Illus. 33).

Stop-Out Varnish

Dissolve 1 ounce of rosin in 2 ounces of denatured alcohol (shellac thinner). This makes a good stop-out varnish. If it should run or spread, thicken it at the time of use with dry lampblack powder.

A 4-pound "cut" of shellac also makes a good stop-out. ("Cut "refers to the proportion of shellac to thinner; "4-pound cut" means that 4 pounds of shellac have been dissolved in one gallon of alcohol.) Buy it ready-made or make it yourself by dissolving 4 ounces of shellac flakes in 8 ounces of alcohol. Where 3-pound cut (the usual commercial grade) must be used, thicken the shellac by leaving the cap off the container for a while, thus permitting some of the solvent to evaporate.

The stop-out varnish may be made easier to see on the plate by coloring the solution purple with a few drops of methyl violet. (The addition of lampblack turns it black and opaque.) Keep a container of alcohol on the table for rinsing the brush (Illus. 33). Stop-out varnish is brushed on the edges of the plate to protect them from the acid and is painted on the unworked areas of the plate to assist the ground in resisting the acid.

Illus. 34. To prevent scratching, the etching point must be conditioned before it is used on the plate. Start at Position A, twirl point in smaller and smaller circles on stone or metal surface to Position B. Check with magnifier for smoothly rounded point.

Illus. 33. To patch blemishes in the ground, pick up ground from the ball with a turpentined brush and transfer it to the plate.

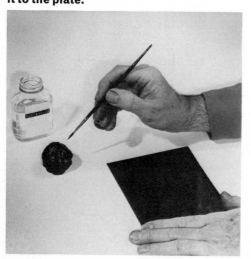

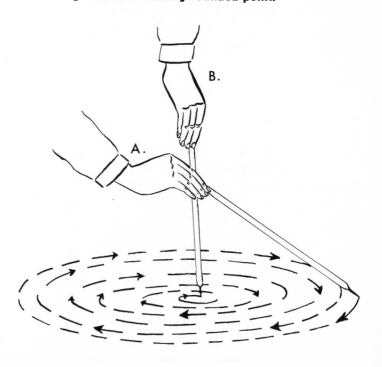

The Etching Needle

An etching needle is used to scratch the design into the ground. Wherever the needle cuts through the ground, bare metal is exposed to the action of the acid.

Many kinds of points may be used (Illus. 26)—sewing needles of all sizes, steel phonograph needles, mimeograph styli, etc.

A heavy darning needle may be inserted into the chuck of a draftsman's pencil in place of the usual pencil lead. Very fine needles may be mounted in the end of a wooden dowel. To center the point, revolve the dowel in the chuck of a lathe or an electric drill while the needle, gripped by pliers, is thrust eye-end foremost into the end of the dowel, into which it literally drills itself without effort. Leave about a ⅜-inch point exposed and make it firm by melting and shaping a few drops of sealing wax around it.

An etching, like a drawing, may contain both thick and thin lines. There are several ways to accomplish this, but for now we shall consider only one: Using needles of different sizes—very fine points for extremely thin lines and heavy points for wider lines. You should provide yourself with at least three etching needles—one a very fine needle from a sewing kit, a second point made from a medium darning needle or a steel phonograph needle, and a third that is the heaviest darning needle you can obtain.

None of these points will serve in their original shape, as all are far too sharp. They would gouge not only through the wax but also into the metal, making it difficult to draw and causing the acid to react faster where the digging in was deepest. The result would be uneven or spotty tones spoiling the effect of unity in the print.

Illus. 34 shows how the point is conditioned, or rounded, for proper service. Make sure that the point is evenly rounded and not flattened on one side.

In use, the point should glide over the surface, turning up the ground in a neat furrow. The displaced ground curls away from the point and, unless it is frequently brushed away with a badger-hair or other soft brush (Illus. 26), it will soon obscure the work.

The Mimeograph Roulette

Stationers handling mimeograph supplies can supply you with roulettes as well as styli. The roulette is a small, toothed wheel set in a handle.

Different kinds are available—one makes a succession of transverse dashes; another lays down a row of dots. Both can be used to create areas of tonality. The roulette will have less tendency to clog if touched with a lightly turpentined rag. For more information on the roulette, see Chapter 13.

The Échoppe

The *échoppe* was invented centuries ago to make an etching look like an engraving. The engraved line starts with a point, increases in thickness and finally tapers off to a point again at the end. The etched line, on the other hand, starts with a blunt end, proceeds at a uniform thickness, and concludes with another end as stark and blunt as its beginning.

To produce the effect of the thick and thin line, the *échoppe* was created with an angled point (Illus. 35). When used edgewise, the point cuts a thin line. When turned 90°, the point plows a regular furrow. By turning the instrument one way or the other, you can produce variation in line thickness, resulting in a reasonable imitation of the engraved line.

The Worktable

Whether you work by daylight coming in through a window or by artificial light, you will find it advantageous to have a means of diffusing the light to minimize glare from the needled lines on the plate. A wood frame to which parchment tracing paper has

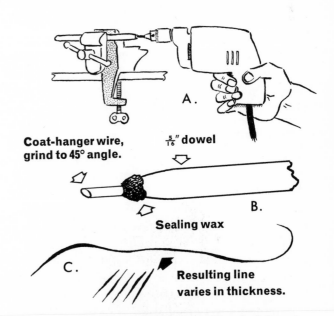

Illus. 35. Making an *échoppe*. Drill end of dowel with 3/32" bit (A). Insert wire, secure with sealing wax and grind point to 45°. The resulting tool is the *échoppe* (B), which makes a line similar to an engraved one, varying in thickness (C).

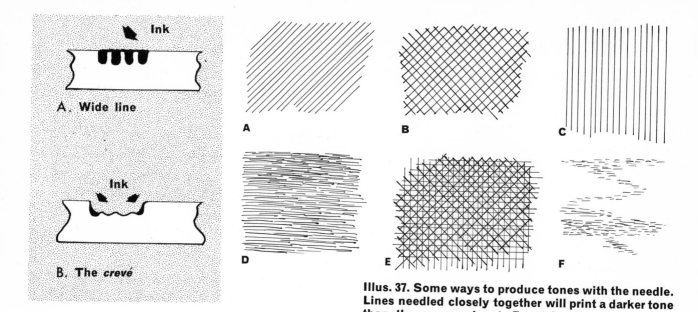

Illus. 36. To make a wide-printing line, needle thin lines close together (A). If overbitten, a *crevé* is produced (B), so watch plate in acid closely.

Illus. 37. Some ways to produce tones with the needle. Lines needled closely together will print a darker tone than those spaced out. Examples D and F provide more informal shading than the others; E is double cross-hatching. Closely needled, it results in solid black.

been stapled or tacked makes an excellent diffuser (Illus. 25).

Even with a diffuser, there will be enough glare to make the lines seem wider or thicker than they really are and therefore closer together than they are in fact. Lay a piece of parchment tracing paper on the plate and the lines will show up without glare in their true relationship to each other. Better still, slip on a pair of Polaroid sunglasses. Ordinary sunglasses will not work. They only color the glare. Polaroid gets rid of it.

Useful, too, is a low-power magnifying glass of 4 or 5 inches diameter, mounted on a goose-neck. A small, 5-power linen tester may be used to study the etched lines.

Needling the Plate

Unlike a drawing pencil, the etching needle is held in as nearly a vertical position as you find comfortable. Drawing with the needle is different from drawing with a pencil in other ways. Paper has a tooth and this communicates a drag to the hand holding the pencil. The plate, however, offers practically no friction to impede the movement of the point. More rigid muscular control is therefore necessary to guide the needle and keep it from moving off in undesired directions.

With ordinary drawing, the weight or "color" of a line is varied by pressing lightly or heavily with the pencil. However, when handling the etching needle, you must always use a firm, even pressure, regardless

of whether the needle is fine or coarse, or whether the line is to be thin or thick. A light touch will cause the point to cut only part way through the ground, leaving a thin layer of wax still covering the metal. Worse, you will scarcely realize this until such lines fail to bite in the bath. However, a close inspection and a comparison with firmly needled lines will show that the insufficiently needled line is dull in color, with a waxy look that betrays the thin film over the plate. If you detect such a line, reneedle it. In some cases, it may have to be blotted out first with liquid ground.

Don't be afraid to make mistakes—you can always correct them. If a line wanders off where it is not wanted, but where it will not interfere with other lines, brush stop-out varnish over it. If the needling gets out of hand and you don't like what you are doing, wash the ground away with turpentine and start over.

Visualize what the probable result of each line will be in the print and use the different size needles accordingly. If you want a very wide line, one that is wider than any of your needles will cut, don't scrape out the ground to the width you want. Such a line will be entirely unsuccessful. A wide line is made by laying several fine lines side by side (Illus. 36*a*). If such a line is left in the acid for too long, the fine, separating barriers between the lines will be eaten away, resulting in a *crevé* (pronounced cruh-vay') (Illus. 36*b*). The ink will adhere only to the edges of such a line, which will print as two mealy-looking

Illus. 38. Be sure to paint the edges of the plate with stop-out varnish.

side lines with a dirty grey streak between them.

Sometimes a *crevé* may cover a considerable area. When that happens, the area can be made to print a darker tone, or black, by roughening the bottom with a burin, the scraper point, a dry point, a roulette, or a mezzotint rocker.

Illus. 37 shows several ways to create tonalities with the needle. The heavier the lines are needled or the longer they are etched, or the closer together they are, the darker the printed tone will be. Illus. 37, *e*, the double cross-hatching, is an example of a "dark manner" that was greatly favored by Rembrandt. Deep, luminous blacks may be created by cross-hatching an area, or an entire plate, then cross-hatching again diagonally to the first work. A fine needle must be used. The needling may be done free-hand, or a ruler may be used for more accurate spacing and drawing.

If the ground tends to chip when you are needling the second cross-hatching, stop and etch the first to the full depth desired. Then clean and reground the plate, needle the second cross-hatching over the first and etch it in. If desired, the entire plate may be treated in this manner; then grey tones and lights can be brought out of the black by working it with scrapers and burnishers as explained in Chapter 13, in reference to mezzotint.

When needling, you must also consider the type of acid bath to be used. Remember that lines may be needled more closely together for the Dutch bath than for the nitric acid bath to produce the same depth of tone, as the Dutch bath bites a finer, deeper line. Acid baths will be discussed in the next chapter.

Don't needle the plate too heavily with hatching, cross-hatching and scribbling where the idea behind the print does not require it. An area of blank plate tone is often more eloquent than a mess of frenzied lines. (Plate tone is the slight tone laid down in the print from the thin film of ink remaining on the un-worked areas of the plate.)

Do not rest your hand heavily on the grounded plate. Where it is necessary to touch the ground, protect it from abrasion by covering it with a piece of paper. Lingering too long in one place may cause the wax to soften from the warmth of your hand.

When you sign your name to the plate, remember to write your signature backwards, or you will be obliged to read it backwards on the print.

Where the back of the plate is pre-coated with acid resist, as is the case with photo-engraving metal, only the edges need to be protected with stop-out varnish. If the back of the plate is bare metal, however, it must be protected from the acid by painting it with asphaltum varnish. If the asphaltum looks spotty when dry, give it a second coat.

Although the ground is supposed to protect the plate from the action of the acid, it sometimes has weak spots where "foul biting" may take place. To prevent this in the broad, clear areas, brush them with several coats of stop-out varnish, up to the needled lines (Illus. 39). If the varnish shows any tendency to run, thicken it with lampblack, which may be bought at a hardware dealer (ironmonger).

The plate is now left until the stop-out varnish is thoroughly dry and hard before submitting it to the acid bath.

Illus. 39. The needled plate. Different-size needles were used and clear areas were stopped out.

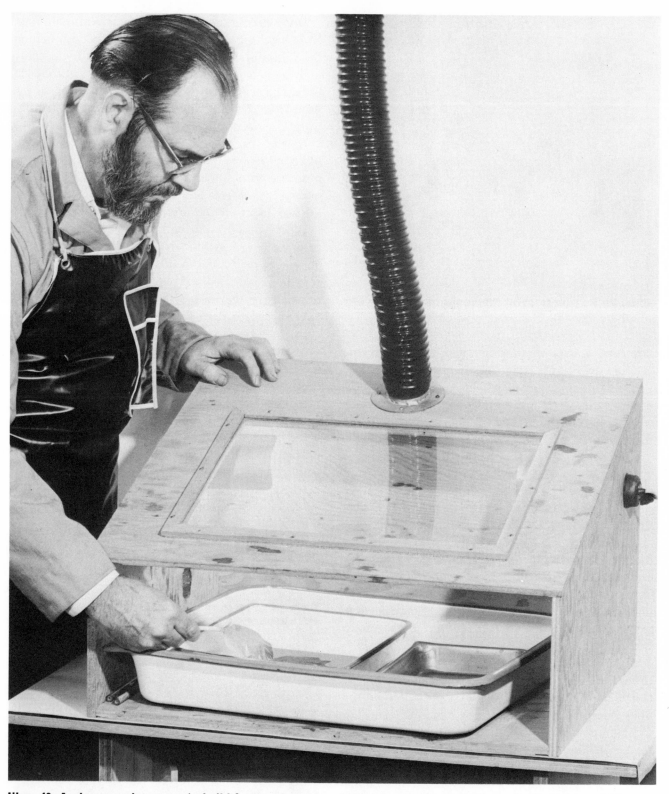

Illus. 40. An inexpensive, easy-to-build fume exhaust hood of plywood eliminates hazard of inhaling acid fumes. Flexible tubing or clothes-drier exhaust hose connects with squirrel-cage exhaust fan mounted on a window board. Inside lights assuring full visibility are shielded by metal to prevent glare from shining in the etcher's eyes. (See illus. 49, page 32.)

3. ETCHING THE PLATE

Nitric Acid

The early etchers used nitric acid only. The use of hydrochloric and iron perchloride is relatively recent.

As purchased in the Chemically Pure (CP) or Analytical Reagent (AR) grades, nitric acid measures about 40 degrees on the Baumé hydrometer* at 60 degrees F. Acids are customarily sold by the pound instead of the pint or quart, and nitric is available in 1-pound and 7-pound bottles, quantities suitable for the occasional or serious etcher.

Use of Nitric Acid with Copper

It will be up to you to try the various concentrations of acid and decide for yourself which bath best suits your own temperament and ways of working. A fast, harsh-acting bath is one part of acid to one part of water, preferred by some etchers. One volume of acid to two of water is a fairly slow bath but safe. Faster but still controllable is a solution of

*The Baumé (pronounced Bo-may) hydrometer is an instrument used for measuring the density, and therefore the strength, of acids.

two volumes of acid to three of water. A good, all-around formula is prepared by diluting three parts of acid to five of water.

Use of Nitric Acid with Zinc and Steel

The vigorous action of nitric acid on zinc calls for greater dilutions than for copper. One part acid to three parts water is a strong bath that bites coarsely but gives rapid results. A 1:6 dilution is better for general use, while 1:9 is about right for fine needling or aquatint.

For mild steel plates, try 1:7. If the bath etches too slowly, increase the strength up to about 3:7.

Hydrochloric Acid

Also known as muriatic or tinner's acid, hydrochloric acid is available in CP and AR grades in 1-pound and 6-pound bottles. (It is of lighter weight than nitric.) The bath is a chemical mixture called "Dutch bath" or "Smillie's bath" after the American etcher who developed it. As the chemical action of the bath is slow when cold, warming to

Illus. 41. Acids and diluted baths are stored in glass bottles having ground-glass or plastic tops. Note clarity of used zinc baths (left) and tone of used copper baths (right).

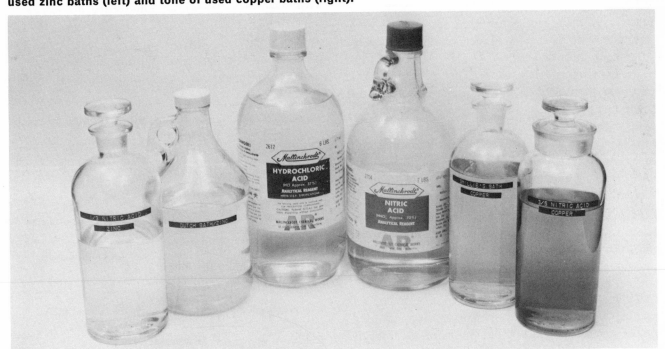

Illus. 42. This exaggerated comparison of the bitten lines of different acids shows how the result in the print can depend on the etcher's choice of acid. (1) Nitric bites a line that is wide and shallow; (2) the Dutch bath bites narrow and deep; (3) iron perchloride etches a thin, slightly ragged line.

about 90 degrees F. is recommended. Float the tray in a larger tray of hot water.

Dutch Bath for Use with Copper:
 Water, 25 ounces
 Hydrochloric acid, 5 ounces
 Potassium chlorate, 1 ounce

Dutch Bath for Use with Zinc:
 Water, 22 ounces
 Hydrochloric acid, 2½ ounces
 Potassium chlorate, ½ ounce

Dutch Bath for Use with Mild Steel:
 Water, 19 ounces
 Hydrochloric acid, 5 ounces
 Potassium chlorate, 1 ounce

In each case, boil about 8 ounces of the water and pour it over the potassium chlorate crystals in a graduate. Stir in the remainder of the water, and, when cool, add the acid.

Always pour acid into water! This advice is more pertinent to sulfuric acid, but it is well to exercise the same precaution with nitric and hydrochloric acids as well. The mixing of acid with water generates heat, and water poured into acid could result in an explosive burst of steam that might dangerously splatter acid around. Let bath cool to room temperature before using.

CAUTION: Mix by a ventilator or an open window. The formula gives off chlorine gas as it is mixed. Do not breathe the fumes.

Iron Perchloride

This bath is preferred by photo-engravers for etching fine halftone plates on copper (it is not used on other metals). Mix 1 pound of the iron perchloride crystals with 1½ pints of water. Dilute with ¾ pint

of water for use; or, add water until a Baumé hydrometer reading of 25 to 30 degrees is reached. This solution bites a fine but slightly irregular line.

Iron oxide forms while etching and settles in the lines, stopping the action, so the plate must be placed in the bath face-down instead of face-up as in the other baths. Support the plate above the tray bottom on narrow strips of glass at each end, placed so as not to interfere with the etched lines. Remove the plate from the bath at intervals to check the progress of the etch.

Iron perchloride gives off no fumes and is entirely safe to use. The addition of 10 per cent hydrochloric acid to the bath is said to dissolve the sediment, permitting face-up etching of the plate.

Label the Baths

Plainly label the bottles in which the acid baths are kept and avoid mistakes. Follow the color code

Illus. 43. Keep this safety precaution in mind to avoid an accident in handling acid.

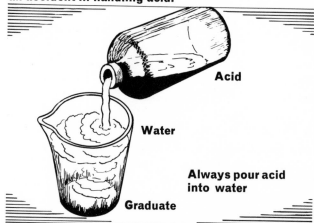

Acid

Water

Always pour acid into water

Graduate

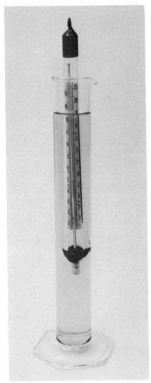

Illus. 44 (left). Use a tube thermometer with an internal scale for acid.

Illus. 45 (right). The Baumé hydrometer in 1 part acid to 2 of water reads approximately 20 degrees.

of the chemist—a red label for nitric acid and a blue one for hydrochloric. Or tie colored ribbons around the necks of the bottles. If you happen to be color-blind, as some persons are, stretch a rubber band around bottles containing Dutch bath, two rubber bands around bottles containing nitric acid.

Storing Acids

Full-strength acids are stored in the bottles they come in; diluted baths are stored in clear glass bottles of suitable size (Illus. 41, page 27).

Keep acid bottles in a locked cupboard if there is a chance that children or unauthorized persons may get at them. *Acids are dangerous!* If they are kept on a shelf, the shelf must not be too high—never strain to reach or take down an acid bottle and you will help to avoid accidents. Do not store acids more than a step or two from the mixing sink for the same safety reason.

A quart bottle will hold all the bath needed for a series of small plates. A 48-ounce or half-gallon jug will hold enough to cover an 11 × 14-inch plate in its equivalent size tray. Clear glass bottles allow the color of the bath to be seen for visual judgment of its strength.

Water-clear to begin with, nitric in which copper

is etched turns blue-green. The hue becomes deeper and deeper as more and more plates are processed. When of a deep, turbid color, the bath is exhausted and must be poured down the sink. Let water run copiously after it to flush the drain.

Reserve a couple of ounces of the old bath to add to the newly mixed bath to restrain its initial vigor. If no old bath is available, a new bath may be conditioned by dropping enough copper filings into it to produce a pale tint of color.

Copper turns the Dutch bath green; zinc gives it a pale straw color. Zinc has no color effect on nitric. Any bath is ready for discard when it becomes slow and erratic in biting.

The Baumé Hydrometer

It is by no means necessary to own a hydrometer (Illus. 45), but the use of one takes some of the guess-work out of processing. The weighted glass tube contains an internal scale (acid would soon eat away an external scale) marked in degrees Baumé from 0 to 70 degrees. In distilled water, the hydrometer floats vertically with the 0 degree mark level with the surface. It floats progressively higher as the density of the fluid in which it is immersed increases. Full strength nitric, as purchased, is far from "pure acid"; it is about 70 per cent acid and 30 per cent water, which is why adding an equal quantity of water does not reduce the Baumé reading (40 degrees) by one half, as is sometimes stated. Instead, the hydrometer reads 27 degrees in a 1:1 bath. This is a high reading, indicating a strong bath.

The stronger the bath, the less the ground is able to resist it. A longer life is assured for the ground if the bath is not stronger than about 24 degrees Baumé, the reading for a 3:5 formula. A 1:2 bath reads out at 20 degrees B., which is a great deal softer acting. By this it will be seen that the higher the hydrometer reading, the more active the bath and the faster and coarser the plate etches out.

The hydrometer is useful for checking the strength of a fresh bath but serves no essential purpose with a used one, which continues to indicate the same degree Baumé plus a little extra, owing to the metal dissolved in it.

Action of the Baths

Warning: Use separate solutions for copper and zinc. One metal must not be etched in the same solution used for the other or the resulting electrolytic action will cause irreparable damage to the ground.

Illus. 42 shows how the different baths bite a line.

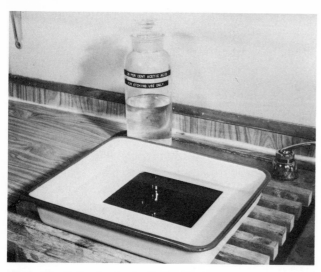

Illus. 46. A 5-minute bath in 28 per cent acetic acid precedes the etching bath.

Since nitric acid results in wide lines, closely-needled lines are preferably etched in the Dutch bath when a fine half-tone is desired. Etching in nitric could result in running the lines together in a solid black.

Etching Trays

Photo trays of hard rubber or plastic may be purchased in a range of sizes from 5 × 7 to 16 × 20 inches and larger. Rectangular Pyrex baking dishes make good small trays; or, you may construct trays of wood with glued joints. Protect the wooden inside with several coats of asphaltum varnish or a thick layer of wax melted and flowed on.

Another method uses the plate as the bottom of the tray and special bordering wax for the sides. Soften the wax in warm water and apply in strips

along the edges of the plate; then run a hot spatula around the edges to weld the wax to the metal.

The Acetic Acid Bath

Soaking the needled plate for five minutes in 28 per cent acetic acid (Illus. 46) removes grease and oxidation from the lines and assures prompt starting of the etch, particularly if some time has elapsed since the plate was needled. Do not use *glacial* acetic acid full strength—dilute to 28 per cent by mixing three parts acid with eight parts water.

After soaking the plate face up in its tray, funnel the acetic acid back into its bottle and immediately pour on the etching bath to a depth of about ⅜-inch over the plate.

Etching the Plate

Even though no exact timing of the etch is possible, realization of the time involved keeps you better informed as to what is going on in the bath, so supply yourself with a timer or watch.

Since etching is a matter of chemical reaction, it would seem reasonable to suppose that the same size plate bathed at the same temperature should always etch out in the same time. However, the "time-and-temperature" development method of the photographer has no bearing in etching. There are too many variables involved, some of which are totally uncontrollable, such as the matter of firmness with which the needle is pressed through the ground. Invariably, some lines will always be more lightly needled than others—drawn with less pressure. These, if they etch at all, will require an indeterminate length of time for the acid to work its way through the film of wax and to get started on the metal. Keep a needle by the tray as such lines can often be needled in the bath as they show up. Because of the many variables in etching, a temperature-time chart cannot be provided. One plate may etch in 10 minutes in a particular bath, and a similar plate may etch in an hour in the same bath. However, the following examples may provide a rough guide for the beginner.

In a fresh bath of one part nitric to two parts water (20 degrees Baumé), a simple, one-bite, copper plate will etch in 20 to 30 minutes. In a bath of three parts nitric to five parts water (24 degrees Baumé), the plate will etch to a reasonable depth in 10 or 15

Illus. 47. Bubbles accumulate on the lines in the nitric acid bath. The next chapter tells how to time the etch by these bubbles.

minutes. In all cases, longer etching deepens the lines and causes them to print darker.

A fresh solution of one part nitric to three parts water will etch a zinc plate in 5 or 6 minutes. The first faint, grey line etches out in about 30 seconds. A line drawn with a fine needle and etched for a minute prints with a thin, wiry consistency. A 1:6 dilution will take twice as long to etch to the same depth; 1:9, three times as long, and so on. In all cases, the longer a bath has been used, the more slowly it will etch each succeeding plate.

Bubbling

In a nitric bath, bubbles form along the lines (Illus. 47). If no bubbles are seen on a line, it is visual evidence that the acid is not getting through and the line is not biting. Reneedling of the line is then called for. This may be performed in or out of the bath, preferably out. (It may take a few minutes in the bath before the bubbles show up.)

If bubbles appear where there are no lines, the acid is biting foul through the ground and eating away the plate where no etching is wanted. Rinse the plate and dry it by pressing a blotter against the ground. Paint the offending area with stop-out varnish and do not return the plate to the acid until the varnish is dry. A fan may be used to accelerate drying.

If bubbles are allowed to accumulate in the lines, they gradually stop the etching action, resulting in a ragged line. To guarantee fresh, clean-printing lines, keep them free of bubbles with a feather (Illus. 48) or a Chinese pencil (or any other brush that does not have a metal ferrule).

The Dutch bath generates no bubbles. Foul biting may therefore go on without being detected until the plate is cleaned after etching. However, the milder action of the Dutch bath is less conducive to foul biting as it is not so hard on the ground. A little nitric added to the bath will make it bubble.

It may sometimes be advantageous to start a plate in the Dutch bath and etch it long enough to get the narrow, deep lines well started. The plate is then rinsed and dried and the etch concluded in nitric. Or, the etch may be started in nitric and concluded by transferring the rinsed and dried plate to the Dutch bath. Either method provides complete control over the etch, resulting in the fine lines characteristic of the Dutch bath in less time.

Since closely needled or cross-hatched lines bite more rapidly than separated lines, they bubble up quickly in nitric and the bubbles must frequently be

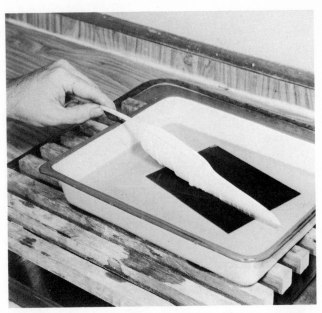

Illus. 48. Remove bubbles by lightly brushing with a feather or by tilting the tray to expose the plate to air.

feathered away. If the ground starts to break up, or *crevés* become visible, remove the plate at once and rinse it.

Develop an eye for the etched line and learn to recognize one that is properly etched while the plate is still covered with ground. Here are some simple tests: (1) Insert a fine needle in the finest lines of the plate. If the point holds, they are probably etched deeply enough, evidence that the heavier lines are also well etched. (2) Select an isolated line, dampen a brush with turpentine, and carefully remove a small spot of ground, about $\frac{1}{4}$-inch across. Examine the revealed line carefully—use a 5-power linen tester if necessary. If the line appears underbitten, cover the spot with liquid ground, let it dry, and reneedle the line involved.

If such examination shows the line to be bitten deeply enough, wash off the ground with turpentine, using denatured alcohol to remove stop-out varnish. The plate is then ready for bevelling the edges before printing.

Cautions in the Handling of Acids

Normal baths will not seriously harm the hands but they will turn the skin rough and yellow. Keep a tray of clear water near the etching tray, for rinsing the fingers. Wear finger stalls (rubber sheaths) for protection. These are better than rubber gloves, which are awkward and therefore tend to discourage the etcher from using them when he should.

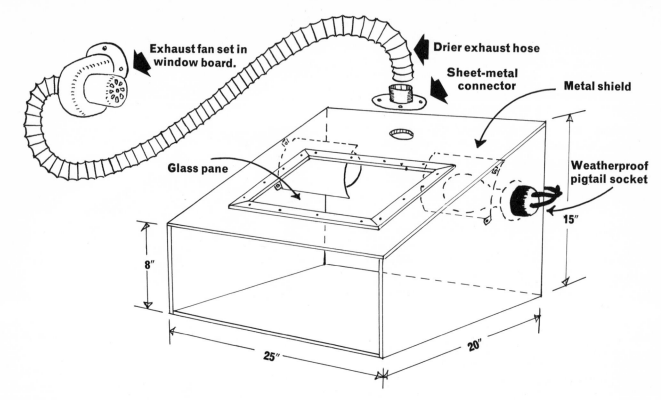

Illus. 49. Diagram for making the fume exhaust hood pictured at the beginning of this chapter. Use this or a similar device to avoid inhaling acid fumes while etching.

If full-strength acid is splashed on the skin, flush the affected area for 15 minutes in running water. Acid of any strength splashed on clothing will destroy color and/or cloth. You may save at least the cloth by drenching the splash immediately with ammonia, which is a strong alkali that neutralizes the acid. As a safeguard for clothing, wear a plastic apron (Illus. 40) from which splashes can be easily wiped with a damp rag.

If acid gets in the eyes, flush continuously with water and call a physician immediately!

Never pour acid into a graduate held up to eye level. A splash can imperil your eyesight. Do not even hold in your hand the graduate into which acid is being poured. Set the graduate in a sink and hold the acid bottle in both hands to pour. Pour acid *slowly.*

If possible, etch in a room where running water is available. If this is not possible, furnish yourself with a bucket or dishpan of water for rinsing hands and plate. Avoid inhaling fumes from the acid. Use a vented range hood or a similar device as shown in Illus. 40 and 49, or at least work near an open window or a ventilator.

If you start to cough, get away at once to fresh air. If dizziness or faintness follows, drink plenty of

water and take aluminium hydroxide gel; drink milk or take egg whites beaten in water. The antidote for nitrous-gas and hydrochloric-acid poisoning is the same. If reaction is severe, call a physician.

The Etching Log

Enter in a notebook everything about every plate: subject, size, metal, bath, temperature, Baumé reading, time of day, weather, time-length of each bite, and other information. All this is valuable for reference and self-instruction.

Illus. 50. The plate edges must be bevelled before printing. The bevel should meet the back of the plate at a 35 to 45° angle.

Illus. 51a. Machine file bevels plate quickly.

Illus. 51b. Smooth bevel with a hand file.

Illus. 52. Rub bevels with Scotch stone, then snake slip.

Illus. 53. Polish with charcoal, then 4/0 emery paper.

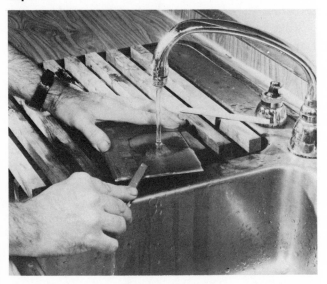

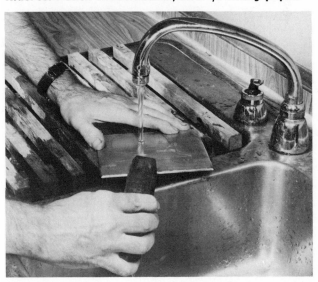

Bevelling the Plate Edges

To avoid cutting through the print paper and perhaps even a press blanket when running a plate through the press, after the plate is etched, the square-cut edges must be bevelled to an angle of 35 to 45°, depending on the amount of clear space surrounding the etched area. The bevel should make a sharp edge with the back of the plate (Illus. 50—and Illus. 156, page 99).

If you have a high-speed hand grinder or an electric drill, chuck a rotary file in it and quickly do the rough filing (Illus. 51a). Clamp the plate to a table, covering the etched face for protection with a blotter or piece of cardboard, plus an old plate on top. Or, you may do the entire filing job with a fine-cut hand file (6-inch, Illus. 51b), which has to be used anyway in order to smooth the bevel after machine filing.

From now on, work at a sink with a tilted board or grate supporting a glass plate for a smooth backing. Lay a sheet of #80 grit waterproof abrasive paper on the glass and hold the plate face downward so that the *bevel* only rests flat against the paper. Using water, rub each bevel on the grit 15 or 20 times with 6-inch strokes crosswise to the bevel's length. Follow with finer grit papers (#120, 180, 220, 280, 320, 400 and 600) in succession, using an equal number of strokes on each. Then apply a few strokes of Scotch stone (Illus. 52); briefly rub with snake slip and charcoal (Illus. 53). Dry plate and polish with 4/0 emery paper. Highly polished bevels result in 10 to 20 minutes, depending on the plate size.

4. FURTHER METHODS OF WORKING THE PLATE

There are many ways to work the plate to give form and depth to the design by means of lines of various weights. One of these ways has already been discussed; i.e., the design was worked up and several needles of differing size were used in drawing it on the plate. The plate was then bitten for a single period in the bath.

Another method is to achieve several results with only one needle, according to the rule formulated by the 19th-century French etcher Maxime Lalanne. The rule is: Areas of closely-spaced needling etch faster and therefore deeper in a given length of time than widely-spaced lines do. So, where heavy lines and dark tones are desired, needle the lines close together. Where a lighter tonality is to be expressed, needle the lines at well-spaced intervals. Use the same point on all lines—a medium-fine point is best —and give the plate a single bite, as you did for the several-needle method.

It is well to remember the rule and to apply it where necessary but, as Lalanne warns, do not depend upon it altogether. Although useful when applied to the working of certain local passages, the method fails appreciably to produce any "color" or feeling in the print. It may sometimes be used in combination with the following procedure.

Drawing the Plate in Stages

Another way to produce both fine and coarse lines on the same plate is to etch some lines for a longer time than others. An obvious method of doing this is to needle the darkest lines and areas first and place the plate in the bath. After a time, the plate is removed from the acid, rinsed, dried, and needled with the next darkest lines and areas. The plate is returned to the bath, the first lines being etched further. This procedure is continued until, after the plate has made numerous trips into and out of the bath, the finest lines are needled and bitten.

Such a technique is useful in a limited way when it is desired to add lighter lines to an area that has already been needled and bitten to a dark tone. In an area of cross-hatching, finer lines may be needled between the original lines after these have etched for a while, producing a more delicate gradation of tone than if the lines had been needled more closely together to begin with.

Etching with Stopping Out

A more controlled statement is produced by stopping out. All the lines are needled on the plate to begin with, using a single point or several, as desired. As the lightest lines etch to their proper depth, the plate is removed from the bath, rinsed, dried, and the completed lines are painted out with stop-out varnish. If the varnish tends to invade near-by lines by capillary action, thicken it with lamp-black.

Always dry a plate before stopping out. Varnish mixed with water will not repel acid. Wipe the back of the plate with a towel but press a blotter against the grounded side. Let the varnish dry before returning the plate to the bath. A fan speeds drying.

Take etching a landscape as an example for the stopping-out method. The lines of most diminished strength are to be found in the sky and the distant planes. Such fading away is called "aerial perspective"; if you have done any landscape drawing, you are already familiar with the term. However, instead of lightening the lines by reducing the pressure on pencil or crayon as in drawing, the strength of the etched lines is regulated by the length of etching time. As a rule, strong lines in the foreground are etched longer than faint lines in the background. (There may be weak lines in the foreground, too, indicative of tone, and they are stopped out before the other lines in the same vicinity.)

Your faintest lines in the copper sky will be etched sufficiently in about a minute in a fresh bath. In another 5 minutes, stop out the distant hills. Keep on in this fashion, working towards the foreground, until the plate has been etched throughout.

Timing the Etch by "Bubblings"

As mentioned before, there are too many variables in etching to allow for dependence on timing for accurate results. A method described by Lalanne, however, gives a reasonable means of determining how long to etch the first faint lines. This method may be used only with nitric acid as the Dutch bath does not furnish the requisite bubbles.

When you first put the plate into the tray of acid, watch it closely for the accumulation of bubbles. Allow them to collect until the lines are covered. Then brush the bubbles away and allow a second

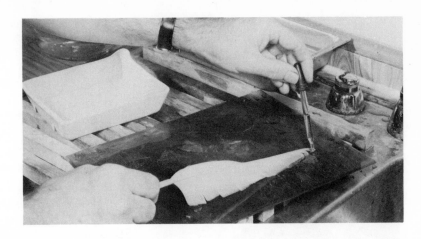

Illus. 54. A feather is used to push acid around in a localized manner. Acid is applied with an eye-dropper.

"bubbling" to come up. The bubbling must be full and complete, so allow enough time. Some days, the bubbles will come up swiftly; on other days, they will be very slow about collecting. Of one thing you can be sure, however; each period of bubbling, regardless of the time required for it, will produce exactly the same amount of etch.

Two bubblings result in a very fine line. After the second bubbling, remove the plate from the bath, rinse and dry it, and stop out the finest lines. Until you have gained experience, you can only guess when a given line or area has been etched enough. Study the lines with a 5-power linen tester and consider both the width and the depth of the lines (in comparison with the finest) in judging whether sufficient etching has taken place.

Drawing in the Bath

You have already read about the method of needling and biting the darkest lines and areas first and the lightest ones last. Drawing in the bath is a method that follows this same procedure, except that the plate is in the bath all the while.

Use the Dutch bath, as this works slowly enough to make the method feasible. Start drawing with the needle as soon as the plate is covered with acid, the darkest lines and areas first. It is practically imperative that you have an original drawing nearby from which to copy.

To arrive at a reasonable result by drawing in the bath is a pretty good indication that you have your materials under control. Otherwise, there is no practical benefit to be derived from etching the entire plate that way.

The beginner can make use of the principle involved, however, for *correcting* the plate while it is in the acid bath. As soon as the needled plate begins to etch, many defects show up glaringly. This is the "I wish I had" stage, where you say to yourself, "I wish I had needled this area more closely," or "I wish I had not left that gap where those lines should meet," and so on. You may also become aware that you have left lines out completely. Instead of removing the plate from the bath for such minor repairs, simply needle them in the bath. The acid attacks the needle, of course, and it must be replaced frequently.

Feathering the Plate

This is a method of biting the plate outside the bath. The acid bath is poured on the plate in a localized manner and pushed about with a feather from one area to another, biting each part of the plate in accordance with its need. It is said that Whistler and his disciples made wide use of this technique.

The method may also be used for local etching after the general etch is completed (Illus. 54). The acid bath is dropped where needed with an eye-dropper and carefully nudged about with a feather. Also, the plate may first be inundated with water dripped from the faucet. Into this puddle, let fall a drop of undiluted acid directly upon the work that needs further etching.

Directly under the drop, etching goes to work immediately, biting with a furious ebullition which quickly dies out as the strength of the acid is expended. Away from the center of activity, the action becomes progressively less vigorous as the acid mixes with the water. The result is a heavily bitten spot fading out to nothing all around.

To keep from overdoing this kind of thing, work at a sink with the water running, so that the acid can be instantly washed away if it gets out of hand.

No matter which method of working the plate you choose, do not forget to bevel the finished plate to ready it for printing.

Illus. 55. Etching press by Charles Brand of New York.

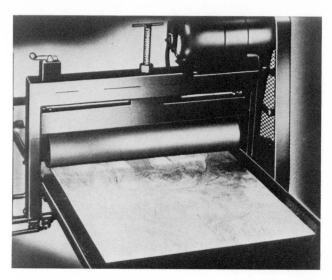

Illus. 57. The Dickerson Combination Press prints from litho stones as well as from intaglio plates.

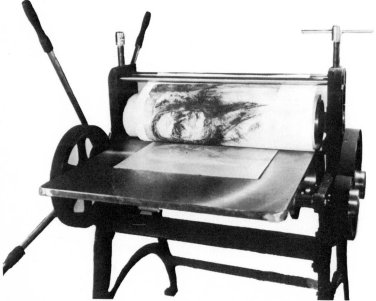

Illus. 56. A 28-inch press by Rembrandt Graphic Arts, Stockton, N.J.

Illus. 58a (left). A 14-inch press, built by author.

Illus. 58b (above). Bed removed from the press, showing construction. Note gearing on drive roller to reduce effort of turning. The top roller runs free.

5. PAPER AND THE ETCHING PRESS

Although your plate is now ready to print, restrain your impatience and first learn something about paper and its role in helping you to realize the full potential of what you have up to now accomplished. In addition to paper, you will need a special kind of printing press, called an "etching press," to produce prints from your plates (Illus. 55–58).

You can print on almost any kind of paper but some kinds give better results than others. You must determine for yourself which paper is best suited to your equipment and to your way of working. Etching supply houses carry broad selections of paper suitable for etchings. Handmade rag papers are preferred as they give a better appearance to the print than do machine-made papers. It would be wise to buy a few sheets each of several different kinds to try them out. Try also some cold-pressed, rag watercolor paper in various weights.

Best result are obtained in the print if you print on the face side of the paper. The reverse side usually shows the mark of the screen upon which the pulp was laid in manufacture. If the paper has a watermark consisting of a word or a letter, you are looking at the face side when it reads correctly. In any case, print on the smoother side of the paper.

Waterleaf Papers

This term refers to papers made without "size." "Size" is glue, gelatin, or similar material with which the paper is impregnated to give it stiffness, durability, etc. Unsized papers have a soft, blotter-like texture and are fragile when damp. They must therefore be given special treatment in preparation for printing. Included are most Japanese papers, such as Goyu, Hosho, and Torinoko among the lighter weights, and Mokoruku and Kochi among the heavier.

Splendid as such papers are, they are expensive, and the beginner or occasional amateur may prefer a paper that is less costly but of good printing quality while still possessing some of the more desirable waterleaf characteristics.

Speedball Printmasters Paper for Block Printing is an inexpensive, machine-made paper that imitates parchment. Another machine-made paper is Tableau, which bears a strong resemblance to some of the lightweight Japanese papers, though it is fantastically strong when wet.

To print on Tableau, you need only soak the sheet a few minutes in water (Illus. 59), drain it, and place it between blotters to absorb the excess water. This makes the paper ideal for quick proofing (trial printing), as it dispenses with the more complex processing required to suitably dampen waterleaf and some sized papers.

Sized Papers

The best papers are made from rag pulp. Some examples are Fabriano (Italy), Ingre d'Arches MBM, Rives, Vacar, London Town, German Copperplate, and Curtis Rag. The list of available papers is practically endless and to attempt to describe them all would be impossible.

Some are "laid" papers (having a ribbed appearance) and others are "wove" (textureless surface). Whether your etching would look best on a laid or wove paper is up to you to determine. Also, some papers have more or less of a tone, being off-white

Illus. 59. Soak Tableau paper in a tray of water.

to one degree or another, or having a tinge of buff. Sometimes etchers attempt to tone their own papers (that is, give them an antique look) by soaking them in coffee, tea, beer or ale.

Some papers are so heavily sized as to be useless for printing, and others may be printed on only after prolonged soaking has broken the resistance of the size.

Newsprint

This paper is cheap and available in art stores in a variety of cut sizes. You will use a lot of it, both for printing trial proofs and for backing the plate and the printing paper.

Newsprint is unbleached paper made of woodpulp. If it were not so short-lived (it deteriorates in a short time) and of such an unpleasant tan color, it would make an excellent, all-around printing paper. Like Tableau, it needs only immediate wetting and blotting between blotters to be made ready for printing.

Blotters

Plain, white blotters in a 19 × 24-inch size are available from photo supply shops as well as from wholesale paper houses and dealers in etching supplies. Cut these sheets to the size you require for use in damping paper and drying the prints.

Damping Waterleaf Papers

Most waterleaf papers have very little wet strength and must be handled carefully when damp to avoid tearing.

First cut as many sheets of printing paper to size as you will need. Each sheet should be a few inches wider and longer than the plate. Take an equal number of blotter sheets and wet half of them, plus an extra one. Place a yard-square piece of heavy (4-mil) vinyl plastic sheeting on the table, lay a wet blotter on it and cover the wet blotter with a dry one. Lay on another wet blotter, then a dry one, and so on, until all the blotters have been stacked. Lay a sheet of $\frac{1}{4}$-inch plate glass on top of the pile and bring the plastic sheeting up and over the glass to keep the moisture in. The glass should be rectangular and large enough to cover a full-size blotter if necessary. Leave for an hour or two, until examination shows that the dampness has equalized throughout the stack and all the blotters are equally damp.

Now interleave the damp blotters with sheets of *dry* waterleaf paper. Place one sheet of *heavy* paper between each pair of blotters. If the paper is light in weight, two or three sheets may be placed together, atop one another. When the "paper bank" is full, lay the glass back on top and once more bring the plastic up and around to keep in the dampness. Add a weight, such as the ink slab, to insure flatness.

In a few hours, the paper will be damped and ready for printing. If necessary, the paper may safely be left until the next day. Do not let paper soak too long in summer, as warm, humid weather promotes the growth of mildew. If the damp paper cannot be

used within two or three days, it should be dried by placing between dry blotters and redamped when it is needed.

Damping Sized Papers

Some heavily-sized papers, including rag water-color paper, must be soaked in a tray of water until the size is either washed out or rendered flexible. Soaking may take from 5 minutes to an hour or more, depending on the kind and weight of paper. When the sheets are flexible, interleave them between dry blotters (Illus. 60) and leave under a weight until the moisture equalizes.

Paper treated in this manner is usually ready for printing in 15 minutes or less. Where more time is available, another method avoids soaking the paper in a tray and ordinarily does not require the use of blotters.

Pile cut-to-size paper to one side of the plastic sheeting on the table and put a tray of water opposite. Lay the first sheet of paper face down on the plastic. Wet a sponge in the tray, squeeze it out, and sponge the paper with straight, lengthwise strokes (Illus. 61). Next, lay the sheet face up in the middle of the plastic and sponge the face side. Treat each sheet of paper the same, stacking them as they are sponged.

If the paper should tend to cockle or bunch up, next time place each sheet as it is sponged between blotters that have been damped as described for damping waterleaf papers. In either case, lay a piece of plate glass ($\frac{1}{4}$-inch thick) on top of the pile and bring the edges of the plastic sheeting up and over the glass to keep the moisture in. Otherwise, the edges of the paper may dry out and become wavy, causing wrinkles to be pressed into the sheet when printing. Redamp dry edges with a moist sponge just before printing.

The Etching Press

An etching press is a highly specialized piece of printing equipment consisting of a flat bed upon which the plate and paper are laid, then passed between a pair of heavy steel rollers by turning a handwheel generally called a star wheel. Most etching presses may be adjusted to print not only from etched plates but also from type-high wood blocks, linoleum blocks, and lead type.

Illus. 55 shows one model from a line of modern etching presses. These presses feature ease of operation owing to a special gearing system. Another company makes a complete line of presses (Illus. 56), available in traditional cast iron and modern, all-steel design. A third company handles a line of etching presses including the combination press shown in Illus. 57. This press also prints from lithographic plates and stones and features lightness of weight (only 400 pounds). It has a built-in electric motor. The other presses may be motorized on order.

The press shown in Illus. 58a and 58b was built by the author; the plans for its construction appeared in Popular Mechanics Magazine, November and December issues, 1966. Copies may be available at your public library.

If there is an art school or an art center near you where you may use a press, you are in luck. Otherwise, contact dealers in presses and request their literature. Presses are available in bed-widths from 12 inches upwards.

The Etching Blankets

The blankets are next in importance to the press itself. On their quality depends the quality of the print. Formerly, as many as five thin blankets were employed, all of the same thickness or weight. The modern trend is toward the use of only three blankets, each of a different thickness and kind, and each with a different function.

The thinnest blanket, about $\frac{1}{16}$-inch thick, of fine felt (sometimes called swanskin), is referred to as the "fronting" blanket, or "sizing catcher." This goes on the bottom, next to the press bed. Its function is to absorb the water and sizing material squeezed out of the paper. When it becomes too wet in the course of printing to absorb any more, it is hung up to dry and is replaced by a dry blanket.

In time, the fronting becomes stiff with size and must either be discarded or washed in cool water with a gentle detergent. Its use can be prolonged by

Illus. 61. Sized paper can be dampened with a wet sponge, stacked under glass and then wrapped with plastic sheet until moisture equalizes.

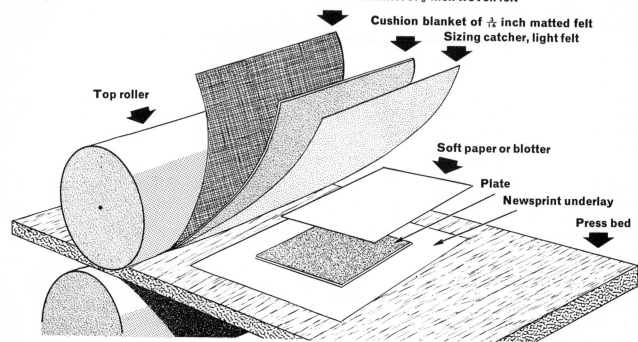

Illus. 62. Arrange the press this way to adjust the roller pressure for correct printing.

Pusher blanket of ⅛-inch woven felt

Cushion blanket of 3/16 inch matted felt

Sizing catcher, light felt

Top roller

Soft paper or blotter

Plate

Newsprint underlay

Press bed

placing a sheet of dry newsprint on top of the printing paper and plate to absorb most of the water and size, as well as the ink that may be squeezed entirely through thin printing paper.

The heaviest blanket of the three is 3/16 of an inch thick and is made of matted felt. (¼-inch thickness may also be used but it costs more.) This is called the "cushion" blanket and it goes above the size catcher.

The topmost blanket gets the most wear, as it is subject to friction from the steel roller. It is called the "pusher" blanket and is made of ⅛-inch thick, hard, woven felt.

Dimensions of the Blankets

The press must be equipped with one set of blankets in which each blanket has the same dimensions as the press bed. (If much printing is contemplated, a set should consist of one blanket of each weight plus an extra sizing catcher to substitute for the first when it gets too wet for further immediate use.) This set of blankets is to be used only for large plates (large in relationship to the bed-size).

If a small plate is printed with large blankets, the risk is that a pocket will be formed in the blankets, rendering them useless thereafter for printing larger plates. Therefore, other sets of blankets are used. As blankets are expensive, exercise care in selecting the right size for any given plate.

In addition to the full bed-size blankets, a series of smaller blanket-sets may be made up in the following dimensions: Blankets cut 7 × 9 inches in size for plates up to 4 × 6 inches; 10 × 12-inch blankets for plates up to 7 × 9 inches; 14 × 17-inch blankets for plates up to 11 × 14 inches; and so on, in accordance with the size of the press bed.

Where the press is a large one, the blanket sets are often diminished in width, but not in length; the width of the blanket being 3 or 4 inches greater than the longer dimension of the plate being printed.

How to Buy Etching Blankets

You may buy blankets from a dealer in etching supplies. If you live in a city away from any such dealers, look in the classified section of your telephone directory under *Felt and Felt Products* and call a dealer in felt. Don't ask for etching blankets, as the dealer won't understand what you mean. The sizing-catcher felt is known to the trade as "decorative felt, white." The thick, matted felt is called "orthopedic" felt, since it is used for padding in orthopedic devices. Pusher-blanket material is known simply as woven felt. Buy the blanket material in bulk and cut it to the desired sizes with scissors or a knife guided by a steel straight-edge.

Adjusting the Press

Once adjusted, the press seldom requires re-

adjustment. The procedure for adjusting the press is as follows:

(1) Screw down both adjusting screws (Illus. 63) until the top roller is squeezed against the press bed and neither screw can be turned any farther.

(2) The top and bottom rollers are now parallel, so back off each screw one full turn. Henceforth, always adjust both screws the same amount, up or down, as required.

(3) Lay the uninked printing plate face-up on a sheet of newsprint in the middle of the press bed (Illus. 62).

(4) Lay a piece of *dry* Hosho, Vacar or other soft paper face-down upon the plate.

(5) Lay on the blankets in proper order (Illus. 62). Stagger the leading edges so that they will feed under the roller one blanket at a time.

(6) Start winding the bed through the press by turning the star wheel. If the blankets refuse to pass under the roller, loosen both adjusting screws equally. If similar difficulty occurs when the plate reaches the roller, loosen the screws again, but not more than a quarter-turn at a time, until passage is gained for the plate.

(7) Remove the print paper and examine it with a magnifying glass by side light. The design of the plate will be seen embossed in relief on the paper. The finest lines should be clearly seen, standing high enough to cast a shadow. If not, the screws are too loose and must be tightened. Turn them down one-eighth of a turn and run the plate through the press again with a fresh piece of paper.

If the results are still unsatisfactory, repeat the screw adjustments as necessary, running a clean piece of paper through the press each time, until the entire design of the plate can be seen embossed on the "dry proof." If all the lines are visible and the face of the paper has a hard, shiny look, too much pressure has been applied and you must back off the screws a little until the paper loses its shine but the embossment of fine lines is still clearly seen.

Once the press is adjusted, tighten the locking nuts (if there are any). In any case, mark each screw head with a spot of paint as shown in Illus. 64. Also, stick a piece of adhesive tape to the press frame on each side and ink upon it the measurement "X", as shown in the drawing, for each screw. It may at some future time become necessary to loosen or tighten the screws a little to accommodate some individual plate. By following the "X" measurements, it is then easy to return the screws to their original setting when going back to regular printing. (Some etching

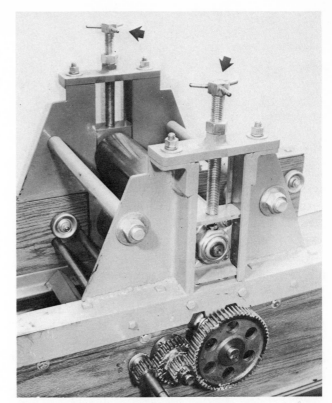

Illus. 63. Arrows point to press adjusting screws, used to regulate the pressure of the top roller to the needs of the printing plate.

Illus. 64. Mark both adjusting screws and keep written record on press frame of measurement "X."

When pressure is properly adjusted, mark adjusting screw in this position.

Arrow points in direction of bed travel.

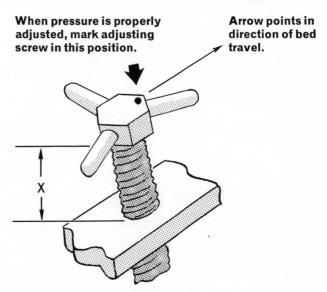

presses may be equipped with a micro-dial indicator gauge on each adjusting screw so that the pressure can be easily re-adjusted to its original setting.)

6. INK AND INKING THE PLATE

Etching Ink

For use in printing the etched plate, the ink must possess special properties not shared by the heavy, varnish-laden inks used by offset and letterpress printers.

The beginning or occasional etcher is better off buying ready-made ink in tubes or cans. Plain black ink is available under a variety of names such as: Etching Black, Vine Black, Black, Intense Black, Warm Black, and so on. Choose one from a supplier's list.

Colored inks are also available, but the only such inks of present interest to us are burnt umber and burnt sienna. One of these added in small quantity to black ink gives it a warmer tone that may be more suitable for some types of print.

As ready-made inks are generally too stiff in body for use as they are, provide yourself also with some raw linseed oil or a special wiping compound. Either of these may be mixed with the ink to loosen it up and make it easier to wipe.

Dry Pigments

In time, if you do much etching, you will want to mix your own inks from dry pigments and the requisite oils. There are good reasons for this. Mix-your-own inks are cheaper than ready-made; dry pigments may be stored indefinitely, while prepared ink sooner or later deteriorates; and mixing your own ink lets you fit the quality and tone of the ink to the requirements not only of the plate but also of the paper you are using. You achieve, in short, a flexibility of control over the printing that is scarcely approached by the use of prepared ink.

The following black pigments are in present-day common usage: Frankfort Black, a warm-toned pigment, very easy to wipe; Vine Black, an intense, wiry color that is difficult to wipe when used alone. Vine Black is generally mixed with Frankfort Black to improve the wiping quality. Lampblack prints with a bluish tone; other black pigments are Carbon Black and Bone Black (Ivory Black). All are permanent, as are the earth colors: the umbers, ochres and siennas.

Grinding Pigments

The literature on etching contains numerous formulas for mixing inks, some using as many as three or four pigments in order to derive the real or fancied benefits of each.

A good, basic formula is: two parts Frankfort Black, one part Vine Black, plus as much burnt umber as desired to produce a warmth of tone or to expedite drying. Burnt sienna pigment may also be added to secure warmth of tone.

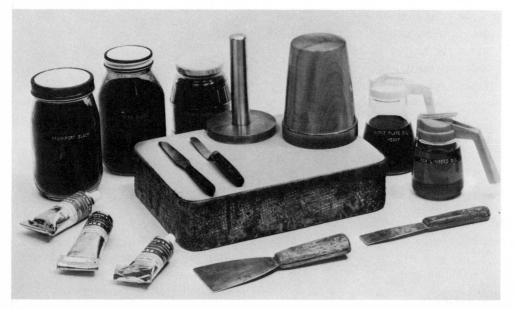

Illus. 65. Ink pigments are kept in closed glass jars (left); various oils needed in handy syrup dispensers (right). Also shown: prepared inks in tubes, palette knives, putty knives (foreground), ink slab (litho stone), stainless steel muller, and wood-body, Pyrex disc muller described in the text.

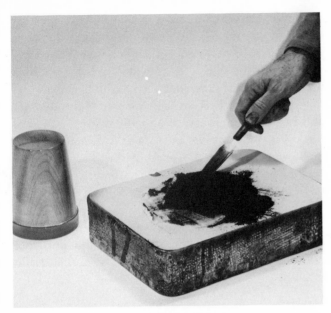

Illus. 66. Dry pigments are mixed together on the ink slab with a palette knife.

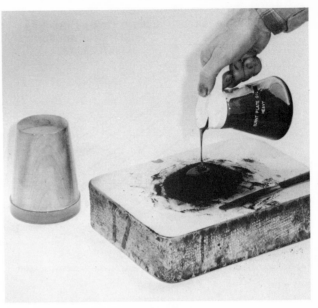

Illus. 67. Heavy burnt plate oil is poured into indentation made in top of cone of pigment.

In addition to the pigments of the formula, your ink-making activities require that you have a supply of burnt plate oil in both the light and the heavy grades. Burnt plate oil is linseed oil that has undergone a treatment of boiling and burning until it is of a thick, honey-like consistency. A medium grade of burnt plate oil is made in the studio by mixing equal quantities of light and heavy grades. You will also need raw linseed oil.

Do not make the mistake of grinding too much ink at once. If a lot of ink will be needed, grind several small quantities and combine them.

To grind up enough ink for several small printing sessions, measure out 4 level tablespoons of Frankfort Black on the ink slab. (Illus. 65 shows a litho-stone ink slab.) Add 2 tablespoons of Vine Black and, to speed drying of the ink, 1 tablespoon of burnt umber. Scrape all the pigments into a heap and mix them carefully with a palette knife (Illus. 66). Allow no abrupt motions of the blade, as the powder is very fine and will spurt into the air if you are rough with it. Another way to mix dry pigments is by briskly shaking them up in a tightly capped glass jar.

When the dry pigments are thoroughly mixed, make a cone of the powder and indent the top. Pour a small quantity of heavy plate oil into the depression (Illus. 67). Mix the oil into the pigment, using a stiff-bladed putty knife or wall scraper. Add more oil if it appears to be needed, until all the pigment is soaked with oil but has a dry, mealy look. Neither excess oil nor loose pigment is desirable. The

mass at this stage is of a heavy, gummy consistency. Mulling (grinding) makes the ink fluid and smooth.

An old litho stone makes a good ink slab, or use any slab of slate, marble or plate glass. Choose one of generous size, around 14×18 inches.

The stainless steel muller shown in Illus. 65 is of commercial make. The muller next to it is homemade and is inexpensively constructed by attaching some kind of a handle to a Pyrex disc. Pyrex is harder, longer lasting, and therefore more suitable for this purpose than glass. Such a disc, measuring $4\frac{1}{4}$ inches in diameter by $\frac{3}{4}$-inch thick, is commonly sold for telescope-making purposes by optical supply houses.

Illus. 68 shows how to make a muller with a lathe-turned handle of hardwood. However, if no lathe is

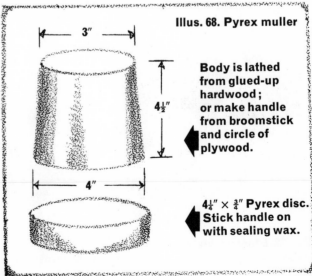

Illus. 68. Pyrex muller

3″

4½″

4″

Body is lathed from glued-up hardwood; or make handle from broomstick and circle of plywood.

$4\frac{1}{4}″ \times \frac{3}{4}″$ Pyrex disc. Stick handle on with sealing wax.

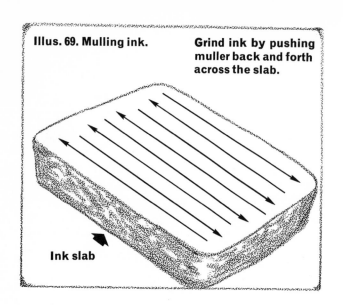

Illus. 69. Mulling ink.

Grind ink by pushing muller back and forth across the slab.

Ink slab

available, a good handle can be made from a piece of dowel or broom handle mortised and glued into a round piece of plywood cut slightly smaller in diameter than the disc. Use optician's pitch, jeweller's wax, or sealing wax to stick the handle to the disc.

First, heat the Pyrex disc by placing in a cold oven and raising the temperature to 400 degrees F. Open the oven, pull out the oven rack a little way, and melt some wax on the back of the disc. The low coefficient of expansion of Pyrex makes it possible to treat the disc in this manner. A glass disc would break.

Cover the entire disc with a puddle of wax. Place the handle in the middle of the disc and give it a twist to make good contact. Set the muller aside

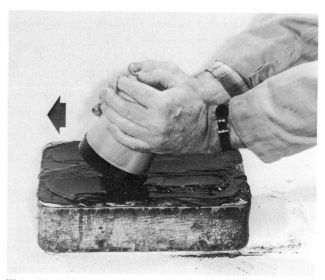

Illus. 70. Tilt muller back when pushing it away.

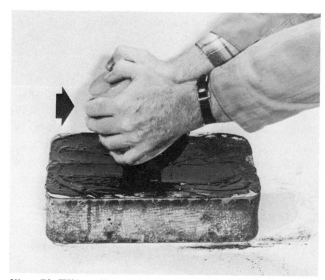

Illus. 71. Tilt muller away when pulling it back.

Illus. 72. Store ink underwater to keep it fresh.

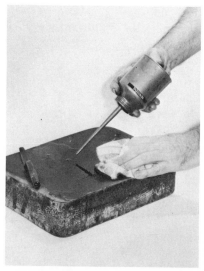

Illus. 73. Clean tools and ink slab with kerosene.

Illus. 74. Apply ink to dabber with a palette knife.

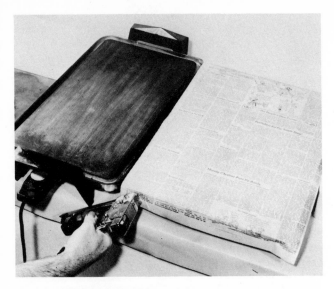

Illus. 75. Before starting to print, make a pad of newspapers and staple it to the jigger. As each sheet becomes soiled with ink, tear it off and discard.

until cool. If any crack remains around the base of the handle, stop it up with a water-putty filler. Apply several coats of clear polyurethane (a plastic finish available at hardware stores) to the wood.

Both the ink slab and muller are given a tooth by sprinkling the slab with water and #220 carborundum grains and rubbing the muller around on the slab until both surfaces are ground flat and are evenly textured.

Mulling, or grinding, the ink is done with the edge of the muller. Spread the ink out over the face of the ink slab and push and pull the muller back and forth through it (Illus. 69). Tilt the handle towards yourself when pushing the muller away (Illus. 70) and tilt it away from yourself when pulling the muller back (Illus. 71). Mull in this manner for 5 or 10 minutes, until the texture of the ink becomes silky and smooth.

When pulled up with a corner of the putty knife, ink of proper consistency slowly topples back. It should roll slowly off a tilted blade. If the ink is too thick, add a few drops more of heavy plate oil and mull some more. If too thin, add more pigment and continue grinding. Test the ink against the slab with your fingertip. If it feels gritty, keep on grinding until it feels smooth.

Storage of Ink

To store the ink, scrape it from the slab and pile it on a small piece of slate or in a sauce dish. Put it away underwater in a crock (Illus. 72) to keep it fresh and usable. If, after a few days, slime tends to form in the water and cling to the ink and its

container, it is owing to the water in your locality and not to the presence of the ink. Clean out the crock, refill it with fresh water, and add about 1 tablespoon of 28 per cent acetic acid (or $\frac{1}{2}$ cup of 5 per cent vinegar as marked on the label) per $\frac{1}{2}$ gallon of water. If slime continues to form, there will be less of it and it will not make a nuisance of itself by adhering to the ink or its container.

Unless covered with water, ink will form a skin where it is exposed to air, causing problems in printing. Commercially prepared ink in a tube will keep indefinitely without causing trouble. Ink in a can, however, must be used within a reasonable length of time or it will harden. Once the cover of the can has been removed and some of the ink taken out, put the remainder of the ink in a glass jar or earthenware dish and store it underwater as described above. Or, if ink will be used from the jar every few days, simply fill the jar up with water on top of the ink and cap it. Add acetic acid or vinegar (a few drops) to inhibit slime. If ink is stored underwater in a can, the can is liable to rust and contaminate the ink.

When ink is removed from the water for use, first work a little medium or light burnt plate oil into it on the ink slab to recondition it. Then add a few drops of raw linseed oil and work it in well with a palette knife.

Inking the Plate

Cleanliness must be stressed. Grit on the dabber or one of the wiping pads can score a plate with scratches that take hard work to remove. At each printing session, cover the table under the heater and the jigger with clean newspaper. Also, make a thick pad of newspapers and staple or thumbtack it front and back to the edges of the jigger (Illus. 75). All your inking and wiping will take place on this pad and, when the topmost sheet becomes excessively soiled, you strip it off and throw it away.

Lay the plate on the heater and let it get hot enough so that the ink will run and fill the lines. The temperature should be just under that required for grounding.

Knead some ink on the ink slab with a palette knife to loosen it up. Add a few drops of raw linseed oil or some wiping compound to make it easier to wipe. Spread ink on the rounded face of the dabber with a palette knife (Illus. 74). (Ink dabbers can be bought or can be handmade as discussed in Chapter 1.)

It used to be customary to ink the plate and to go

Illus. 76. Inking with dabber is best done on the jigger.

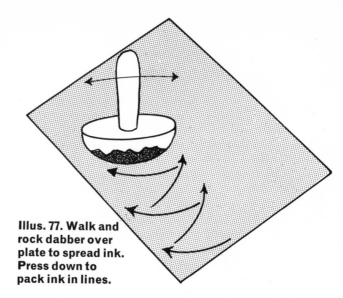

Illus. 77. Walk and rock dabber over plate to spread ink. Press down to pack ink in lines.

Illus. 78. Wiping the plate four ways constitutes a wiping cycle.

Wipe and turn 90°

1.

Wipe and turn 90°

2.

Wipe and turn 90°

3.

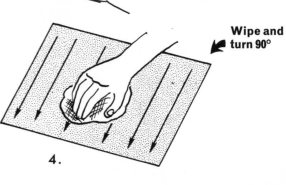

Wipe and turn 90°

4.

Illus. 79. Final wipe.

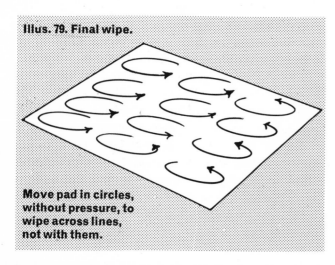

Move pad in circles, without pressure, to wipe across lines, not with them.

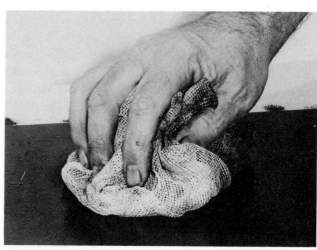

Illus. 80. The tarlatan pad has flat wiping surface.

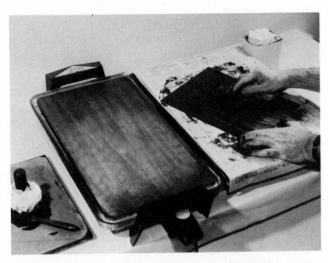

Illus. 81. To avoid soiling the heater with ink, the plate is wiped on the newspaper-covered jigger. Soiled sheets are easily torn off and thrown away.

through the first wiping cycle on the heater. Experience shows, however, that this practice only provides additional work by making it necessary to clean ink off the heater with a rag and kerosene each time the plate is inked.

It is not only cleaner but also more comfortable for you to push the hot plate off the heater on to the newspaper-covered jigger (Illus. 76) to ink it. Don't slide the inked dabber around on the plate; that only invites scratches. "Walk" the dabber around on the plate by rocking it from side to side (Illus. 76 and 77). Exert sufficient pressure on the dabber to force the ink into the lines. You must make sure at this stage that all the lines are *filled* with ink, not just bridged over. Make doubly sure of fine lines by rubbing the ink in with your fingers. When the plate is properly inked, it will be covered all over with a thick coating of ink.

If the plate has had a chance to cool while being inked, return it to the heater to get it hot again.

Wiping the Plate

The ink is wiped from the plate with pads made from a stiff, coarsely woven cloth called tarlatan. Or, you may use mosquito netting, crinoline, or starched cheesecloth (starch it yourself).

Cut three pieces of tarlatan, each about a foot-and-a-half square. Crumple them between your hands a few times to reduce their stiffness. Make each piece into a pad having a flat wiping surface, without folds or wrinkles that would drag ink out of the lines (Illus. 80). Lay the pads on the table beside the jigger in numbered order. When making a new pad, smear a little ink on the wiping face to condition

it. As each pad is used, return it to its numbered place.

Wear a shop coat or an apron to protect your clothes. Through the belt or drawstring pull a cotton rag. This is the "belt rag" for wiping your hand.

Before you begin wiping the plate with the first pad, carefully scrape the top coating of ink from the plate with the edge of a piece of cardboard and return the ink to the ink slab. This practice results in a considerable saving in ink and lengthens the wiping life of the tarlatan pads.

Make the first wipe (that is, with the first in the series of wiping pads) with the plate hot, either on the heater, unless you prefer not to soil it with ink as noted above, or on the newspaper-covered jigger (Illus. 81). Consult Illus. 78 for the wiping procedure. Wipe toward yourself, skimming the surface with the pad. First wipe the plate lengthwise. Do not apply pressure. Then turn the plate 90° and wipe across the short dimension. Turn again and wipe lengthwise once more; then wipe again across the short dimension.

When the pad clogs with ink, remake it to provide a fresh face and continue wiping. The first wipe is intended more to pack the ink into the lines than to remove much if any of it from the plate.

Wiping with subsequent pads is performed on the jigger as the plate cools. Take up the second pad and again wipe the plate in all four directions. Whereas the first wipe left the plate still covered with ink, the second wipe permits much of the plate to show through. Take up the third pad and wipe through the third cycle with straight, parallel wipes without bearing down or scooping. Wipe the plate several times in every direction, turning it around as you wipe. When the pad gets too soiled with ink, shake it out and make it up with a fresh face. Wipe until the surface of the plate appears clean.

Continuing to use the same pad, now go over the plate in circles or figure eights (Illus. 79) as many times as necessary to even the tone on the plate.

The plate may be printed at this "rag wipe" stage. There will still be a considerable amount of ink on the plate, which will give a dark tone to the open areas of the print. View the plate in a back light for streaks and keep on wiping until these have been blended into the general tone.

Most etchers, however, do not print a plate until it has been hand-wiped. The edge of the palm is used for wiping. If the palm is clean, smear a little ink on it and wipe it off on the belt rag.

The hand must be chalked before each wiping

Illus. 82. Chalk hand on large-size sticks held in a box.

Illus. 83. Wipe off excess chalk on belt rag.

stroke (Illus. 82) and the excess chalk wiped off on the belt rag (Illus. 83). The purpose of the chalk is to dry the hand of the oil picked up on the previous wiping stroke.

The hand wipe is performed quickly and sharply, but without pressure. The hand may move perhaps two inches on the plate. If it moves too far, it smears the ink instead of picking it up. Work around the plate with a series of short, sharp wipes (Illus. 84), chalking the hand and wiping it off on the belt rag between wipes. Work from the edges toward the middle, using some judgment as to where the wipe should be thorough and where a little of the ink should be left to affect the print. Wipe *across* the main lines rather than with them, as this avoids dragging the ink out of the lines.

Also remember that the hand must move *swiftly* in the hand wipe in order to remove the ink—slow motion only smears it. Not only may the edge of the palm be used, but any part of either hand, whichever part can best get at the area in question. In some places you will have to work more around the lines than over them. In very tiny places, a toothpick, either bare or wrapped with cotton, may be used to pick up the excess ink.

Wipe the hand after every chalking and before touching the plate, as chalk in the lines causes unsightly breaks. Keep a piece of coarse sandpaper at hand and use it occasionally to clean ink off the chalk block.

After wiping is completed, dampen a soft cloth and carefully wipe the bevel (Illus. 85).

Illus. 84. Diagram of hand-wiping. Go round and round the plate with short, sharp strokes, working from edges toward the middle. Do not apply pressure.

Preserving Wiping Pads

Since the plate has to be inked and wiped for each print, wait until you have finished your printing session, then shake out the pads, lay the tarlatan squares on newspaper, and scrape off the excess ink with a putty knife or wall scraper. Hang the cloth squares up to dry. Later, store them away in a covered metal container. When pad #1 becomes so fouled with ink that it can no longer be scraped clean, discard it. Move pad #2 to the #1 position, #3 to the #2 place, and make a new #3 pad, conditioning it with a little ink before working with it.

Retroussage

Some etchers feel that hand-wiping produces a print too cold in tone and they therefore resort to *retroussage* (pronounced *ret-troo-sahj'*) to "pull back" some of the ink from the lines and spill it upon the surface of the plate.

The operation involves a soft, rolled cloth (or cheesecloth) which is lightly whisked and danced about upon the plate (Illus. 86) to smear the lines a little.

You do not have to follow this procedure if you do not like the result of it. When applied, however, retroussage should take place all over the plate and not just in separate areas, which destroys the unity of the print. For a strong effect, retroussage the plate hot, while it is on the heater; for a light effect, retroussage cold on the jigger. A medium effect is obtained with the plate just warm.

Twirl the rag across the plate to avoid dragging it lengthwise along the lines, which would tend to deplete them of ink. Work in both directions across the lines so as to drag the ink out on both sides. This gives a more pleasing effect than if the ink lies only on one side of the line.

Illus. 86. In *retroussage,* a rolled rag is held as shown and flicked lightly across the plate to pull some of the ink from the lines.

7. PRINTING THE PLATE

Temperature of the Plate

Compared with a cool plate, a warm plate more readily releases the thin film of ink remaining upon its surface after wiping. This results in a print having a darker plate tone, all else being equal. Where such tone is particularly desirable, the plate may even be returned to the heater after wiping to get it hot again.

Where the least plate tone is desired, the plate may be set aside after wiping to cool down to room temperature. For ordinary results, however, the plate is generally printed immediately after wiping, when it probably will set off as much plate tone as you are likely to want.

Trial Proofing

Your first proofs, called "trial proofs," may be made on newsprint. Soak the paper in a tray of water for a few minutes and blot dry. (When you get to where even your trial proofs have value, you will want to print them on rag paper.)

To print, first lay a piece of dry newsprint in the middle of the press bed. This prevents any ink that may be on the back of the plate from soiling the press bed. Change the newsprint after each run through the press.

Lay the inked plate face up on the newsprint (Illus. 87), its longer dimension parallel with the rollers. When run through the press in this position, the plate has less tendency to curl (become concave toward the face side). However, such curvature is easily corrected by running the plate face downward through the press a few times (without printing).

If a plate happens to be too long for convenient printing in the recommended position, it may, of course, be run through lengthwise (Illus. 88). That is why press beds are longer than they are wide. With a good press, you should be able to print a plate whose width is equal to the length of the top roller. There is usually enough space between each end of the roller and the press frame to allow turning

Illus. 87. Generally you place the plate on the press bed with its longer dimension parallel with the rollers. An underlay of newsprint keeps the bed clean, prevents transfer of ink to the margin of the printing paper.

Illus. 88. When the long dimension of the plate is as long as or longer than the rollers, run the plate through the press as shown. If the plate tends to curl, run it through face down to straighten it out.

Illus. 89. All three blankets are visible in this view of running a plate through the etching press. A slow, steady revolution of the rollers must be maintained; do not allow the press to stop while the plate is under the roller, as this might mark, and so spoil, the print. Though some etchers run the plate back through the other way, once it has passed through, this may sometimes spoil the print rather than improve it.

51

up into such space 2 or 3 inches of printing-paper margin. (To permit this, the blankets should be no wider than the roller.) Plates approaching the capacity of the etching press produce more evenly toned prints when the press is motor-driven.

After placing the plate on the press bed, position a sheet of damped newsprint on top of the plate (Illus. 90). Leave more or less equal margins as you put the paper over the plate. This is easy to do, as the paper is translucent when wet and you can see the plate through it. Except where the plate contains large areas of solid black tone, it is quite safe to move the paper about on the plate without fear of smearing the ink.

On top of the print paper, lay a sheet of dry newsprint. The purpose of this "buffer sheet" is to absorb the water squeezed out of the print paper and thus prolong the working life of the "sizing catcher" blanket.

If you use long blankets, feed them under the top roller and throw them back over it before placing the plate (Illus. 90). If you are printing with cut-down blankets, lay them on over the plate and paper, staggering them at the leading edge so as to pass easily under the roller. With a slow, even turning of the star wheel, wind the bed through the press.

Once the bed has been wound through the press, lift the blankets and again throw them back over the top roller. Remove the buffer sheet of newsprint, now wet, by carefully peeling it off. Throw it away. It cannot be used again. A small print generally comes loose from the plate by itself; a larger one may tend to stick. Handle carefully. Jockey the paper a little to and fro as you lift it; use pick-up clips (Illus. 90 and 91) to protect the margin from the ink on your hands.

Lay the print face up on a dry blotter and study it critically. The plate mark (the impression of the bevelled plate edge, countersunk into the paper) should be smooth and clean. If it looks dirty, examine the bevel to see if more filing and stoning are needed to smooth it. Black spots on the print indicate the presence of foul biting that resulted in pits in the plate. Such pits hold ink. You may leave these pits as they are, erase them from the plate by methods to be explained in Chapter 8, or remove the ink from such flaws with a toothpick each time the plate is printed.

All the lines should be whole, having a firm, well-inked look about them. If the lines have a broken, mealy look, or if weak double lines show where

strong single lines should exist, either (1) you failed to pack the ink well into the lines; (2) you got the ink in well but later pulled it out with careless or inexperienced wiping; or, (3) the press is applying insufficient pressure.

If you adjusted the press as described in Chapter 5, you can discount cause number three. Pull another proof, taking more care with inking and wiping. (It is not necessary to clean the plate between printing and re-inking it.)

Makeready

It may occasionally happen that a print, by being more or less poorly printed, shows that less pressure was applied to one area of the plate (usually the middle or along one side) than to another. One of two things may be at fault: either the press rollers and/or bed are old and worn, or the plate has been scraped and worked to the point where it is thinner in one place than another.

If the plate prints the same regardless of where it is placed on the bed, the fault lies with the plate. Paste tissue paper to the back of the plate in the area corresponding to the area of reduced pressure in the print. This pasted-on paper is called makeready and may be applied in whatever thickness is required to make the plate print normally all over.

If the defect in printing lies with the press (the low-pressure area will shift as the plate is moved about on the bed), the remedy is the same, except that care must be taken to always place the plate in the same place on the bed, which must be plainly marked. Tissue, through which the marked place is visible, is used for an underlay instead of newsprint.

Storing the Plate

Whenever you are not making prints from the plate, you should store it in such a manner as to protect the face from stains and corrosion. Rub a thin coat of petroleum jelly over the entire face of the plate, then wrap it in thin, cling-type plastic film sandwich-wrap (such as Saran Wrap, Plastic Wrap, etc.). Rub the plastic down well on the greasy surface to remove air bubbles. Or, roll it down with a hard-rubber roller (Illus. 31, Chapter 2). For further protection, wrap the plate in blank paper and store it in a box or a drawer. Do not store copper and zinc plates near each other, or galvanic action (as in a battery) may ensue and induce corrosion.

Ink that has been carelessly left to dry in the lines must be cleaned out or prints made from the plate will be poor. Apply a solution of caustic soda (lye)

and let soak. Then scrub the lines with an old tooth-brush. If necessary, apply a second treatment. Extremely stubborn cases may require immersing the plate in a boiling solution.

Light stains may be removed from the plate by careful rubbing with a solution of vinegar and salt; or use a commercial copper polish. A new and effective method is to apply a paste of one of the modern enzyme-active, laundry stain-removers or detergents mixed with water and let it soak a few minutes; then rinse the plate under the tap.

Printing the Edition

The edition is the number of fine prints you have previously decided to make from a given plate. This may be anywhere from five or ten to 50 or 100 or more, as you wish.

Since you do not have to print all of the edition at once, make only a few prints to begin with (not more than eight or ten) and save time, effort, and paper. Even two or three may be enough. Damp the paper as described in Chapter 5. When ready to print, open the plastic sheeting, lift the glass plate so that it stands on edge, and take out the topmost sheet of paper with a pick-up clip. Quickly lower the glass back down upon the pile to keep it flat and re-arrange the plastic over the edges to hold in the dampness.

Lay the print paper face-up on the glass and examine it. Blot excess moisture away with a clean blotter. If the paper has been left damp too long, the edges may have dried out and will have a wavy look. Redamp dry edges with a sponge as each sheet is readied for printing. Otherwise, the paper will crease when going through the press.

Also examine the paper for hairs or other foreign material. Brush them off with a cheap, stiff shaving

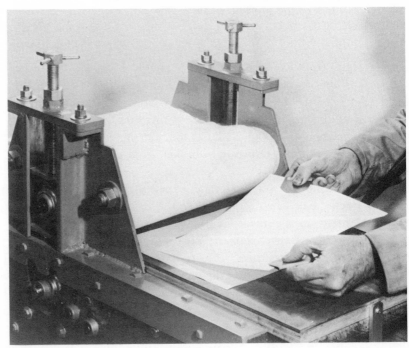

Illus. 90. If you handle paper after you ink the plate, there is bound to be danger of dirtying the print margins. Always use pick-up clips as shown when handling paper.

Illus. 91. Make pick-up clip by bending 2″ × 4″ strip of plastic around a pencil. Hold bend in hot water to soften, then in cold to set the bend. Good clips, though not so long-lasting, may also be made of pressboard or cardboard. Re-inforce the bend with masking tape.

53

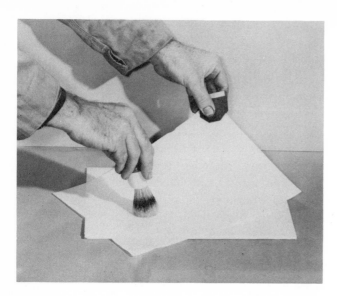

Illus. 92. A cheap, stiff shaving brush makes a good little broom for whisking hairs, dirt and other foreign material from the printing paper, and for brushing up the nap to improve the printing quality.

brush (Illus. 92). Remove clinging particles with tweezers. Then go over the sheet with short, sharp flicks of the bristles to brush up the nap for better reception of the ink. Brushing also rids the surface of slight overdamping. Paper that is too wet or too dry will refuse the ink, resulting in broken lines and spotty tones.

When printing on soft, waterleaf paper such as Hosho, Vacar, Kochi, etc., do not use the brush as the bristles tear up the surface. If, when removing a sheet of waterleaf paper from the plate after it has been printed, the paper sticks to the plate, leaving white fuzz all over it, the paper is too damp. Where this is so for one sheet, all sheets in the blotter pile will be the same. To remedy this, let each sheet as you come to it remain exposed to the air while the plate is being inked and wiped. In this interval, enough water will evaporate from the sheet of paper to correct the excessive dampness. If the printed paper sticks only to the etched lines and not to the rest of the plate, the ink is too stiff. Loosen it up by adding a little more raw linseed oil.

Handling the print paper with clips, lay it face-down upon the inked plate on the press bed, just as you did in trial proofing. Proceed with the printing.

As each print comes off the press, examine it closely. Destroy imperfect prints at once. Immediately place each good print between dry blotters, but take care when laying on a blotter not to smear the ink.

If the ink is mixed only with black pigments, it will take it the normal drying time of raw linseed

oil (2 to 4 days) to become dry. If a tablespoon of burnt umber pigment was added to the mix, however, the ink should be dry by the next day. (If you are printing with commercially prepared ink, add prepared burnt umber ink to it to hasten drying, if necessary.)

If you need the prints in a special hurry, a drier called cobalt linoleate may be added to the ink at the rate of 1 drop for each 2 tablespoons of ink. Beware of exceeding this amount. Cobalt linoleate is a "surface drier"; that is, it will cause the ink to form a skin rather quickly, but the ink underneath will remain fluid for some time. It would be risky, therefore, to use cobalt drier on a heavily bitten plate where you might be fooled into thinking the print was dry when it wasn't.

Flattening the Prints

If the prints buckle when dry, they must be flattened, but this has to wait until the ink dries. To flatten, the prints are first soaked in a tray of water, then placed between dry blotters. A piece of plywood or glass is then laid on top of the stack, with enough weight added to hold everything flat. Leave until the prints are dry. To speed drying, change blotters every half-hour or so.

Relief Printing

The intaglio plate may also be printed as if it were a relief plate, by inking and printing only the raised surfaces. Use regular printing ink (not etching ink), applying it to the plate with a rubber or composition ink roller. Do not heat the plate. The plate can be printed on a platen press, or with the etching press, removing the blankets and adjusting the top roller to reduce the pressure. (Space does not permit full treatment of this subject, but a description of relief printing, including makeready, register, etc., is to be found in the book, *Prints from Linoblocks and Woodcuts*, by this author).

Prints with Margins

You may want to make a print with a margin between the etched area and the plate mark. This style was popular in the last century. After the plate is grounded and needled, needle also a rectangular outline around the area to be etched, using a ruler to guide the point. A boxed-in area is thus located inside the larger area of the plate itself. Before etching, paint out the margins with several coats of stop-out varnish, up to the outline.

When printing a plate with margins, wipe both

margins and bevels clean of all traces of ink with a damp cloth so as to remove all plate tone.

Finishing the Print

Each print of an edition is numbered, but not necessarily in the order in which it was printed. If the edition is intended to be 50 prints, for instance (regardless of how many less than that number are actually printed), write the print number lightly on each print, just under the bottom left corner of the plate mark. Follow it by a slant and follow this in turn by the number of prints in the edition. Example: the first print is numbered 1/50, the second 2/50, the third 3/50 and so on.

Ten per cent of the number of prints in the edition may be printed in excess of the actual number (five prints in an edition of 50, making a total of 55 prints). These are for the artist's personal use. In place of the usual edition number, write the words "Artist's Proof," followed by a Roman numeral instead of an Arabic number.

In the middle, to the right of the number, write the title of the print, if it has one. To the right of that, under the right corner of the plate mark, place your signature. If you do your own printing, follow it with "Imp." This stands for the Latin word *impressit*, meaning "printed it." The addition of your hand-written signature to the print (regardless of the signature on the plate) authenticates the print as a genuine original and is required if the print is to be sold.

Cleaning Up

Always clean up immediately after printing. Wipe ink smudges from the press with a kerosene-dampened rag. Clean the plate by flooding with kerosene and scrubbing to loosen the ink. The bottoms of the lines should show pink (in the case of copper) and bright. Dry the plate with a clean, soft cloth.

Leftover ink may be returned to the water bank. If it has been thinned or has had additives included, keep it separate from untreated ink by placing it in its own small flap of aluminum foil.

Clean the ink slab and mixing tools as you did the plate. Also leave the heater and jigger clean.

Various preparations containing lanolin are available for cleaning the hands. Skat and Boraxo, at your grocery store, are good hand cleaners. If the combination of ink, kerosene and hand cleaner with water has a tendency to dry your hands, finish with a hand *lotion* containing lanolin.

If the ink dabber is to be used again within a few days, it may safely be coated with ink and wrapped in aluminum foil, or put it into a plastic sandwich bag. For longer periods of storage, a covered, wide-mouth jar helps to keep it in good condition (Illus. 93). Pour a little raw linseed oil into the jar for the dabber to rest in.

Leave the muller standing on the ink slab and cover both with a cardboard box to keep dust away.

Care of the Blankets

Do not leave blankets pinched under the roller. If much printing has been done, they will be wet and should be spread out on clean wrapping paper to dry.

When, after much use, the blankets become dirty, they can be washed in barely warm or cool water, using a mild soap or detergent. Squeeze water through the fabric, then squeeze dry in the hands after rinsing several times. Spread the blankets out on clean newsprint or wrapping paper to dry. Do not machine-wash the etching blankets.

Illus. 93. The ink dabber cannot and must not be cleaned. After printing, put it away in a dust-free glass jar having a small quantity of raw linseed oil in the bottom. If ink should dry on the dabber, make a new pad and cover for it. Scrape excess oil from the cover when preparing to use the dabber again.

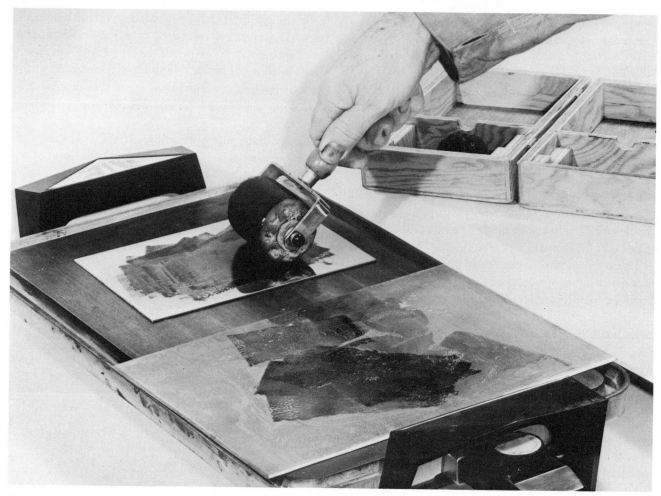

Illus. 94. To reground a plate for rebiting, melted ground is transferred from a blank plate to the etched plate with a roller.

8. REWORKING THE PLATE

States

In etching, a "state" is a stage of development of the plate. The first proofs from a plate, which may be only one or two in number, constitute its first state. As corrections, additions, or deletions are made on the plate and further proofs are pulled, each change represents a different and consecutive state.

Illus. 96, 97 and 98 show stages in the development of a plate. In this particular instance, all the states are additive; that is, each state is characterized by work having been added to the plate. It would be equally a different state if something had been erased from the plate. (See page 58.)

Every time a change is made on the plate, additive or subtractive, one or more proofs may be pulled and labelled and numbered in accordance with the state. When working a very complicated plate, etching the entire design at once may be impossible because of overactivity in the bath. In such cases, a first state may consist of only an outline of the subject. Several proofs are pulled on good paper and these are worked over with a pencil, each proof showing a certain amount of the work to come and each representing a future, different state. The plate is then regrounded and the second state is needled and bitten. A second-state proof is then pulled, the plate is regrounded and the third state is needled and bitten, and so on. Sometimes as many as six to a dozen states may be required to thoroughly exploit the plate's full potential. This also may be accomplished in as few as two or three states. Often, the

first state is the only one. In Rembrandt's day, there was no such thing as a numbered edition and as many prints were made from a plate as could be sold. When a plate wore out, Rembrandt often revived it with further work, each such revitalization constituting another state.

Regrounding and Rebiting

A plate not left long enough in the acid, or bitten in acid that is old and weak, comes out underbitten and prints with a pale, weak tone. Underbiting may also be confined to a small area prematurely removed from the etch by stopping out. Correction of such a plate is sometimes undertaken with the burin, an engraving tool. (See Chapter 11.)

The weakly-etched lines serve to guide the engraving tool. The curl of metal turned up by the point of the tool as it gouges out a line is cut away with the scraper (Illus. 136, 137 and 138, Chapter 11). Where only a few lines are involved, engraving provides advantages of speed and facility over regrounding and rebiting.

Burin-made lines, however, are more austere than etched lines, and an overworked area may not match the rest of the print, resulting in a loss of unity. If this should happen, the plate may be partially regrounded, the rest stopped out with varnish, and the burin marks lightly bitten in to give them the character of etched lines.

Sometimes, too, a plate may be strengthened by use of the dry point needle (see Chapter 12).

Where there is much rebiting to do, the entire plate must be regrounded. This is a tricky business at best and is not always successful. Even when it is successful, rebiting should not be depended upon as a cure for all plate evils. Its use is to be avoided rather than encouraged, as the quality of the rebitten line is never up to that of the line correctly bitten in the first place.

However, when rebiting is absolutely necessary, the plate is cleaned and then warmed on the heater. At the same time, a second, unetched plate is cleaned and placed on the heater. Upon this, a thin ground is rolled out (Illus. 94 and 95). This thin ground is then transferred to the etched plate by means of the roller, which should be passed over the plate a minimum number of times to avoid getting ground down into the lines.

If the entire plate is to be rebitten, the whole plate must be regrounded. If only a certain area needs rebiting, this is regrounded. After the plate has cooled (it is not smoked), examine the lines to be rebitten. If ground has gotten into them, clean it out with the etching needle.

Thoroughly stop out every part of the plate except the lines to be rebitten. Since a thin ground will not long resist a strong acid bath, use either a weaker dilution or the Dutch bath. Etch for no longer than a few minutes to avoid foul biting. If more etching is required, clean the plate, reground it and give it a second bite. Repeat as many times as necessary, until the lines are bitten deeply enough.

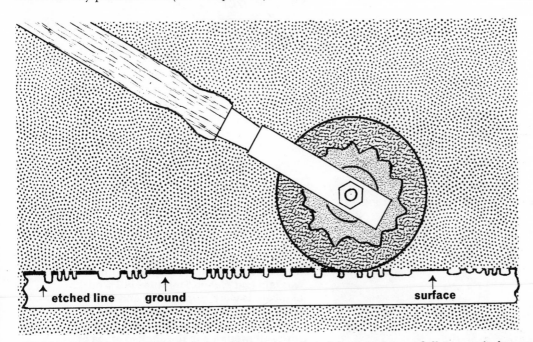

↑ **etched line** ↑ **ground** ↑ **surface**

Illus. 95. In regrounding, the roller is passed over the etched plate carefully so as to lay ground only on the relief surfaces. The lines are left open for rebiting.

Illus. 96. SEASHELL, M. Banister (4″ × 5″, copper plate). First state. Design was drawn directly on the plate from a model, needled in hard ground and etched in a 3:5 nitric acid bath at 23 degrees Baumé, 74 degrees F., for 13 minutes.

Illus. 97. Third State. A second state was created by painting a paste of olive oil and flour of sulphur into the cross-hatched areas in order to deepen the tone. The flour of sulphur treatment may be left on overnight to produce maximum tone. The plate was then grounded with a soft ground and run through the press to imprint the cheese-cloth weave into the ground. Shell and shadow were stopped out; the background etched was 10 minutes in 3:5 nitric.

Illus. 98. Sixth state. An aquatint ground was laid and etched 5 minutes in 3:5 nitric. Light areas were stopped out and the remainder of the aquatint was etched 5 minutes longer. The plate was regrounded with soft ground and the shaded areas of the shell worked up and etched another 10 minutes.

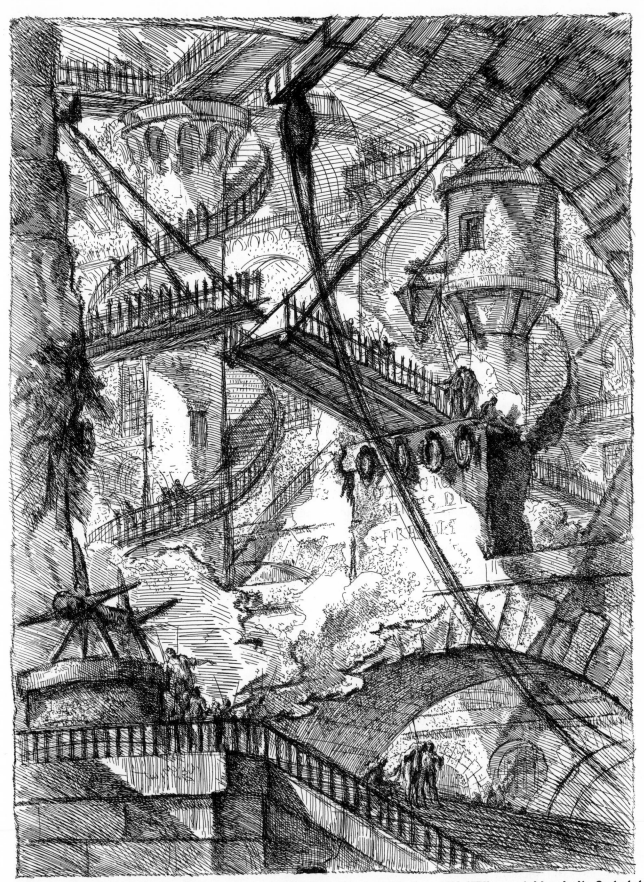

CARCERI (The Prisons), Plate VII, by Giovanni Battista Piranesi (Italian, 1720–1778), an etching in its first state. National Gallery of Art, Washington, D.C., Rosenwald Collection.

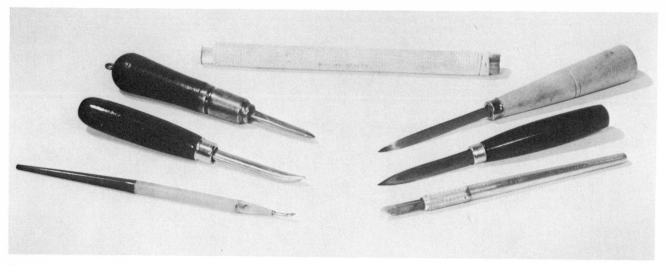

Illus. 99. Tools used in reworking the plate: Top middle—glass-fibre burnisher; left—straight burnisher, curved burnisher, mimeograph burnisher; right, from the top—triangular scraper (flat), triangular scraper (hollow faces), negative retouching scraper. Only one scraper and one burnisher are needed.

Also, the plate may be regrounded with a dabber. In this case, the lines are deliberately filled with the ground; thus, a heavier and more acid-resistant ground may be laid. If ordinary ground interferes with visibility of the lines, lay a transparent ground (see Chapter 1); then reneedle the lines to be re-bitten. Make sure all the ground is cleaned out of the lines; work with a magnifying glass if necessary.

Brush several coats of stop-out varnish on the bevels before biting. If the acid attacks the bevels, they will have to be filed, ground and polished all over again.

Dabbing an Irregular Ground

This is a method of producing on a previously etched plate an area that prints with a spotty-looking tone. When combined with line work, the result carries out well an impression of tumbled rocks, masonry walls, mountainous terrain, etc.; or the method may be used simply for its tonal effect in a contemporary design.

Clean a blank plate, warm it on the heater, and roll out some hard ground upon it. Also clean and heat the etched plate. Pick up some of the ground on a dabber, a wad of cheesecloth, a crumpled piece of aluminium foil, or anything of the kind, and dab it on the desired area in an irregular manner. Don't aim for a smooth, even coverage, but let the plate show through here and there in a random fashion. Stop out all but the area you want etched and bite the plate in your regular acid bath.

Flour of Sulphur

To deepen a tone in a cross-hatched or multi-lined area, or to add a smooth, light tone anywhere on the plate, make a brushable paste of olive oil and flour of sulphur and paint it on the areas you desire to tone. The longer the mixture sits on the copper, the more pronounced the effect will be. It may be left overnight, or the process can be speeded up by warming the plate on the heater or in hot water. The mixture lightly etches the copper to a fine, light tone. If you decide later that the tone is undesirable, you can easily polish it away with charcoal and water.

Illus. 100. This close-up of the negative retouching scraper shows its ease of handling.

Illus. 101. Hold the triangular scraper with one of the flats on top. The plate is of zinc, hence its lightness of tone.

Illus. 102. Hold the burnisher so you can rub lengthwise along the line. Use oil with this tool to assure a smooth finish.

Correcting the Overbitten Plate

A plate that has been left too long in the acid is overbitten and the lines it prints are too dark and heavy. Lightly overbitten lines may be brought back to normal with a tool called the burnisher. Rub along the line with enough pressure to close the edges in towards each other.

When the defect consists of a broader area that prints too dark a tone, the tone may be lightened by rubbing that area on the plate with the charcoal block and water. The longer you rub with the charcoal, the lighter will be the tone, as the surface of the plate is actually being worn away.

If more than this is needed, the line or area is first scraped lightly (Illus. 100–101), then burnished (Illus. 102).

Using the Scraper

The scraper is used wherever any considerable amount of metal must be removed to eliminate some unwanted part of the design. The blade of this tool has a triangular cross-section. On some, the faces between the edges are concave (hollow-ground), except near the point, where they are flat. Other scrapers are flat all along the blade.

The scraper is bought roughly finished. A rough scraper will scratch the plate and to avoid this the working surfaces must be given a smooth, polished finish. The working faces constitute that part of the blade extending from the point to where the curve straightens out on each face. This small part of the blade near the point is all that is ever used in scraping operations.

Rub the flat sides near the point on a fine India stone, using oil, to erase the roughness; then hone them on a white Arkansas stone. Polish with 4/0 emery paper. The faces must be smooth and mirror-bright, as in some uses they contact the surface of the plate. Polishing the faces serves also to sharpen the edges at the same time.

An excellent scraper of unusual design is shown in Illus. 100. It was purchased many years ago for use in negative retouching and is probably not now generally available. One like it could be made from a piece of $\frac{3}{16}$-inch square lathe-tool stock and a length of aluminium rod for a handle. Grind the end to shape on a wheel, taking care not to draw the temper of the tool steel. Sharpen and polish as described in the previous paragraph. This scraper is extremely manageable in restricted areas.

When scraping, take care not to let the tool chatter on the plate, as this results in a chewed surface that will be difficult to smooth. Scrape lightly, methodically, and carefully for some distance around the fault that is being corrected. Try to avoid producing a small, deep hollow. If the hollow left in the plate must be deep, let it also be broad. Hold the scraper as shown in Illus. 101, with one of the flats on top, tipped slightly in the direction of movement. Scraping is done by just the edge lightly caressing the plate.

Using the Burnisher

The burnisher (Illus. 99 and 102) is available both straight and curved. The curved tool is easier to handle. The small burnisher also shown in Illus. 99

61

is intended for work with mimeograph stencils; it is, however, invaluable for work in small areas. A nut pick also makes an excellent burnisher; or, something similar to one can be made from a tenpenny or twentypenny nail, filed to shape, ground smooth, and polished.

The burnisher is always used with oil to cut down friction and result in a smoother surface. After the plate has been burnished, it should be polished with 4/0 emery paper.

The burnisher is used to close up fine scratches and lines by rubbing lengthwise with considerable pressure. Heavier lines can be partly closed so that they print with a lighter tone. In the case of cross-hatching or heavy needling where the area tends to print too dark, the print can be lightened by a vigorous burnishing of the entire area. The burnisher is also useful for eliminating small pits caused by foul biting.

The brush of glass fibres (Illus. 99) may be used for removing light scratches.

Scotch Stone

If a more drastic means than the burnisher is required to remove the undesired area, the plate must be worked with the scraper until all the unwanted lines have been scraped away to virgin metal. The marks left by the scraper must then be ground away with a Scotch stone. This is a fine-textured, abrasive stick, available in sizes ranging from ⅛-inch to 1-inch or so square by about 5 inches long. Small sticks are used in tight places, the large ones on broad areas.

Round one end of the stick on sandpaper and rub it against the plate with plenty of water. Where a large area is being worked down, the stone may be used on its side (Illus. 103). If you work at a sink, flood the plate constantly with water from the faucet. If not, keep a pan of water on the work table and sponge or rinse the plate at intervals.

Snake Slip

This is a white, spongy material in stick form. When rubbed on the plate, it erases the fine scratches left by the Scotch stone (Illus. 104). Snake slip looks something like cuttlebone, though it is somewhat harder than the natural product. In an emergency, regular cuttle-bone may be used as a substitute. Pare away the hard, bone-like rind on one side to prevent scratching the plate. Cuttle-bone works best in large pieces on broad areas, as it crumbles too easily for more precise use.

Another substitute for snake slip is powdered pumice, which is applied to the plate wet on a piece of chamois skin. You can buy pumice at a hardware store.

Also, #400 or #600 waterproof carborundum paper cuts fast and fine when used wet immediately after applying Scotch stone.

The Charcoal Block

By now, the surface is in a condition to be smoothed to an almost-polish by rubbing it with water and a charcoal block (Illus. 105). When used with water, the charcoal cuts faster—its use with oil is messy and unsatisfactory. The result of the charcoal rub is a surface of finer texture than that left by snake slip.

Polishing the Plate

The plate may be brought to its final polish with 4/0 emery polishing paper (Illus. 106). When first applied, the paper has a scratchy feel; but, after it has taken up some metal, it smooths down and rapidly polishes the plate.

It is important, when removing faults, lines or areas from the plate, that the surface be brought back to its original polished condition. Any dullness of the surface will show on the print as a smudged or dirty-looking spot. Therefore, each of the steps involved in reworking an overbitten plate must be carried out to its fullest, the work of one abrasive totally erasing the marks made by previous work.

Crevé

A reworked area is indistinguishable in tone from the original surface of the plate unless so much work has been done in the removal of metal that the level of the surface has been lowered into either a large or a small depression, also called a *crevé* by French etchers, but in this connection to mean "stove in." A *crevé* is, therefore, a dent in the plate, and every time the plate is wiped, special attention will have to be paid to working ink out of it to keep it from printing as a dirty spot. The repair of the *crevé* is called *repoussage* (pronounced ruh-poo-sahj').

Repoussage

This word is also French and means "a pushing up again," which is exactly what is done to the dent, to bring it back level with the surface of the plate.

Tools for *repoussage* include a hammer, some kind of an anvil, punches, and calipers (Illus.107, page 64).

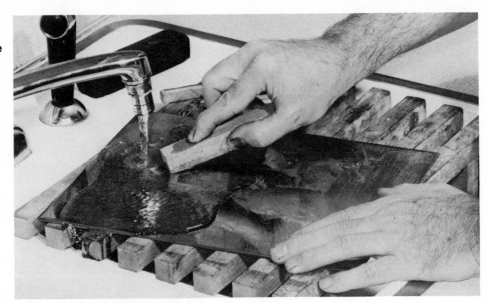

Illus. 103. The Scotch stone is used to rub deep scratches, blemishes and lines out of the plate. If possible, work at a sink with the water running continuously.

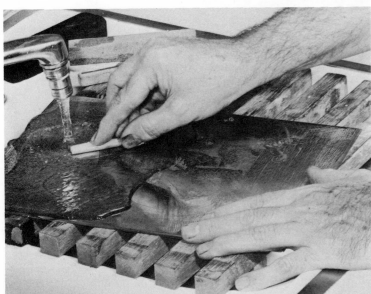

Illus. 104. Following the use of Scotch stone, work the area over in the same manner with snake slip, until all the scratches made by the stone have been erased.

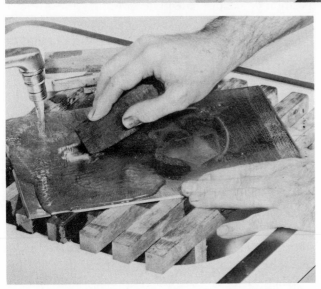

Illus. 105. Any remaining marks appearing on the plate are further reduced with charcoal and water.

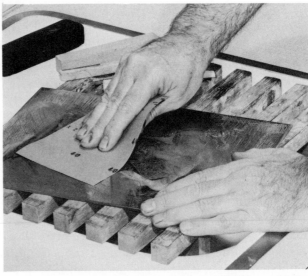

Illus. 106. The plate is given a final polish by rubbing with 4/0 emery polishing paper. Do not use water.

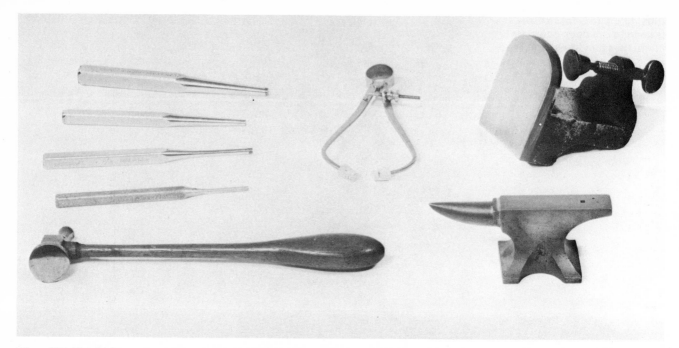

Illus. 107. Tools for *repoussage*: in the middle, caliper points protected by corks; at the left, punches and chasing hammer; at the right, anvils for placement under the plate when using punches. (Any piece of smooth steel may be used.) Punches may be home-made from 20-penny nails or different sizes of bolts.

To correct the *crevé*, the surface of the plate is pushed back to its original level from the back of the plate. In order to do this, the location of the *crevé* must be marked on the back. First, hold a steel rule on edge over the *crevé* (Illus. 108) and determine its depth and outline. Using a pair of calipers, locate the center of the *crevé* on the back of the plate (Illus. 109) and mark its outline on the plate with a white wax crayon.

The *repoussage* hammer is really a jeweler's chasing hammer, ideally suited to this task, but a small, ball-peen hammer will do. A selection of pin punches and some kind of an anvil—the steel press bed, for instance—are also needed. Whatever is used as an anvil, the surface must be smooth, preferably polished, because any imperfection will transfer itself to the face of the plate requiring a lot of work to remove it.

If the *crevé* is small and approximately circular, select a punch that is slightly less than the same size. If the *crevé* is too big to be hammered back with a single punch-mark, select the largest punch and move it about within the outline as required (Illus. 110). Sometimes, the hammer itself may be used, without a punch, using either the broad face or the ball, depending on the size of the *crevé*.

When the plate has been hammered up, fill the depression in the back with paper or thin tissue cemented in to level the surface.

It is also possible to dispense with hammer and punches. Cut a piece of thin cardboard the size and thickness of the *crevé*. Cement it to the back of the plate (Illus. 111), directly behind the depression in the etched surface. Then run the plate face down through the press, with paper and blankets in position to assure adequate pressure, the same as when printing. If the cemented material is of the correct thickness, the plate will come out of the press with a perfectly even surface.

Résumé of Reworking the Plate

Fine pits and scratches are removed entirely from the plate, and lines may be reduced in tone or fine ones removed by rubbing with the burnisher and oil. Where more work is required, the scraper, Scotch stone, and charcoal are used to cut or wear away the metal.

You may start work at any of these stages, eliminating those previous to it, depending on how much metal needs to be removed from the plate.

Where excessive work results in hollowing or thinning the plate, the depressed area is pushed back up to the general level by means of *repoussage*.

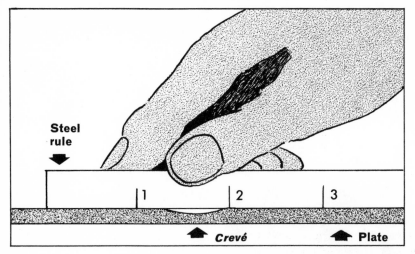

Illus. 108. Lay a steel rule on edge over the *crevé* to determine its depth and extent. Mark the boundary of the *crevé* on the plate with white wax crayon.

Illus. 109. With one point of the caliper placed in the middle of the *crevé*, the other point will indicate its location on the back of the plate. Mark with white wax crayon. (Protect point on face of plate with a cork to prevent scratching.)

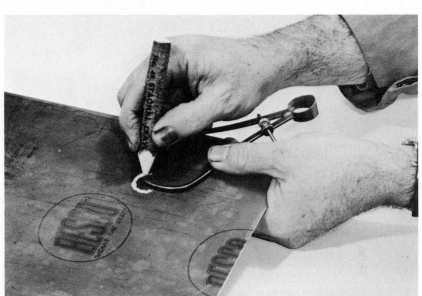

Illus. 110. Hold the punch inside the boundary of the *crevé* and tap lightly to hammer it up even with the face of the plate.

Illus. 111. Another way to push up the *crevé* is to cement a piece of cardboard to the back of the plate which is then turned over and run face down through the press.

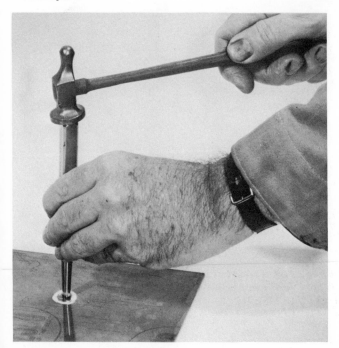

Illus. 112. The drawing to be etched in soft ground is made directly on a sheet of laid paper covering the grounded plate, using pencils of varying degrees of hardness. The board under the artist's hand is raised on $\frac{1}{4}$-inch thick cleats at each end and bridges the plate to keep the hand from touching it.

9. SOFT-GROUND ETCHING

The soft-ground technique was exceedingly popular in the time of Joseph Mallord William Turner, the English landscape painter (1775–1851), and the English etchers Thomas Girtin (1775–1802) and J. S. Cotman (1782–1842). By the latter part of the 19th century, however, the practice of making soft-ground prints had fallen off, and it has never fully regained its popularity.

This does not mean that the soft-ground technique has dropped so far out of fashion that it is never used. It is, indeed, used in many ways. It is unexcelled as a basis for aquatint; it may be introduced into a print worked in mixed media, and it is widely used to reproduce the imprint of textured materials on a plate.

The principle underlying soft-ground etching is simple. The ground is a sticky substance that adheres to anything pressed into it—fingers, tools, crumpled paper or foil, cloth, lace, etc. When the textured object is removed, it takes with it part of the soft ground, leaving its texture as a pattern that may be etched in the acid bath.

Soft Ball Ground

The basis for a soft ground is the same formula given in Chapter 1 for hard ground. When all the ingredients are melted, add an equal quantity by weight of mutton tallow, Vaseline, or axle grease. In hot weather, when the ambient temperature helps to soften the ground, add only 50 per cent of the weight of the other ingredients. Soft ground is available from suppliers in liquid as well as ball form.

Soft-Grounding the Plate

Do not use the same roller or dabber for both hard and soft ground. Each kind of ground must have its own equipment. Since soft ground is greasy by nature, laborious cleaning of the plate is not required. Wipe the plate with a turpentined rag, then wash off the turpentine and dry the plate on the heater.

Roll or dab soft ground on the plate exactly as you did hard ground, covering the metal completely with a dark brown coating. Most of the foul biting ascribed to soft ground results from too thin a ground, so watch it. Roll the ground on *slowly* while the plate is on the heater. Roll with just the weight of the roller; don't press down. If you do, the roller will skid in the greasy ground.

When the plate is covered, remove it to the jigger and continue rolling slowly. Rolling too fast will pick up ground on the roller instead of spreading it out. As the plate cools and you continue to roll the ground, the latter finally assumes an even, dark brown tone and a fuzzy appearance. The fuzzy look signals the end of the operation; the ground has been successfully laid. Let the plate cool. Follow the same procedure when soft-grounding with a dabber.

Do not smoke the ground and avoid touching it, unless you want a reproduction of your finger or palm in the print.

Traditional Soft-Ground Technique

If a piece of paper is laid over a soft ground and a mark is made on it with a pencil, the pressure will cause the paper to adhere to the ground along the mark. When the paper is lifted away, it takes the ground with it wherever pressure has been applied.

Any drawing made on or transferred to such a paper laid over the ground will be printed in reverse, unless you reverse the drawing on the paper so that it will print the right way around after the plate is etched.

If tracing from an original drawing, first make a tracing on parchment-type tracing paper. Turn the tracing over and retrace the drawing with a hard pencil, thus transferring it to the final drawing paper (Illus. 113, next page). Also trace the outline of the

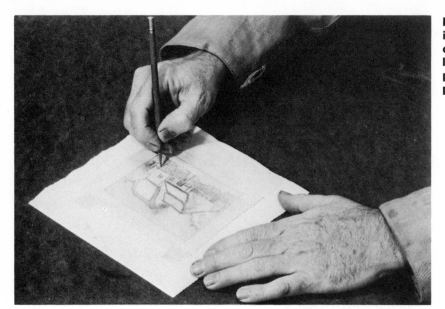

Illus. 113. When a guide drawing is needed, it is made in soft pencil on layout or tracing paper, then laid face down on the final drawing paper and traced off, using a hard pencil or a used ball-point pen.

Illus. 114. The soft-grounded plate should have a drawing frame like this one, with a paper overlay bearing the drawing taped in place.

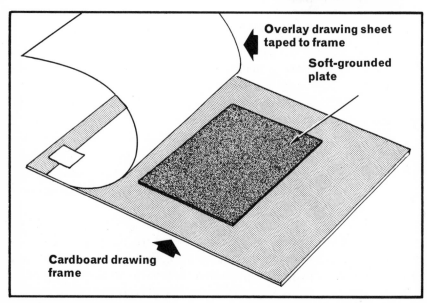

Overlay drawing sheet taped to frame

Soft-grounded plate

Cardboard drawing frame

Illus. 115. Diagram shows the construction of the cardboard drawing frame. The cardboard should be a little thinner than the plate and cut out to make a snug-fitting frame for it.

plate around the drawing to aid in locating the drawing over the plate.

The best drawing paper for soft-ground work is a rag paper having a laid or textured surface. One of the laid printing papers, such as Fabriano (Italy) or Ingre d'Arches MBM works well.

Illus. 114 and 115 show how the drawing is attached with masking tape to a cardboard "drawing frame." This is simply a piece of cardboard a little thinner than the plate, having a rectangular cut-out sized to fit the plate snugly. This frame should be made, using the plate itself as a guide, before the plate has been grounded.

After the overlay is brought down over the plate, the drawing is kept properly positioned by the cardboard frame to which it is attached. The drawing is then gone over with well-sharpened pencils of different degrees of hardness (from 4H to HB). Avoid pencils that are too soft as these only blacken up the drawing paper without having much effect on the soft ground underneath.

Use considerably more pressure than that required to needle a hard-ground plate, to assure squeezing the paper through the ground to the bare plate.

At no time must the overlay bulge or move about on the plate. When the drawing has been made, lift the overlay and check the results. The removal of ground, which should be pronounced, is evidenced by the ground adhering to the back of the overlay, and by the brightness of the lines on the plate. If some areas require further work, replace the overlay and work them up.

The reason for making and using the drawing frame is now apparent—it provides a precise means of replacing the drawing on the plate when further work on it is needed.

The thickness of the overlay paper makes the lines register somewhat wider in the ground than the actual width of the point in use. Therefore, you should use as fine a point as possible. Also, thinner paper produces finer lines. A mimeograph stylus or used ball-point pen is an ideal tool for pressing the paper into the ground when it is not necessary to see the mark of the pencil on the overlay. Where thick points are used, remember to use heavier pressure.

Do not become so absorbed in drawing that you allow the weight of your hand to rest on the plate. To avoid this, construct a bridge of thin hardboard or plywood (Illus. 112) to support the hand. A bridge made of thick boards encourages awkward drawing, so keep the boards thin.

This procedure results in printable lines that differ markedly from those found in hard-ground etchings. The "smooth" undersurface of the drawing paper is not perfectly smooth but is made up of innumerable tiny points forming the texture. Pressure forces these points through the ground to contact the plate. When the paper and ground are removed, the plate is thus exposed to acid in the manner of a halftone screen. When printed, soft-ground lines have the soft, grainy look of pencil lines on a well-toothed drawing paper.

Wherever hard, needled lines are wanted (as the outline around the drawing, Illus. 116), they may be put in after the overlay is removed, using a needle

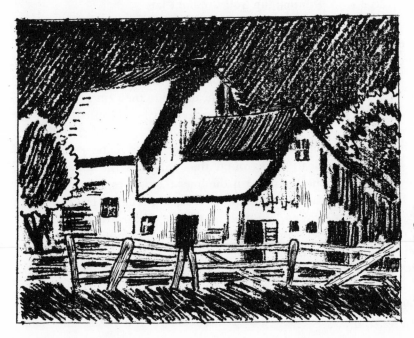

**Illus. 116. ETCHING, M. Banister. The soft-ground etching has the look of a pencil sketch. Corrections are easy to make and often called for. Where extremely fine lines are wanted, such as those in the fence and building, they must be put in on the bare plate with a dry point after etching.
The burr (metal paring turned up by the dry point) is shaved off with a scraper.**

Illus. 117. As a soft ground may not be touched, the plate cannot be blotted dry when taken from the bath for examination or stopping out. A hair-drier (shown) or a small electric fan will speed drying.

of desired fineness in the same manner as with hard ground. Extremely fine lines, however, should await completion of etching and the cleaning off of the ground. They may then be put in with a dry-point needle, after which the burr is scraped away. (See Chapter 12 for dry point.)

Etching the Soft-Ground Plate

Soft ground does have a certain affinity for foul biting—sometimes caused by inadvertent pressure having been applied to the overlay in the course of drawing. Therefore, paint stop-out varnish on blank (unworked) areas before etching.

Zinc is best etched with a 1:6 dilution of nitric acid; a 3:5 bath works well with copper. A nitric bath is recommended as you must be able to tell by the lack of bubbles if any of the lines is failing to etch.

If it becomes thus apparent that some lines or areas are not etching, remove the plate from the bath and rinse it, but do not attempt to dry it with a blotter. Use a hair-drier or fan (Illus. 117). Return the plate to the drawing frame, bring down the drawing overlay upon it, and rework the questionable areas, using more pressure.

If some areas, by reason of heavier tone, reach printing depth before others, stop them out with rosin-alcohol or shellac varnish, adding lampblack if needed to prevent running.

In general use, however, little or no stopping-out of this kind is required in soft-ground work; the entire plate is usually finished in a single bite because the strength of various lines and areas is taken care of in the choice of drawing points.

Printing the Soft-Ground Plate

The darks in a soft-ground plate never go completely black but have a luminous quality caused by the considerable speckle of white paper showing through. Individual lines have a soft, grey tone, giving a silvery appearance to the print.

For this reason, care must be exercised in wiping the plate not to make the lines any softer than they already are. The chalked hand wipe results in a clean background that enhances the luminosity of the lines, but if the lines themselves are over-wiped, they lose too much of their strength. Try to restrict wiping, as much as possible, to the areas around and between the lines and avoid wiping heavily over them.

Correcting the Soft-Ground Plate

If the plate is carried through the etch, is cleaned, bevelled and printed before you notice that some

areas are underbitten, there is still a remedy. The plate may be regrounded. A roller may be used for putting the soft ground on, but the dabber should be used afterward to ensure that all the lines are filled with ground. The plate is then returned to the drawing frame, the drawing overlay is brought down upon the plate, and the underbitten area is reworked and then rebitten.

Sometimes in regrounding and rebiting, it may prove necessary to be able to see the previously bitten lines. You cannot do this with the opaque overlay paper covering the plate. The drawing frame then is not used. Instead, lay upon the plate a piece of parchment-type tracing paper of 100 per cent rag stock. Ordinary tracing paper does not have enough strength to withstand working with pencil or stylus. A good product is Albanene, a paper for engineering draftsmen. This paper also has a fine tooth most suitable for working over soft ground and is transparent enough to let previous work on the plate be plainly visible. Make corrections free-hand, using the previously bitten work as a guide.

In all cases of regrounding, stop out with two or three coats of varnish the areas not intended to etch.

Soft Ground as a Texture Medium

Much modern work makes use wholly or in part of soft ground to reproduce textured materials such as silk cloth, linen, cotton, cheesecloth, tarlatan, lace, leaves, blades of grass, flower petals, leather, textured paper, crumpled tissue or aluminium foil, and so on.

Where this sort of work is undertaken, the preliminary design is first etched into the plate by hard- or soft-ground methods. The plate is then cleaned, grounded with soft ground and laid face up on the press bed. The textured material is laid on and covered with a piece of wax paper (Illus. 118) or sheet plastic to keep the ground that is squeezed through from sticking to the blanket.

Remove all blankets except the $\frac{1}{8}$-inch pusher of woven felt. If more pressure is needed, place sheets of paper or thin cardboard under the plate or on top of the blanket.

Run the plate through the press, then carefully strip the wax paper and textured material away. The textured pattern is left impressed in the ground. Stop out as required and etch.

Any number of textures may be added to the plate for a variety of effects, either texturing various parts of the plate, or laying one texture on top of another to produce dark, luminous tones. Each texture is stopped out and etched and the plate is cleaned and regrounded before adding the next. With some thought given to the effort, unusual combinations of textures may be produced in unlimited variety.

Illus. 118. To reproduce texture, cover soft-ground plate with desired material, lay on wax paper and run through press.

10. AQUATINT AND THE CREATION OF TONAL PASSAGES

If the lines needled in a hard ground may be likened to those made by a pen, and if soft-ground lines compare with pencil strokes, a similar comparison can be made between aquatint and wash. Like wash, aquatint is capable of an infinite variety of tonal effects, from the faintest grey to the deepest black. It gives form and depth to the simple line etching. The Spanish painter Francisco Goya (1746–1828) used aquatint extensively.

The first step towards producing an aquatint print is to etch a linear design or drawing into the plate to serve as a guide for the subsequent laying of tones. If the accent is to be on the linear pattern and the aquatint tones are to be scattered about over the plate, the etching may be done in hard ground. If, however, a painterly effect is wanted—one where the accent is on tones instead of on the linear design—the preliminary etching is done in soft ground as demonstrated in the preceding chapter. Soft-ground lines mingle with and become indistinguishable from the aquatint tones, allowing the forms and masses of the composition to fade into and blend with one another as they do in a painting.

Preparing the Aquatint Powder

The usual ground used in aquatint is a powder of crushed rosin, though asphaltum may also be used. Do not use a machine-processed powder, as it is too fine. Buy lump rosin and crush it yourself in a mortar (Illus. 119). You may use an old coffee mug or a heavy earthenware bowl for a mortar. The handle of a table knife or the end cut off a broom handle will do for a pestle.

When ready for use, the crushed rosin will be composed of all sizes of particles, from reasonably coarse to fine.

The Rosin Bag

Nylon hosiery, because of its coarse weave, makes the best rosin bag. Cut a square from a nylon stocking and put a pinch of rosin powder in the middle of it. Tie the material up around the rosin in the form of a bag. A single thickness of hosiery will provide a coarse mesh for laying a coarse ground. Make up a second bag, using two thicknesses of the material. Use this one for laying a fine ground. When not in use, keep the bags sealed away in a glass jar with a screw top to keep out dust.

Illus. 119. For laying an aquatint ground pulverize lump rosin in a mortar or bowl. Grind only a few ounces at a time and until no lumps are left. The resulting powder will contain both coarse and fine particles.

One supplier of etching materials makes available a series of screen-bottom sieves for laying aquatint grounds of various degrees of fineness.

Dusting the Plate with the Rosin Bag

Use of the rosin bag affords the skilled operator a great deal of flexibility in laying a ground. A coarse ground may be laid in one area of the plate and a fine ground in another. Some areas may be skipped entirely.

When you dust the plate, choose a work area where there is neither traffic nor air currents. Close doors and windows and cover the table with newspaper. Lay the plate on a piece of blank paper slightly larger than the metal. Because the dusted plate must not be touched, the paper beneath it is necessary to pick up the plate and move it about without jarring.

Before dusting, clean the etched plate as thoroughly as you did for laying a hard ground.

Whenever the rosin bag must be held quite high above the plate to afford even distribution of the particles, the rain of dust should be shielded. Set a cardboard carton with the top and bottom cut out over the plate. After dusting, remove it slowly and carefully.

Hold the bag well above the plate and tap it with the forefinger or a pencil (Illus. 120). If the rain of dust tends to clot on the plate, hold the rosin bag higher. As you tap the bag, move it about over the plate, so that the entire surface becomes evenly covered with the powder. In laying a fine aquatint ground, a properly dusted plate looks thickly white all over, though close examination reveals metal between the grains.

When using the coarse rosin bag, a thinner sprinkling is desired and the sheen of metal is quite visible among the dust particles. If the grains are laid so closely together that they touch, they will melt together when heated and form a shield that is impervious to acid (Illus. 122, next page).

The rosin dusted on the plate must now be melted to make it stick (Illus. 121). Don't cough, sneeze, or breathe heavily over the plate as you lift it carefully by means of the paper and set it down without jarring on the heater. If this is a thermostatically-controlled electric griddle, it should be set in the range of 150–175 degrees. If you are using some other kind of heater, test for the correct temperature by dropping a few grains of rosin on the hot surface. The heat should be just such that the particles melt and remain on the surface as separate globules. If the grains liquify, flatten and run, the heat is too high.

Watch the plate carefully as it warms. As soon as the white, opaque dust *turns transparent* in any area, move the plate to expose a fresh section to this hotter part of the heater. When the rosin has turned transparent all over the plate, the operation is finished. Transfer the plate to the jigger at once and let it cool.

Illus. 120. Dust plate with rosin bag.

Illus. 121. Handle the aquatint plate by the paper underlay.

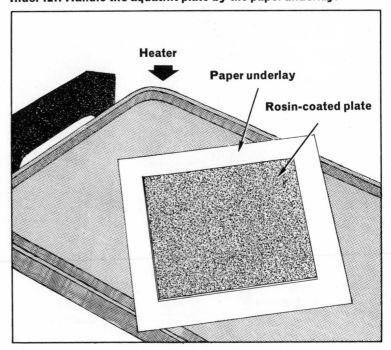

Heater

Paper underlay

Rosin-coated plate

Illus. 122. Diagram A shows the result of laying too heavy an aquatint ground. The grains fuse together when heated and form an acidproof shield. Diagram B shows too thin a ground. A good aquatint ground is something like Diagram C, with the grains separate, permitting the acid to bite between them.

Examination with a magnifier will disclose whether the operation was successful. If the rosin has run together to form a solid sheet of acid resist, wash it off with alcohol and try again with less heat. A proper job of grounding shows up as individual droplets solidified on the plate.

The Aquatint Box

If you prefer the ease of laying a perfectly distributed aquatint ground every time, you will enjoy using the aquatint box (Illus. 123–124). Make this of plywood to whatever dimensions will accommodate the largest plate you intend to dust with it.

Place a pound or so of crushed rosin in the trough-shaped bottom of the box and blow it up in the old-fashioned way with a bellows. Or use a vacuum cleaner, attaching the hose to the cleaner's exhaust port (where the air blows out) and make use of the powerful stream of air thus provided.

If a fine aquatint ground is desired, wait a few seconds after the rosin has been blown up in the air inside the box before putting the plate in. This will

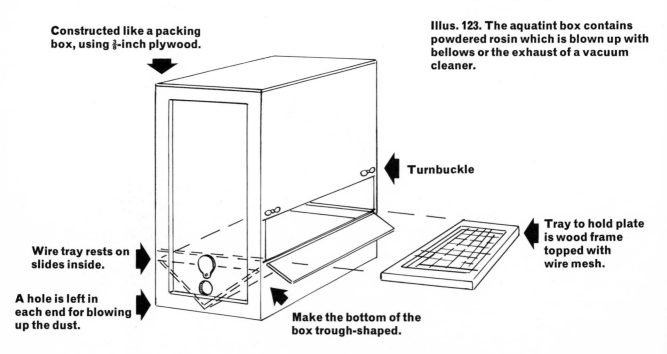

Constructed like a packing box, using ⅜-inch plywood.

Illus. 123. The aquatint box contains powdered rosin which is blown up with bellows or the exhaust of a vacuum cleaner.

Turnbuckle

Tray to hold plate is wood frame topped with wire mesh.

Wire tray rests on slides inside.

A hole is left in each end for blowing up the dust.

Make the bottom of the box trough-shaped.

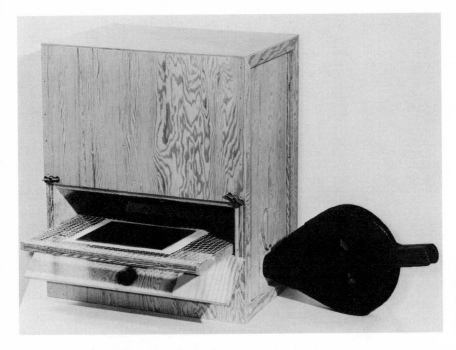

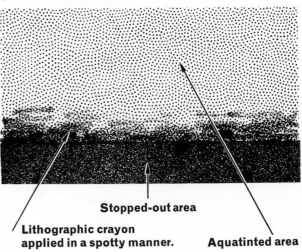

Illus. 124. An open aquatint box shows the plate resting on paper underlay. Vacuum-cleaner exhaust does better job than old-fashioned bellows shown.

give the coarse particles time to settle. The plate should be clean and ready on the wire shelf made to slide into the box.

If coarse particles are wanted in the ground, put the plate in immediately—or, blow up the dust while the plate is in the box. Allow a little time for the dust to settle on the plate; then withdraw the wire shelf and examine the results. If more dusting is needed, blow the rosin up again and return the plate to the box. This may be done as many times as needed, which may be several times if a fine ground is being laid.

The appearance of the ground may be altered by running a comb or a rounded point through the dust, making a pattern. The rosin is then melted and, in the etch, the acid bites the pattern into the plate.

Stopping Out Aquatint

Be careful in the use of stop-out varnish on aquatint as the alcohol in it dissolves rosin. If a mistake is made, the rosin will have to be cleaned off with alcohol and the ground relaid. Thickening the varnish with lampblack helps to control it.

The lightest tones are stopped out first, at whatever stage you wish to stop the etch. After a few more minutes in the bath, the plate is again removed and the areas of next-lightest tone are stopped out, and so on. Two or three stoppings-out should be enough. Study Goya's aquatints for simplicity in the use of this medium.

When a soft, hazy edge to the aquatinted area is desired, a fade-out may be produced with a litho-

graphic pencil or crayon (Illus. 204, page 125). The greasy crayon resists acid. It should be put on with considerable pressure to assure that it will stay put in the bath.

Use a No. 2 lithographic pencil (harder and softer grades may also be used) at the edge of the aquatinted area, where it is delineated by the *thoroughly dry* stop-out varnish. Lay the pencil grease on thickly at the very edge and work inward upon the aquatinted area, applying the pencil in a streaky, spotty fashion that finally wisps out to nothing (Illus. 125). Keep in mind that you are working in the negative—areas of black crayon on the plate will appear white in the print.

Illus. 125. Apply litho pencil to the edge of an aquatinted area to produce a fade-out. Diagram shows how the application looks on the plate. Blacks shown appear white in the print.

Stopped-out area

Lithographic crayon applied in a spotty manner.

Aquatinted area

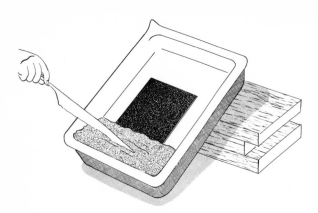

Illus. 126. The creeping bite is used to graduate a tone from one end of the plate to the other. Pour acid bath into tilted tray holding plate and change angle of tray according to areas to be etched. Keep acid stirred with a feather to soften the edge of the bite. See text.

Biting a Soft Edge on Aquatint

Another means of producing a fade-out of tone is to use the feathering method of biting. Pour the diluted acid into a puddle on the aquatinted area that is being treated (work at a sink while doing this). With water from an eye-dropper, promptly weaken the effect of the acid along the edge of the puddle, where you desire to produce a fade-out. Mingle the water and the acid in this area with a feather or a Chinese writing brush in such a manner that the aquatint ends up being less deeply bitten on the faded edge than elsewhere.

The Creeping Bite

To graduate a tone from dark to light from one side or end of the plate to the other, the "creeping bite" is used (Illus. 126).

Pour diluted acid into a tilted tray containing the plate until the bath just comes up to the boundary of the darkest tone. As the bite progresses, stir the acid with a feather or blow upon it so that the bath ripples back and forth at the edge, thus fading out the heavier tone produced where the plate remains completely immersed. The angle of the tray is then lowered a bit, allowing the acid to creep up farther on the plate. Continue the rippling until at last the plate is entirely immersed. Leave it so until the lightest tone has been etched.

Fading Out Aquatint with the Burnisher

It is sometimes possible, after the plate has been etched, to produce a fade-out of a tonal area by rubbing heavily along the edge with a burnisher. This flattens out the summits and closes in the open spaces, resulting in a lightening of the tone. Where this is not enough, the aquatint may be scraped down or removed altogether with the scraper. The area can be further reduced and the tone lightened by use of the Scotch stone and finer abrasives.

Etching the Aquatint Plate

For a normal aquatint ground on copper, 3:5 nitric acid may be used. On zinc, use a bath of one part acid to six parts water. For fine grounds, use greater dilutions or resort to the Dutch bath. Remember that nitric tends to widen the bite as it etches downward and at about the same rate. Therefore, it quickly begins to undercut the rosin particles before much depth has been gained. If your attention wanders, the bite could result in a *crevé*.

To get the best results to be provided by both acid baths, first etch the plate in the Dutch bath until the bite is well started. Then transfer the plate to the nitric bath. This results in a rapid increase in depth without much further widening at the surface.

For very fine aquatint, the use of iron perchloride may be of advantage in spite of having to bite the plate face downward in the bath.

The Underbitten Aquatint

If a grey tone results where you intended an area to be black, the aquatint is underbitten. In this case, it is possible to resume biting after regrounding with a hard ground as described in Chapter 8.

The roller (well-oiled at the bearings) must be run very lightly on the plate and a very thin ground laid to avoid squeezing it down into the etched pits. While the plate is in the bath, keep a sharp eye out for "lifting" of the ground. If the ground begins to flake off, stop the etch, clean the plate and lay another rebiting ground. This may be done as many times as necessary, until the plate has been etched to the desired depth.

If in your first aquatinting, too fine a ground was laid, resulting in too light a tone, the plate may be cleaned and a second aquatint ground laid over the first. This may not, however, always be successful.

Correcting Aquatint

If the printed aquatint shows occasional white spots that mar the evenness of the tone, these may be obliterated by picking at the causative areas on the plate with the point of a burin or the scraper (Illus. 127). Even when large, such areas can be picked

and furrowed and so broken up as to blend with the surrounding tone.

Sandpaper Aquatint

A reverse aquatint, in which the dots are bitten into the plate, may be produced with a hard ground and sandpaper. Lay a piece of fine sandpaper on the grounded plate, cover it with a sheet of cardboard and run it through the press with only the $\frac{1}{8}$-inch thick blanket. Run it through several times, shifting the sandpaper a little each time to strengthen the tone. The plate is then stopped out and etched in the same manner as regular aquatint.

Salt Aquatint

A tonality similar to sandpaper aquatint can be produced by sprinkling a hard ground, while it is melted, with table salt. The salt grains sink through the fluid ground into contact with the plate. When the ground is cool and hardened, immerse the plate in lukewarm water and dissolve the salt out by gentle rubbing.

Lift-Ground Aquatint

Instead of delineating a form by stopping out around it, you can draw directly on the plate in aquatint, producing lines, spots and tonal areas at will, all having the character of the pen or brush with which they are put down. This is possible by means of the lift-ground technique, which will now be described.

The Lift-Ground Solution

To make the drawing on the plate, a special solution is used. Make a saturated solution of sugar in water (stir sugar into a small amount of water until the water will dissolve no more sugar). Mix a spoonful of the sugar solution with an equal quantity of India ink. Add a few drops of a wetting agent, such as liquid soap, Tincture of Green Soap, Kodak Photo-Flo, or Non Crawl Color Medium. This smooths the consistency and reduces the surface tension so that the tendency of the medium to crawl on the slick surface of the plate is eliminated.

Another lift solution is composed of equal parts of tempera color and liquid gum arabic, plus a few drops of wetting agent. Also, Prussian Blue water-color may be used as a lift solution as it comes from the tube. If it tends to crawl on the plate, add a wetting agent.

Draw the design directly on the thoroughly cleaned plate, using round, sable watercolor brushes and/or pens of varying degrees of fineness. Let the work dry. The sugar solution will not dry hard, but will remain sticky.

Grounding the Plate

If a ground were to be rolled or dabbed over the lift drawing, it would certainly cause damage; so, for safety's sake, use a hard ground in liquid form.

Sluice liquid ground over the plate as described in Chapter 1, then lean the plate face in against the wall to dry.

Illus. 127. Spots that print white where not desired in aquatinted plate may be reduced by picking with a lozenge-shaped burin or the point of the scraper.

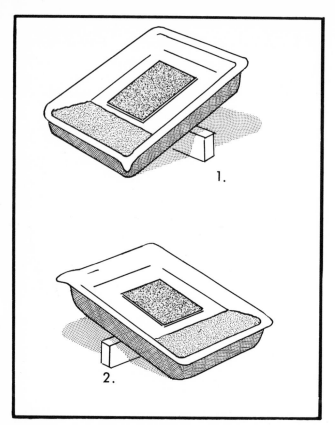

Illus. 128. The diagrams illustrate the tip-tray method of flooding a plate with liquid or spirit ground. (1) The tilted tray with plate in bottom is filled almost to plate with solution. (2) The tray is tipped in the opposite direction, sluicing the plate with the fluid.

If the ground looks streaky or thin in spots when dry, warm the plate on the heater to make it run slightly and smooth itself out. The ground does not have to be smoked.

Before putting the plate into the lift bath, check the ground for dust spots, scratches and pinholes. Close these with liquid ground on a brush.

The Lift Bath

The lift bath is a tray of lukewarm water in which the plate is soaked for half an hour. Owing to the sticky nature of the lift solution, the ground covering it does not actually harden. Water seeps through the ground and soaks the drawing, causing it to swell and break up the overlying ground. The lifting process may be helped along by gentle rubbing with the fingertips.

Laying an Aquatint Ground in the Lift Areas

Dry the plate carefully, using a hair-drier or fan; then dust it with aquatint powder. Afterward, heat the plate to fix the rosin ground. Thin lines do not require aquatinting; only broad lines and areas that would otherwise etch out as *crevés*. If you fear that the asphaltum-wax ground may melt and flow into the areas to be aquatinted, you may avoid the possibility by heating an aquatint ground first, over the entire plate. Then make your drawing with a brush and the lift solution directly on the cooled rosin. When dry, sluice the plate with liquid ground, which will be "lifted" from the aquatinted areas to be etched while the plate is in the lift bath.

Spirit Ground

Floating a spirit ground on the plate is an alternative method of applying a rosin aquatint ground which may be used to advantage in grounding lift areas, as it is not necessary to heat the plate in its use.

Make the ground solution by dissolving 5 ounces of crushed rosin in 15 ounces of denatured alcohol (shellac thinner). Allow to settle for a day or two; then decant the clear solution into a clean bottle.

To one part of this solution, add two parts of alcohol for a coarse texture aquatint. Add three parts of alcohol for a fine texture aquatint.

The solution may be flowed over the plate in the same way as liquid ground, or the tip-tray method (Illus. 128) may be used. Since the rosin will stick to the plate as a stop-out varnish does when dry, it is not necessary to heat the plate. However, where the spirit ground is used alone (not in conjunction with the lift-ground method), the plate may be heated to speed drying. Heat also has an influence on the formation of the resulting pattern.

Pick-Up Grounds

First, half-fill a tray with plain water and sprinkle drops of liquid asphaltum, liquid ground, rosin dissolved in alcohol, or shellac stop-out varnish on the aqueous surface. Stir the material about until a marbleized pattern results.

Apply a suction cup to the back of the thoroughly cleaned plate for easy handling (Illus. 129) and hold it face down over the tray. Touch the plate lightly to the surface, then quickly lift it up and put it aside to dry. Remove the suction cup, stop out the areas you do not want to print, and etch the plate.

Deep Etch

This is a method of deliberately producing a *crevé*—ordinarily the bane of the etcher—in order to make use of its distinctive printing qualities.

The plate is stopped out all over with asphaltum varnish except in those broad areas intended to be

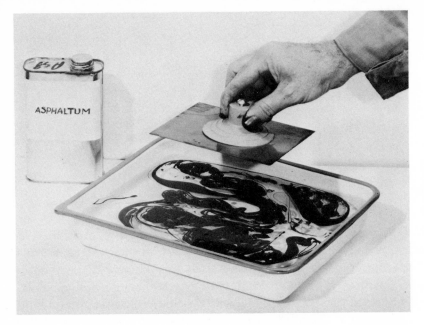

Illus. 129. To lay a marbled-tone ground on a plate, float asphaltum on a water bath, stir to form a pattern. Hold plate by suction cup on back; touch face lightly to asphaltum. Let dry and etch.

etched. Since the areas to be etched are broad, open areas, the process is also called "open bite."

After biting to a shallow depth, stop out parts of the etched areas. (Instead of painting out partial areas, you may spatter or spray stop-out or asphaltum varnish over the etched places.) Repeat the bite. The operation may be performed three or four times or more to produce the desired printing effect.

Deep etch results in broad, irregular cavities or recessive areas in the plate. In the wiping procedure, the ink piles up around the edges and prints black outlines, thus delineating the shelves and ledges left by the various bites.

Further modification can be made by working the bottoms of the *crevés*, which ordinarily print as a grey tone, with roulette, dry point, scraper point, mezzotint rocker, etc., to deepen or modulate the greys and to intersperse them with areas that print black.

When inked for either intaglio or relief printing, or for a combination of both—inking either with color or with black and tones of grey—the resulting pattern can be very interesting.

Open bite may also be carried on until the acid bites completely through the plate, leaving a hole. Such a hole can be made more quickly and easily, however, with a jigsaw. In any case, the edges of such openings must be bevelled to protect the paper and the blankets. The hole in the plate results in an embossment in the paper that is absolutely white—having no plate tone—and which seems to "pop out" at the viewer.

Cut-Outs

Free-form shapes, animal outlines, profiles, etc., can be jigsawed from the plate, or etched out by open bite. Such cut-outs can then be grounded and needled with whatever details are desired, and etched. Several separate cut-outs may be printed simultaneously—a figure with a dog following, a row of gourds, etc.

To place the cut-outs in the same relationship to each other during each printing, an underlay is prepared with the various shapes marked upon it. As the cut-outs are inked and wiped, they are placed upon a sheet of thin tissue covering the diagram, which is visible through it. The plates are then covered with damp paper and printed. After printing, the tissue is discarded, leaving the diagram clean. Each shape, as an individual plate, impresses its own plate mark into the paper, and each must therefore have its edges bevelled.

Illus. 130. Exaggerated cross-section of a deep-etched plate. Relief surfaces are first stopped out, then the first deep etch is bitten—perhaps 1/64-inch deep. A second stopping out may leave exposed some of the bottoms of the first deep etch before the plate is re-bitten.

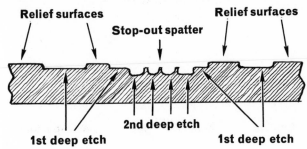

Relief surfaces Stop-out spatter Relief surfaces

1st deep etch 2nd deep etch 1st deep etch

11. ENGRAVING

The earliest method of creating an intaglio printing plate was to engrave it by hand with an engraving tool. Although etching replaced engraving because of its greater ease and speed, it could never achieve the distinguished line of the burin, the line carved directly by the artist into the stubborn face of the plate.

The Burin

Also called an engraving tool or graver, the burin (Illus. 131) comes in many sizes and shapes and is used for a variety of purposes in making intaglio plates.

The square-shank burin comes in different sizes and is used to cut lines of differing widths and depths. The lozenge-shaped burin (Illus. 131) is useful for picking at the surface to produce textures of a dotted or a dashed-line effect. The tint tool is used to produce tonal areas by making many fine lines side by side. Also, because of its shape, the tint tool is particularly good for engraving curved lines and is preferred for that use. The multiliner, or multiple lining tool, is made to engrave as few as two lines or as many as six lines at once, depending on the individual tool, for producing shading effects. The multiliner may be bought in many styles, both as to the number of lines that may be engraved at once and as to the separation between the lines (number of lines to the inch). Over-use of this tool, however, generally results in a mechanical look.

The scorper (a jeweler's chisel) has a round bottom for cutting trenches and scooping out hollows. Flats are used to clean and flatten the bottoms of such hollows. Neither tool has much application in printmaking, though the flat may be "waggled" or "walked" on the plate for an interesting effect.

The square-shank burin in numbered sizes 6, 10 and 12 are sufficient for the beginner. If only one size is chosen, the number 10 is most suitable.

Illus. 131. Burins and cross-section of shank as described in the text.

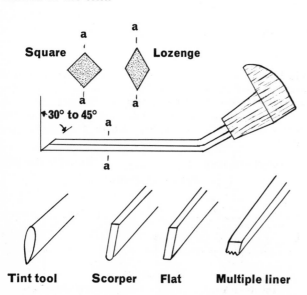

Illus. 132. Sharpen the two bottom faces of the burin on an India stone.

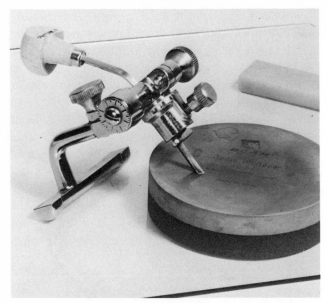

Illus. 133. A glass plate under the India stone and jig (holding device) assures accuracy in sharpening the point of the burin. Use machine oil on the stone and grind with firm, even pressure.

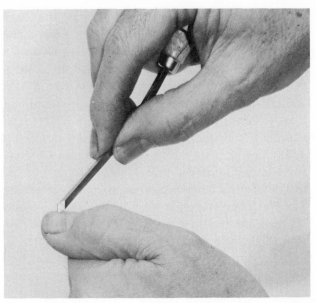

Illus. 134. Test the honed burin before using it. When touched to the thumbnail without pressure and then gently pushed, a sharp point sticks. If the point slips, it is dull.

If the shank of the lozenge-shaped burin were cut straight across, it would show a cross-section that is not square but a parallelogram in the shape of a diamond or lozenge. One such burin, a number 8 or a number 10, may be added if desired.

Sharpening the Burin

A burin has a square shank of steel, the end of which is ground, at an angle, to a diamond shape. The angle of the point may be anywhere from 30° to 45°, preferably closer to 45°. A point more acute than 30° is fine for wood engraving, but it may break off in metal. The newly-purchased burin must be sharpened before it is ready for use.

When used on the plate, the burin is held so that the flattened side of the wooden handle faces downward. The two bottom faces of the shank, forming a "V," are sharpened on an India stone to a precise right angle (Illus. 132). (There is no reason to sharpen the upper faces.) Sharpen both faces with an equal number of equal-length strokes while holding the shank flat against the stone. When the bottom edge (the angle of the "V" formed by the two bottom faces) is sharp, no line of light will be seen along it, such as would be visible if the edge were turned. The shank is honed in the same way on a white Arkansas stone.

To sharpen the point, the burin must be stood on end, the angled face flat on the stone. This can be done if the wrist is held rigid, but to grind the face absolutely flat requires considerable skill. Several holding devices, which make this difficult task simple, are available. One such device is shown in Illus. 133. Illus. 134 shows how to test the point against the thumbnail.

Using the Burin

The beginning etcher's main use for the burin will be as a corrective tool, for deepening and/or widening etched lines, for strengthening underbitten lines, and for adding lines or tonal areas where needed.

Generally, engraved corrections on the plate will blend in with the etched lines. If they do not, and if they markedly interfere with the unity of the print, the plate may be regrounded, leaving the engraved lines open. They are then lightly etched to alter their character.

To use the burin, hold it in your hand with the handle snuggled into the middle of your palm. The shank is gripped between the thumb and the second finger, while the index finger assumes a position on top of the shank close to the tip and provides the pressure required. The third and fourth fingers are curled out of the way under the handle and help to secure it in place. If you cannot grip the tool in exactly this manner, just hold it as it seems comfortable to you and in such a manner that you can make it obey your will.

When working with the burin, assume a com-

fortable position, sitting sideways to the table (Illus. 135). The work table should be several inches lower than an ordinary one. At a table of normal height (29 inches), sit on a 24-inch stool to make up the difference. Professional engravers use a solid leather pad to rest the plate on for easy manipulation. A large, soft, artificial sponge, however, is an excellent and more economical substitute (Illus. 135). A small plate can be worked just as easily on a smooth, hard-surfaced table top.

The burin is never turned or twisted to go around a curve. The plate must be turned against the point. At the same time, the burin is tilted ever so slightly toward the outside of the curve.

A diffusing screen and Polaroid glasses are both helpful in cutting down glare on the plate. Or, the surface of the plate may be dulled by brief immersion in very weak acid, by scrubbing with pumice, or by rubbing over it with a wad of window putty or plastic modelling clay.

The higher the angle of attack at which the burin is held, the deeper the point will penetrate and the wider the resulting line will be. To start a line, the tool is held at a very low angle. As the point begins to cut, the hand is slowly raised, causing the line to expand to the desired width. As the end of the line is approached, the hand is slowly dropped, depressing the angle of the tool until the point emerges from the metal, leaving a tapered end to the line. Where the line ends in an existing cross-line, the hand is raised a little just at the point of contact to prevent the burin from over-running the line.

The metal cut from the plate is turned up in front of the burin point in the form of a little curl. Where the line comes to a tapered end, the burin automatically cuts off this curl as the point lifts itself out of the metal. Where the line is stopped abruptly, the curl remains firmly anchored and must be cut away with the scraper (Illus. 136 and 137). Do not try to brush it away with your fingers; it is sharp enough to cut.

Before the plate is printed, lightly polish all engraved lines with 4/0 emery paper to remove any burr that may exist along the edges of the cuts.

Drawing on the Plate

You can draw directly on polished copper with a litho pencil. Then etch the plate about 5 minutes in a bath of one part nitric acid to six parts water to dull the exposed copper surface. Clean off the drawing with turpentine and the bright trace of polished copper on the dull surface will be easily

Illus. 135. A large, artificial sponge under the plate allows the engraver to have full control of the plate with one hand while he holds the burin in the other. To cut a curved line, tilt the burin slightly toward the outside of the curve while turning the plate against the point. On the table are various-size burins, a scraper, burnishers, a linen tester for checking the work, and a large magnifier.

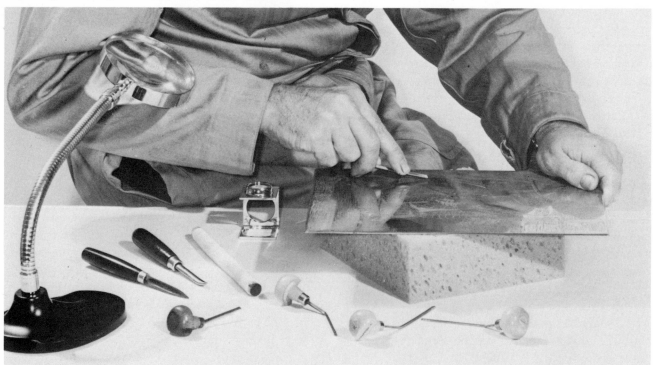

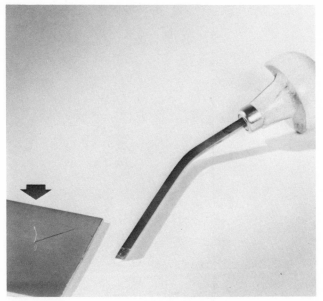

Illus. 136. As the burin cuts through the plate, it turns up a burr or curl of metal ahead of it.

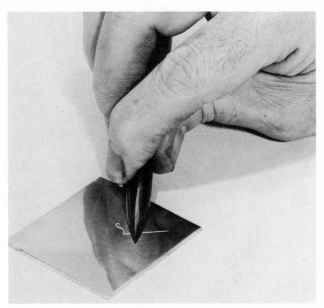

Illus. 137. The burr is sharp and well-anchored. Cut it away at work intervals with the scraper.

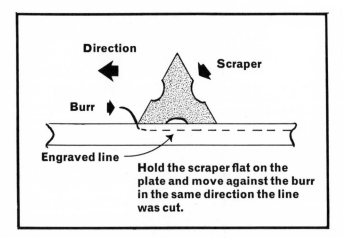

Illus. 138. Cutting off the burr.

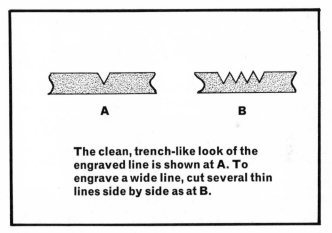

Illus. 139. Diagram of the engraved line.

seen. Or, the litho-pencil lines may be gone over lightly with a dry point (see Chapter 12). When the plate is cleaned, the scratches remain as a guide.

Zinc has enough tooth to retain graphite and may be drawn on with a lead pencil.

If a drawing is to be traced onto a plate, the metal is first coated with gum arabic and the tracing is made through carbon paper. To accept the gum, the plate must be cleaned thoroughly with ammonia and whiting. The dried gum will flake off a dirty plate. Use a 20 per cent solution (1 ounce of gum arabic powder dissolved in 5 ounces of water). Rinse the cleaned plate but do not dry it. Shake off the excess water and immediately brush on the gum

arabic solution, which will spread evenly over the plate without crawling if the metal is clean.

When dry, the gum will take either direct pencil marks or a tracing made through carbon paper. Trace with a sharp, hard (4H) pencil and bear down with considerable pressure.

Go over the drawing or the traced lines *lightly* with a dry point needle; then wash off the dried gum arabic before engraving.

The edges of the plate may be bevelled and polished either before or after engraving and the plate is inked and printed in the same way as an etched plate.

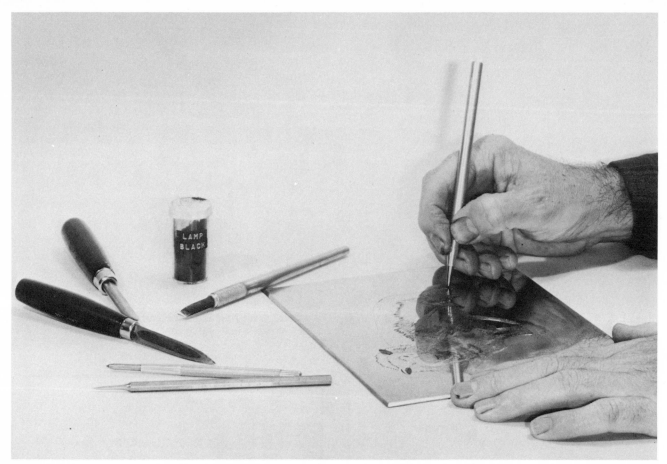

Illus. 140. The dry point (diamond in use) is held easily and applied firmly to the plate. As work progresses, rub lampblack into the lines to make them more visible on the plate. View in mirror.

12. DRY POINT

The effect of the dry point needle differs from that of the engraving tool in that the burin *cuts* a furrow through the metal, whereas the dry point simply scratches the line. Also, the metal removed from an engraved cut is scraped away, but the dry point leaves a burr turned up all the way along each line and this is left in place to hold the printing ink.

The term dry point possibly derives from the fact that the plate is worked dry, without the use of acid. The dry point print must never be improperly called an etching, or a "dry point etching" as some say, as no etching with acid is involved.

Rembrandt made wide use of the dry point needle to lend richness to his prints and as a corrective medium in reworking his plates.

Many artists specialize in dry point, as it elimi-

nates what to some may be the obnoxious chemical aspects of etching as well as the array of tools needed for engraving. Only the plate itself and a dry point needle are required.

Dry Point Needles

Three types of points are in common usage: (1) steel, (2) cemented tungsten carbide, and (3) diamond. The steel point may be a heavy darning needle, a machinist's scriber, or one of the several designs available from dealers in etching supplies. Some scribers have steel points that may be removed, chucked in an electric drill, and resharpened (Illus. 141). Use oil on the stone and hold the drill at a steady angle so as to sharpen to a tapering point.

The cemented carbide point also comes in the form of a scriber. It is harder and more durable than steel and renders a stronger-printing line. After much use, the point is bound to become dull and the instrument should be replaced, since resharpening is a difficult procedure. The low cost of the carbide scriber makes replacement practical.

With the same pressure and effort used to scratch the plate with a steel point, the tungsten carbide tip cuts a deeper, heavier furrow. By the same token, the line made with a diamond is even stronger, all else being equal. Among dry point artists, a diamond is the preferred point, though a good one is expensive. The diamond must be ground to a conical point, without facets (Illus. 142), and mounted in an inflexible handle. A flexible handle destroys control, and if such a handle comes into your possession, unscrew the diamond mounting from the tip and have a new handle made at a machine shop from a length of aluminium rod.

The conical point can be manipulated with equal ease in every direction on the plate. A point made from an unground diamond chip is less expensive, but it will scratch more easily when held one way than when turned another. This results in jerky, uneven control and poor drawing.

The diamond must be treated with care to prevent chipping and ruining it. As an inadvertent stroke over the edge of the plate might fracture the diamond, the plate should be bevelled before working on it with the point, particularly if any lines are to be scribed close to the edges.

An excellent dry point may be made from a dental

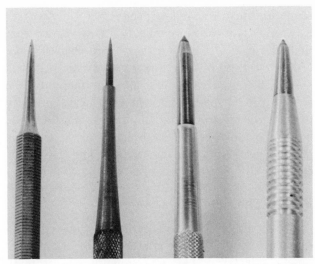

Illus. 142. Left to right: Dental tool pointed in lathe; scriber, replaceable steel point; scriber, cemented carbide point; diamond, conically ground.

tool (Illus. 142), as the steel is an extremely hard, long-wearing alloy. The scraper end of the tool is broken off and the tip sharpened to a true point while revolving in a lathe or drill chuck. Hold an oilstone against the revolving end and bring it to a tapering point.

Using the Dry Point

The dry point is generally held at a comfortable angle similar to using a pencil (Illus. 140). The point is applied to the plate with a firm, even pressure. However, the angle at which the point is held has a great deal to do with the character and printing strength of the line. (See Illus. 143, page 87.)

The finest lines are made by holding the point vertically, at an angle of 90° to the plate (Illus. 143). As the diagram shows, this position throws up a double burr, one at each side of the scratch. The burr, however, is so negligible and the scratch so fine, that all three print together in a single line.

The scratch made by the point holds only a small part of the printing ink. The real strength of the dry point line is the result of ink trapped under the burr. Since the needle at a vertical angle makes only a slight burr, the printed line is weak.

As the point is tilted away from the vertical and back toward the hand, the line grows progressively stronger, both because the point digs in more deeply and because a heavier burr is thrown up on that side of the point which is opposite the hand. At an angle of 60°, the normal angle of holding a drawing pencil, the effect is at its best. As the angle is made flatter, the burr grows larger and heavier. The

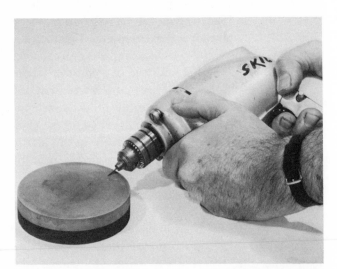

Illus. 141. The steel dry point needle may be chucked in a drill for sharpening to a simple, tapering point. Use an India stone with oil; finish on a hard Arkansas stone with oil.

larger and heavier the burr, the structurally weaker it becomes and the more quickly it wears away from the plate in printing. At an angle less than 30°, the resulting ragged burr becomes too weak for printing.

An effect something like an engraving may be achieved if the plate is drawn with heavy pressure to make the lines as broad and deep as possible. The burrs are then scraped completely away and the plate is printed as an engraving. The dry point character is completely eliminated.

The Dremel Electric Engraver

This machine has a vibrating carbide point (a diamond point is also available) and a dial control on the side (Illus. 144) for regulating the strength of the stroke. The point works more like a dry point than an engraver, throwing up a heavy burr that is in many respects similar to that created by the mezzotint rocker. The engraver is held and used like a drawing pencil, producing every type of line from fine to coarse without the effort required when using a dry point.

Working the Dry Point Plate

Either copper or zinc may be used. Copper is generally considered easier to work with and the burr stands up better in printing; but good dry points can also be pulled from a zinc plate. Zinc seems to have a grain, so that the point moves more easily in one direction than in the direction crosswise to it. This drawback is not noticeable when using the electric engraver, however.

Beautiful prints may also be produced from long-wearing steel plates, which are easily worked with the electric engraver. Heavy steel plate is not required. A thin steel plate (28 gauge, for instance) may be cemented with Duco cement to a piece of ordinary mat board. The mat board is cut $\frac{1}{4}$ inch less in length and breadth than the plate and cemented to the metal so that the latter overhangs it by $\frac{1}{8}$ inch all around. Before working the plate, run it face up through the press, with all the blankets in place. The pressure will bend the overhanging metal down all around the mat board, creating bevelled edges without effort. Such plates may be heated for inking as usual, but use care to keep ink from getting on the cardboard backing and under the bevel. The cardboard may be shellacked to protect it.

A method of transferring a drawing to the dry point plate is described in the chapter on engraving. Another way, however, is to cover the back of the drawing with litho crayon, then trace the drawing

on to the plate. The black grease sets off on the metal. The drawing may then be lightly scratched in and the litho-crayon lines turpentined away.

Or, you may lay a thin, hard ground on the plate and smoke it. You need not worry about making the ground acid-proof. Attach a pencilled guide drawing face down to the plate and transfer the drawing to the smoked ground as explained in Chapter 2. Scratch in the drawing lightly with the dry point so that it will remain as a visible guide after the ground is turpentined away.

Again, you may rub the plate with a stub of candle or a white wax crayon. (Colored crayon may be used but the drawing shows up better on white.) Trace the reversed drawing directly without carbon or other transfer paper. When the paper is stripped away from the plate, it will take with it the pressure-adhered wax and the drawing is visible in shining traces on a dull field. Lightly scratch in the design and turpentine away the wax. The visibility of the scratched-in design may be enhanced by rubbing dry lampblack powder into the scratches.

It is possible to draw directly with pencil on the rubbed surface of photo-engraving zinc (as well as on steel).

The plate may be drawn with a diamond, carbide or steel point; or all three points may be used for the difference in rendering afforded. Where blacks are to be created, the steel point will do as well as the diamond and should be used, to avoid the possibility of chipping the diamond with such work.

Dry Point on Plastic

Dry points, as well as engravings, may be made on plastic plates. If a drawing or photograph is to be followed, it is placed under the plate. The latter is transparent and quite thin, making it easy to go over the lines of the original with the dry point or burin.

Since the plastic plate may not be heated, the printing ink is reduced to a more fluid consistency than usual with raw linseed oil. Pressure on the press is kept to an absolute minimum. Even so, the plastic plate wears quickly and not many proofs may be pulled.

Printing the Dry Point

Not more than 2 or 3 dozen prints are to be expected from a copper plate; perhaps a few less from zinc. But, where many prints are wanted, the copper plate may be steel-faced (an electrolytic deposit of steel is applied to the face of the plate to provide a hard, long-wearing surface). At the first

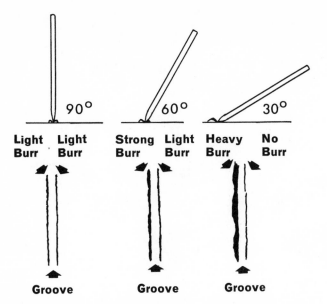

Illus. 143. The dry point line changes character as the angle of the point alters.

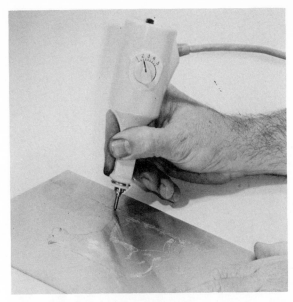

Illus. 144. An electric engraver is easy to use, has a character that is distinctly its own.

sign of wear (when the copper begins to show through the steel), the steel facing is removed and replaced with a fresh deposit. This can be repeated indefinitely.

Since zinc must first be copperplated before steel facing, a double thickness of metal results. This is said to affect the printing quality of the plate.

Etched or engraved copper plates may also be steel-faced for large production runs beyond the usual yield of 100 to 200 prints.

There is little demand for steel facing, hence you are likely to have difficulty finding such a service. However, it would pay the serious etcher who uses long printing runs to investigate chrome plating, which is available in any city. It is common practice to chrome-plate commercial printing plates and rotogravure rolls and it doubtless would serve just as well on intaglio plates.

For the beginner, plating is too expensive to be worthwhile, so your main concern will be to get as many prints as possible from an untreated plate. To do this, some essential changes in the normal routine of inking and printing must be made in order to preserve the fragile burr of the lines.

Use regular etching ink but render it more fluid by the addition of extra raw linseed oil or wiping compound. Do not use a dabber, which might crush the fragile burr. Apply the ink carefully with a wad of soft cloth. Also use a soft cloth instead of tarlatan for wiping and take care not to drag the ink out from under the burr. Finish with the chalked hand

wipe. Work around the lines rather than over them; use mostly your thumb and fingers.

Print on a thick, soft paper such as Hosho, Vacar, etc., and relieve the pressure in the press by turning up both adjusting screws by equal amounts. An over-reduction of pressure results in prints that are too pale, so don't ease off too much. If the screws have been marked for their normal position, the press can be quickly returned to its original adjustment after the printing session.

Each print, as the burrs on the plate wear away, will be slightly lower in quality than the preceding one. Printing is stopped when the quality becomes too degraded.

Correcting an Etched Plate with Dry Point

It is not always possible to do this, because of the difference in the quality of the lines. The dry point line does not look like the etched line. However, areas of heavy black shading and individual fine lines both fit well into an etched plate, and such additions are easy to make. Blacks are created by close-hatching or cross-hatching, and fine lines are made by scraping away the dry point burr.

Correcting the Dry Point Plate

It is sometimes possible to burnish away a very lightly scratched line. If this does not work, the line (or lines) must be scraped out of the plate. Follow scraping with the other procedures necessary to regain a polish (Chapter 8).

Illus. 145. This photograph shows the method of setting up and using the rocking-pole device for mezzotint. The aluminium trough serves as a guide for the pole. As the rocker blade is rocked back and forth, it automatically creeps forward, along the "way" marked on the plate with the chalk and roughens the surface. The "way" in use is lined up with the trough, which is clamped to the table edge. The plate is held in place by thumbtacks around the edges.

Illus. 146. The mezzotint rocker (right) is a chisel-like tool with teeth on its curved edge, which leaves imprints on the plate.

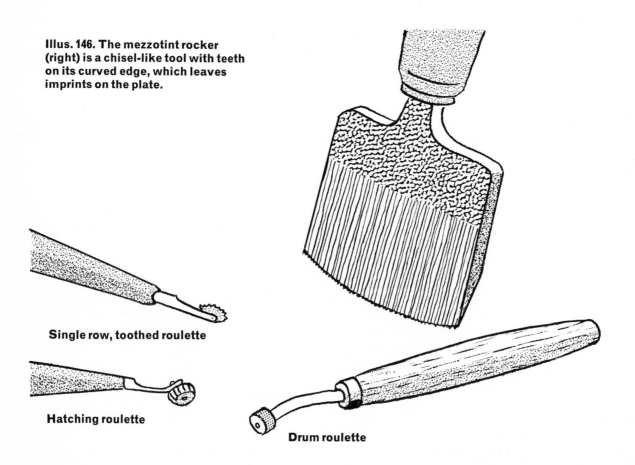

Single row, toothed roulette

Hatching roulette

Drum roulette

13. MEZZOTINT AND METAL GRAPHIC

The technique of mezzotint was invented by a German named Ludwig von Siegen, who produced the first plate in Amsterdam in 1642. Rembrandt was then living in Amsterdam and was at the height of his career. Although Amsterdam had a population of about 200,000, it is most likely that Rembrandt was acquainted with von Siegen and his work, because all artists in the city had to belong to the guild in order to practice their art. Rembrandt did not involve himself with the new technique, however, preferring his own "dark manner" of working and reworking the plate with cross-hatching in a hard ground (see Chapter 2).

In 1645, while visiting in Amsterdam, Prince Rupert, the English admiral, became interested in mezzotint and took the technique back to England with him. It became an overnight sensation and was called "the English manner," finding practical application as a means of reproducing paintings in black and white.

Mezzotint remained a reproductive medium until the latter part of the 19th century, when it was superseded by photo-engraving. The practice went out of style and has been struggling for survival ever since.

The "black manner," as mezzotint came to be called, received the appellation from the fact that the plate is first given a rough surface that prints totally black. A tool called the mezzotint rocker, or cradle, is used to roughen the surface in a particular way. The artist then works with scrapers and burnishers to draw lights and half tones out of the darkness, reproducing the most delicate nuances of shading.

The Mezzotint Rocker

This is a tool shaped like a large chisel. The bevelled edge of the blade is curved instead of flat (Illus. 145–146). On the unbevelled flat side of the blade, parallel lines are engraved, terminating at the curved edge in tiny teeth. In the heyday of mezzotint, rockers were available with as few as 50 teeth to the inch and as many as 100 or so. Nowadays, the 80-teeth-per-inch rocker is generally available, and this produces a good, rich quality of black. The rocker blade in general use is 2½ inches wide; 1-inch and ½-inch widths are also available. These are used for local rocking and repair work on the plate.

The Rocking Action

When the rocker is held upright and its curved edge is rocked back and forth on the plate, the many teeth leave a line of pits which print as closely-spaced dots. Each pit has a burr thrown up around it. Ink is retained both in the pit and under the surrounding burr, in a manner typical of dry point. The soft, velvety black which is characteristic of mezzotint cannot be produced by any other means.

The Roulette

The roulette is so called because it has a small wheel on the end, which is rolled on the plate to roughen it and produce a printing tone. Roulettes are available in different sizes and patterns. Illus. 146 shows the barrel roulette, which applies a close-spaced stipple to the plate. The others are mimeograph roulettes made for working on stencils, but they are also suitable for use on zinc and copper plates and are available at stationery stores that handle mimeo supplies.

The single-row or line roulette possesses a single row of teeth. When run across the ungrounded plate with some pressure applied to it, it produces a row of dots somewhat similar to those made by the mezzotint rocker. In addition, the larger, irregular-cut, French roulette is also available.

Keep the bearing of the roulette oiled and before working, apply a light film of oil to the plate.

Roulettes are generally used for repair work on overscraped or overburnished plates where vanished printing tone must be returned. They may also be used by themselves to produce tone in small areas, particularly on etched, engraved or dry-point plates. The mezzotint rocker may also be used in a local way.

Rocking the Plate

The first step is to etch the design into the plate. The etched lines not only are visible through the burr thrown up by the rocker, but also make it

Illus. 147. Diagram of the eight directions in which to rock a mezzotint plate. In each step, the plate is shown with the same side at the top. The ways are marked in with chalk and the entire plate is rocked before the ways in the next direction are marked.

A. Mark the ways (dashed lines) 1½-inches wide, parallel to the length of the plate (arrow).

B. Mark ways parallel to the width of the plate (arrow).

C. Mark ways parallel to one diagonal of the plate.

D. Mark ways parallel to the other diagonal.

E. Divide the length of the plate into fourths (arrows). Draw a line from the first quarter-point through the middle of plate and mark ways parallel to it.

F. Draw a line from the opposite quarter-point through the middle of the plate and mark ways parallel to it.

G. Take a point at one-quarter the length of the width. Draw a line from that point through the middle of the plate and mark ways parallel to it.

H. Draw a line from the opposite quarter-point through the middle of plate and mark ways parallel to it.

possible to avoid extra work by rocking only those areas where blacks and greys are wanted.

To rock a plate while holding the rocker free-hand requires more skill than the average printmaker has time to develop. The rocking-pole device (Illus. 145 and 148) assures thorough and proper rocking of the plate, without any particular skill on the part of the operator being necessary. Even with the rocking device, however, rocking a plate of any size takes an extraordinarily long time, and the would-be mezzotinter should be psychologically prepared to spend long sessions leaning on the rocking pole.

The plate shown in Illus. 147 measures 5 × 5½ inches and took the author about 1½ hours to rock in an eight-direction pattern. With experience and perseverance, you may be able to shave some time from this example, but using the mezzotint rocker is not for anyone in a hurry.

To use the device, one end of the guide-trough is clamped to the edge of the table (Illus. 145). The other end is supported on tubular aluminium legs.

Clamp a piece of plywood to the top of the table to protect it.

Illus. 147 diagrams the eight steps involved in a complete rocking of the plate. For the first step, rule the plate with chalk lines about 1½ inches apart and parallel to its length. The alleys between the chalk lines are called "ways" (indicated by dashed lines in Illus. 147), along which the rocker moves as it rocks one way at a time. The ways are ruled narrower than the width of the rocker for easier rocking and to keep the ends of the tool from digging into the plate.

Line up the first way at one side of the plate with the guide trough and pin the plate to the plywood with thumbtacks around the edges. Set the mezzotint rocker on its pole into position at the start of the way.

Because the pole holds the rocker at a slight angle to the surface of the plate, as the device is rocked, the toothed edge creeps forward along the way, laying lines of dots neatly beside one another.

When the first way has been rocked its entire

length, the plate is moved over to line up the neighboring way with the trough and the procedure is repeated. When all the lengthwise ways have been rocked, chalk new ways across the short dimension of the plate (Illus. 147B) and rock the entire plate again, one way at a time.

Next, mark chalk lines that are parallel to one diagonal of the plate and rock over the entire plate again (Illus. 147C). Following this, mark ways parallel to the other diagonal, as at Illus. 147D, and rock.

To continue the rocking, the angles between previous rockings must now be split. Divide the length of the plate into quarters. (The arrows on the diagram divide the line into fourths.) Locate a point one-quarter of the way from one corner. As shown in Illus. 147E, draw a chalk line from this point, through the middle of the plate, to the opposite side of the plate. Mark ways parallel to this line and rock the entire plate.

Next, choose the quarter-point at the opposite end of the same side and draw a chalk line through the center to the other side of the plate (Illus. 147F).

Note that this line crosses the ways that have just been rocked. Mark ways parallel to the line just drawn. Rock over the entire plate.

In the same manner, rock the plate once more lengthwise. This time take a quarter-point of one of the short sides (Illus. 147G), mark ways parallel to the line drawn through the middle of the plate, and rock them one after another.

The quarter-point at the opposite end of the same side is then taken and a chalk line is drawn from it, through the middle of the plate, to the opposite side (Illus. 147H). This final rocking over the entire plate completes the job.

Working the Plate

Following some kind of a guide, either the pre-etched design as mentioned earlier, or a sketch drawn lightly on the burr with a litho pencil, the mezzotinter uses a variety of burnishers and scrapers in working up the plate. Burnishers applied to the burr can flatten it to a greater or lesser degree and bring out grey tones, heavy or light as needed. The lightest tones are arrived at by scraping away the

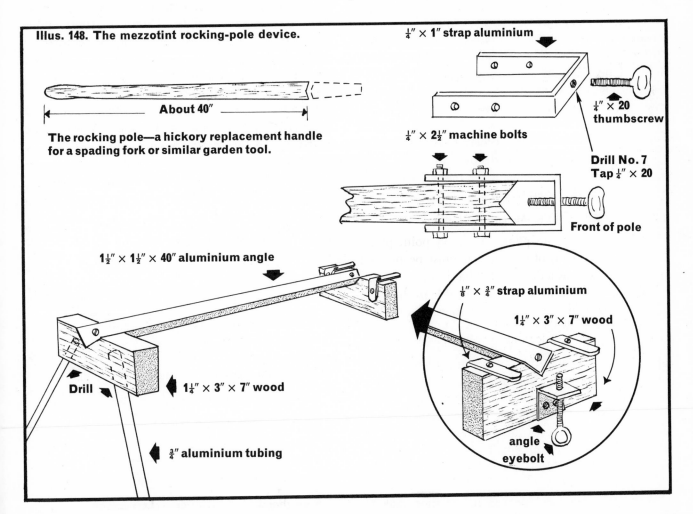

Illus. 148. The mezzotint rocking-pole device.

The rocking pole—a hickory replacement handle for a spading fork or similar garden tool.

About 40″

¼″ × 1″ strap aluminium

¼″ × 2½″ machine bolts

¼″ × 20 thumbscrew

Drill No. 7 Tap ¼″ × 20

Front of pole

1½″ × 1½″ × 40″ aluminium angle

Drill

1¼″ × 3″ × 7″ wood

¾″ aluminium tubing

⅛″ × ¾″ strap aluminium

1¼″ × 3″ × 7″ wood

angle eyebolt

burr to virgin metal, which is then brought back to a polished condition with Scotch stone, snake slip, charcoal, and so on.

Although the regular scraper may be used, the flat scraper (Illus. 149 and 150) is generally preferred as it allows more control in shaving off large areas of burr. The flat scraper may be made from an old file and it is a good idea to have several sizes. The sword and leaf scrapers, designed for work in tight quarters, may be forged from $\frac{3}{16}$-inch drill rod (a tool steel) and hardened by heating in a gas flame until cherry red. Quench the heated end in a bath of water or oil, then place the tool in an ordinary oven with the thermostat set at 350 degrees F. Leave it there for an hour or two to draw some of the temper, then quench it again. Sharpen and polish the edges and the scraper is ready for work.

You can make small burnishers from different-sized nails, grinding the ends to a rounded shape and polishing them with 4/0 emery paper or crocus cloth. Use these burnishers where light lines or small spots must be worked into areas of black or dark tone.

If a plate is only partially rocked (that is, only in those areas where the burr is desired), the tone overlapping the outline of the design must be scraped down and totally erased, right up to the outline. If an area is overscraped, resulting in too light a tone, the tone can be returned to it with the barrel roulette. In restricted areas, use the single-row roulette. In some small places it may be better to produce a tone by means of the roulette to begin with, instead of the rocker. Where space permits, a tone that has been burnished down until too light may be replaced by means of the regular rocker or one of its narrower counterparts.

Inking and Printing the Mezzotint Plate

Since the mezzotint plate, like a dry point plate, holds ink by means of the burr, it must be printed in the same way as a dry point. That is, care is taken to give the plate as little wear as possible in the press and the ink is made thinner, or more fluid, than usual with raw linseed oil.

Apply ink to the plate with the dabber or a wad of soft cloth. The heaviness of the burr allows the use of tarlatan in wiping, but take care not to draw the ink away from the burr nor to smear it while wiping the lighter tones. Some lighter tones may be more readily wiped with a twist of soft cloth and finally by your chalked fingertip. Small areas and lines are wiped with a wisp of cotton on a toothpick, or by the bare, wooden point.

A thick, soft paper, such as any of those recom-mended for printing dry point, is best also for mezzotint.

Metal Graphic

Three centuries after von Siegen, another German printmaker, Rolf Nesch, came up with an idea promoting what might be called the reversal of deep etch.

Instead of etching deeps into a plate, the metal graphic process starts with a thin plate as a base and builds up heights by soldering other metal to it. Small plates, strips and streamers of sheet metal, wire, screening, and other similar material may be used. Such a plate may be printed by intaglio method, relief method, or a combination of the two, and in tones of black and white or in color. For an example of a metal-graphic print, see Illus. 202, page 123.

Any kind of metal can be used—copper, zinc or sheet steel. The basic plate may be an ungalvanized sheet metal of 28 to 24 gauge. Plates, washers, wire bent into attractive designs, etc. are attached to the plate and may assume a total thickness surpassing that of a 16-gauge plate. Therefore, considerable readjustment of the press roller may be required to avoid damaging the press. Also, the press blankets should be thicker or more numerous, depending on the total thickness of the composite plate.

Duckbill tin snips will do for the coarse cutting of the sheet metal into interesting shapes. Where more exactitude in the matter of cutting is required, use either a metal-cutting band saw, a jigsaw, or a hand-held jeweler's saw with a fine, metal-cutting blade.

Gather a collection of metal in various forms—

Illus. 149. These mezzotint scrapers can be made in a home or school workshop by grinding old files to shape and forging lengths of drill rod or large nails.

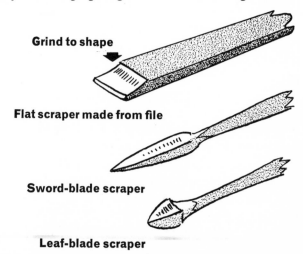

Grind to shape

Flat scraper made from file

Sword-blade scraper

Leaf-blade scraper

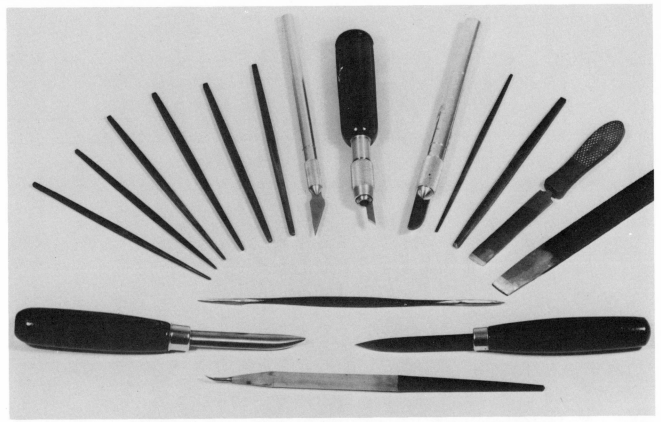

Illus. 150. Foreground: Mimeo burnisher (front), burnisher (left), scraper (right), sword-blade scraper (behind). Background: burnishers for different width lines, which may be made from tool-steel stock or nails. X-Acto knives; flat scrapers. The last two scrapers (far right) were made from files by grinding the tip to a cutting edge.

wire, screen, metal plates with textured surfaces, perforated sheets, etc. All this material may be attached to the basic plate by soldering. However, unless you have had considerable experience with the use of blowtorch and soldering iron, you are likely to run into too many problems to make your task attractive. Strong metal cements are available at every hardware store and these should not be difficult for the student or amateur metal graphic artist to cope with.

Patience will be needed, as the cement takes a little time in which to set and the plate will, therefore, have to be built up slowly. To adhere properly, pieces added on may have to be clamped in place, or the plate may have to be put aside under a weight, until the cement sets, before the work can be continued or completed.

Where desired, surfaces may be tinned on the outer surface (covered with molten solder, wiped on with a hot soldering iron) before being cemented together. After the cement is set, the solder can be roughened and altered with a rasp or a riffler (a curved filing tool).

When the plate has been built up to your satis-faction (it may show three or four layers or more), you may work over the surfaces with scrapers, a dry-point needle, mezzotint rocker, roulettes, or anything else that will roughen them enough to retain ink. Also, the plate may be grounded and needled if desired, or coated with soft ground and textured before etching.

The effects that may be achieved are infinite and limited only by your imagination and your supply of sheet metal pieces. The metal-graphic print is the printmaker's answer to the modern sculptor who welds bits of metal into an interesting sculpture.

Inking and Printing the Metal-Graphic Plate

The ink used for metal graphic should be stiffer than the ink ordinarily used for printing an etched or engraved plate. A stiff ink is not so easily wiped away from the edges of the planes and terraces, where it naturally piles up.

If the metal-graphic plate results in a total thickness greater than that of a 16-gauge plate, choose a pure rag paper that is strong enough not to burst when forced over the heights and down into the deeps of the design.

Illus. 151. While inking in color, the use of a glass plate underneath the etched plate makes for easy clean-up after each inking.

14. PRINTING THE INTAGLIO PLATE IN COLOR

Etching at times has been considered an unsuitable medium for color and the weight of visible evidence upon occasion approves the verdict. However, there is always the possibility that some good may be derived from the practical application of color and it is for the individual to make up his own mind in regard to its suitability.

The beginner may most easily produce colored etchings by first printing the plate in a brownish or warm-black tone of ink on cold-pressed watercolor paper. Then, when the ink is dry, color the print with watercolors in either the wet or the dry method of watercolor painting.

Color Inks

Although color pigments may be bought and the inks mixed in the studio, the beginner would be better advised to buy a few prepared color inks in tubes. Some inks may be used only for printing

etchings and others only for relief printing. Others, however, can be used for both printing methods, and if you plan to combine intaglio and relief printing in the same print, as will be explained later, stocking these dual-purpose inks will cut your color inventory in half.

The Color Aquatint Plate

Where color is to be laid down in the print in broad, flat areas, the corresponding areas of the plate must be aquatinted. The plate is first etched with a linear design in hard ground. Each aquatinted area is then etched to a depth corresponding to the depth of tone desired in the print, though even the deepest tone is but lightly etched.

Use copper plates (or steel) for color, as zinc may tend to degrade the colors. After the linear design has been etched, bevel the plate and pull a few proofs on cold-pressed watercolor paper. Color these with different color schemes, using watercolors, until you create one you would like to reproduce in print.

Now lay a fine aquatint ground over the plate and etch it. Where there is to be no color other than plate tone, stop out before etching. As the etch progresses, stop out other areas, in accordance with the depth of tone desired in each. The deeper the aquatint is etched (the longer it is in the bath), the darker will be the tone of color it prints.

Inking the Color Aquatint Plate

Ink as it comes in the tube is generally too deep in hue and it must be reduced with "extender" to give it a lighter tone without reducing its body. Extender is a colorless material to which a little ink at a time is added and mixed until the desired tint is obtained. Do not add extender to color, or you will wind up with a great deal more ink than you can use.

Regular etching ink is too stiff for use as it comes from the tube. Make the colors fluid enough to run by adding a few drops of raw linseed oil. An oily ink penetrates easily into the intaglio; therefore, it is not necessary in color printing to heat the plate. It is inked, wiped and printed cold—at room temperature.

The ink is applied to the plate by a method originated by the French etchers and which they call *à la poupée*. This means "with dollies"—*poupée* is the French word for doll. The doll, or dolly, is a twist of rag that is dipped into the ink for transferring the color to the plate. Also, small dabbers may be used, made from dowels rounded on the end

and padded and covered with felt. Apply the colors one at a time and wipe each color before applying the next. Work carefully where separate colors join to blend them and make sure the etched lines are filled.

Print the plate exactly the same as you would a plate inked in black. Use a heavy, soft paper for best results.

Relief Design, Aquatint Color Plates

In this method, the linear design is printed in relief and the aquatint intaglio carries the color. Lay an aquatint ground on a clean plate and draw the design on it with a brush and stop-out varnish thickened with lampblack. Asphaltum varnish may also be used. When this dries, etch the plate. The aquatint may be stopped out to vary the depth of the tones, or it may be equally etched throughout all areas of the plate.

Apply colored inks with dollies (Illus. 151) and blend them where they meet. Wipe the plate after each color is applied and give the entire plate a final chalk wipe to remove most of the color tone from the relief surfaces. With damp cotton on toothpicks, or with damp rags in larger areas, carefully go over the entire relief design, scrubbing away the ink down to the metal.

If printed now, the design would show up white in the midst of the surrounding color. What remains to be done is to add color to it. Here is how you do it.

Roll out a colored ink suitable for relief printing on a separate slab. Use a brayer, or ink roller. The

Illus. 152. Roll relief ink on color aquatint plate with large-diameter roller.

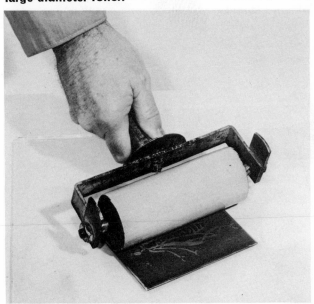

roller must be big enough so that it will cover the entire plate in a single revolution. Otherwise, ink picked up by the roller from the intaglio will be redeposited on the plate, spoiling your effort. Supposing your roller is large enough, roll it just once across the plate, covering the relief surfaces with ink (Illus. 152, previous page), then print as usual.

Now let's have a few words about extra-large ink rollers. The circumference of the roller must be such that it is at least equal to the lesser dimension of the plate. To find the circumference of your roller, multiply its diameter by 3.14, which is the approximate value of π. For instance, a 9-inch brayer 2 inches in diameter would serve to ink plates up to about 6×8 inches, if the plate is rolled on its short dimension.

If you need a really large ink roller, and you live in a city, talk with a dealer in photolithographic equipment about rubber offset blankets (see *Lithographers' Equipment and Supplies* in the classified pages of the phone book). These are available in many sizes and in grades from soft to hard.

With such a blanket you can make a suitable roller. Illus. 153 shows a roller machined from a length of 5-inch steel pipe and covered with a rubber offset blanket. Holes were punched in both ends of the blanket to accommodate the screws holding the blanket clamp.

A wooden rolling pin, or a lathe-turned roller of hardwood, could be used in the same way. Mount the blanket with a similar clamp held by small wood

Illus. 153. You can make a large roller with a rubber offset blanket for relief inking and for offset printing. Obtain blanket from lithographic suppliers.

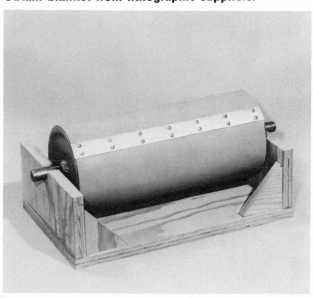

screws. Make sure that the lines printed on the back of the blanket run around the roller and not parallel to its length.

The Linear Print with a Colored Background

Ink a heated, etched plate with black or warm-toned ink to carry the intaglio design. Wipe the plate and clean the surface of tone with a damp cloth. Then roll a colored ink over the relief surface as previously described. When printed, the black lines will appear as if printed on top of the color background, which, in effect, they are. Since black was the first color put down on the plate and the colored ink was rolled over it, the color is printed first on the paper and the black ink lines are printed on top of it.

Relief Inking with Stencils

For selective inking of certain relief areas of a plate, the ink may be rolled on through openings cut in a piece of stencil paper. (Or cut a stencil in drawing paper, shellac it, and let dry.) If several colors are used in separate areas, one stencil may serve for all, using a separate roller for each color. A stencilling set-up is shown in Illus. 154.

If handled carefully to avoid smearing, two or more stencils may be used consecutively on the same plate. However, in cases where one color overlaps another, a problem arises, because under certain conditions, the first ink down will refuse to accept the second. To remedy this, the first ink is rolled down with a minimum amount of oil. Additional raw linseed oil is added to the second ink to make it oilier than the first. When this is done, the second ink may be rolled right over the first without trouble and the two will print together in a combination of the two colors.

Instead of using a stencil to ink the plate, you may place the stencil on the dry print paper and roll on the colored ink or inks. In this way, one ink may be allowed to dry before the next is stencilled on. When the inks are dry, the paper is damped and printed with the intaglio design as usual.

As the paper will stretch a certain amount when damp, the stencil(s) should be made for very "loose register." Loose register is where no line or point is required to be precisely superimposed upon another line or point. When cutting stencils, latitude is allowed for the placing of one imprint on another.

Color Printing with Two or More Plates

Where more than one plate is involved in making a

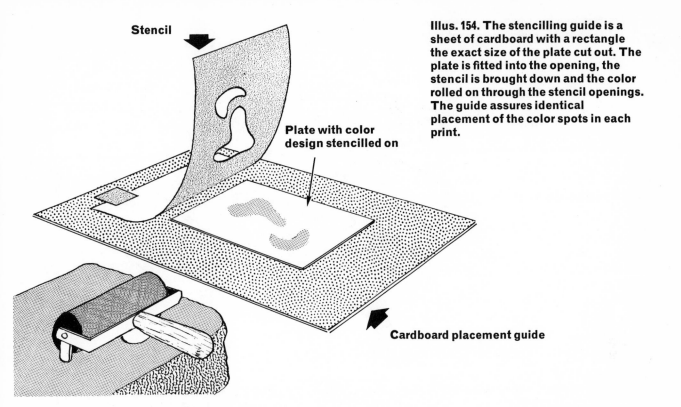

Stencil

Plate with color design stencilled on

Cardboard placement guide

Illus. 154. The stencilling guide is a sheet of cardboard with a rectangle the exact size of the plate cut out. The plate is fitted into the opening, the stencil is brought down and the color rolled on through the stencil openings. The guide assures identical placement of the color spots in each print.

color print, it is imperative that all the plates be exactly the same size.

The more plates in a color series, the more difficult it is to assure register all the way through. (Register is the exact printing of one color with respect to the other colors so that each part of the design, though printed from separate plates, falls into its proper place on the print.)

The first plate, called "the key plate," is etched with the basic, linear design. The plate is prepared for printing and a proof is pulled. This proof is immediately laid face down upon a blank plate and run through the press with reduced pressure (or burnish the back of the proof with a spoon). This sets the image of the proof off upon the plate, which is then put aside to dry. A proof is thus pulled and transferred to each plate in the series.

Suppose there are three plates, destined to print red, yellow and blue. On the yellow plate, all areas are stopped out with asphaltum varnish except for those that are intended to print yellow, or, possibly, green also. On the red plate, all areas except those that are to print red are stopped out. Do the same for the blue plate, where only the blue-printing areas are left bare. Let the asphaltum varnish dry thoroughly before continuing. If any ink or asphaltum has smeared into the clear areas, clean it off with turpentine.

The next step is to lay an aquatint ground on each plate and bite it to the required depth. If, however, any plate is to have work done on it with the etching needle, or if a texture is to be laid with a soft ground, this is done before stopping out for aquatinting. The procedure is as follows.

Immediately after the transfer of the inked design, the plate is submitted briefly to a bath of diluted acid. The ink is then wiped away with a turpentined rag, leaving the design in bright metal on the acid-dulled surface. A transparent ground is then laid, through which the bright trace is easily visible. After needling, or working with soft ground, the plate is etched and cleaned. Then it is stopped out around the area to be printed in aquatint with asphaltum varnish. When this has dried, the aquatint ground is laid.

Register should be taken into account while working the various plates and made loose enough so that minor errors may go unnoticed. In successive printings, even when printed wet-on-wet (wet ink upon wet ink), the paper will dry a little between plates, causing the image to fall farther and farther out of register as it progressively shrinks.

Printing Wet-on-Wet

In this method of color printing, all the colors are printed one after another on the same print before

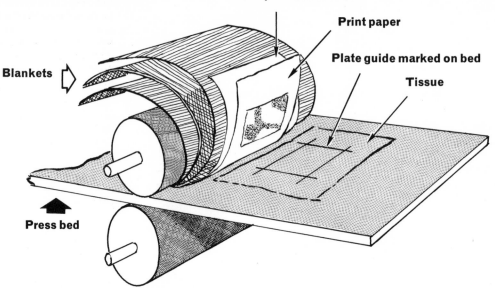

any has a chance to dry. Each print is thus printed in its entirety before the next print is undertaken. To make the colors dry faster, cobalt linoleate drier may be added (one drop per two tablespoons of ink). The plates are inked and wiped cold.

In all color printing of whatever nature, the lightest color is generally printed first. This is followed by the next lightest color, and so on, and the key plate is always printed last. This order is adhered to so that darker colors may be made to overlay lighter ones, where one color is printed on top of another. Trying to print light colors on top of dark seldom turns out successfully.

Light areas in the midst of dark tones are arrived at by providing non-printing areas on the dark plate to correspond with the light color on the preceding plate. The light color shows through the opening or openings in the darker color.

If one color is to be printed over another while both are still wet, keep in mind that the overprinting color must be made oilier than the first one printed.

The first plate is positioned (Illus. 155) in a location plainly marked on the press bed. Instead of laying newsprint under the plate, tissue (or tracing paper) is used so that the marked area will be visible through it. After the plate is positioned, the print paper is laid on, then the buffer paper, and, finally, the blankets, which are pinched under the roller as indicated in Illus. 155.

Thus, when the plate has emerged from under the roller on the other side of the press, the paper, which

you should cut with unusually wide margins, will remain caught under the roller. The print paper is then thrown back over the roller with the blankets.

There is an opportunity for the paper to dry out a little between plates, and this thought may cause you to hurry, resulting in mistakes. Instead, have damp cloths ready and lay these along the edges of the paper to conserve the dampness. In addition, have all the remaining plates in the series standing by, already inked. Simply pick up the plate just printed and replace it with the next in the series (replace the tissue as well if it is too wet or soiled). Remove the damp cloths, bring down the paper and the blankets on the plate, and wind the whole affair back through the press.

The process is repeated for the third plate, if there is one, or until all plates in the series have been printed one after another on the same piece of paper.

The method does result in crushing of the previously printed areas and some smearing may occur, but this is to be expected under the circumstances. The method is, however, a good way to produce a quick proof from a series of color plates intended to be printed wet-over-dry, as shall be dealt with next.

Printing Wet Ink Over Dry

In this method, the first color plate is printed throughout the edition and each resulting print is laid aside to dry. Each print is then run through the press with the second color plate in position.

After the prints dry, the third plate is printed, and so on. At least a day must elapse between plates and sometimes more.

It is, of course, necessary to wet the printing paper and this makes it stretch. It then dries and shrinks between printings. Therefore the paper must be damped each time in precisely the same manner and left to soak for the same length of time, so as to assure the same amount of stretch in the paper at each printing session.

Colors go on better when printed over a dry imprint and there is no need to fuss with the inks, making some oilier than others, and so on. However, the method of achieving register used when printing wet-on-wet will no longer work, as the print paper is removed from the press between colors.

The Register Guide

Illus. 157 diagrams the set-up. The register guide is a piece of 24-gauge sheet metal, both thinner and larger than the plate. A rectangle of the same dimensions as the plate is jigsawed from the middle of the sheet metal. If the opening is carelessly cut, leaving space for the plate to slip around, exact register will not be possible. To make a slightly oversize opening smaller, run a bead of solder along one edge (or two

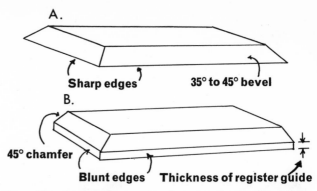

Illus. 156. Comparison of the bevels of a regular plate (A) and a plate to be printed in a register guide (B). The blunt edge of (B) keeps the plate from slipping under the guide as it passes through the press rollers. (Thickness of plates exaggerated.)

adjacent edges) of the opening, then file the solder carefully until the plate fits snugly.

The plate will fit better if the bevel is made narrower than usual. In Chapter 3, it was pointed out that the usual bevel is filed to a sharp edge with the back of the plate. For the present purpose, file the bevel at a 45° angle but do not carry it all the way down the edge to the back of the plate. Leave a certain thickness to the edge of the plate equal to the thickness of the register guide. (See Illus. 156.) In this form, the bevel is really a cham-

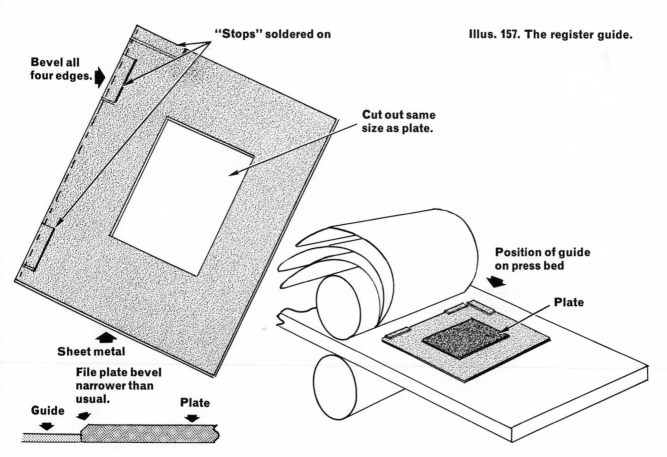

Illus. 157. The register guide.

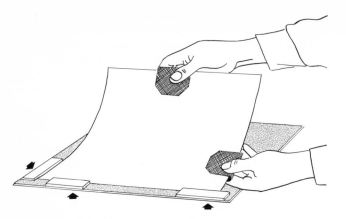

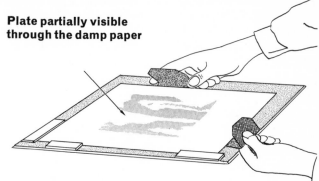

Plate partially visible
through the damp paper

Illus. 158. Handling the damp paper with pick-up clips, bring two edges into contact with the paper stops on the register guide, as indicated by the arrows.

Illus. 159. Carefully lay the paper flat on the plate. Withdraw the pick-up clip nearest the paper stops first, then the other. Do not move the paper.

fer, as it merely takes off the top corner of the edge, allowing that part of the plate with vertical edges to fit closely into the opening of the register guide.

Small pieces of sheet metal soldered at the leading edge and the right-hand edge of the guide (the left-hand edge if you are left-handed) serve as stops for the paper. Illus. 158 and 159 show how the paper is handled when laying it over the plate.

If the register guide is smaller than the area covered by the press blankets, it is a good idea to bevel the outside edges of the guide all around.

On the back of each color plate, scratch its numbered printing position and the color it is to print. Each register guide must be custom-made for the series of plates with which it is intended to work.

Printing Deep-Etched or Metal-Graphic Plates in Color

If you have etched or scratched with a dry-point needle, roulette, mezzotint rocker, etc., the bottoms and/or the relief surfaces of a deep-etched or metal-graphic plate for design purposes, or if you have laid and etched an aquatint ground for printing a tone or solid black, this intaglio work should be inked and wiped first. Allow the plate to cool, then wipe every trace of ink-tone from the unworked parts of the bottoms, terraces and relief-surfaces with a damp rag. Clean small areas with a damp, cotton swab on a toothpick. Take care not to wipe the ink out of the intaglio.

Illus. 160 shows how the relief areas are now inked, using a soft, gelatine ink roller. Ink the roller with the desired color and roll it over the plate. The plate may also be rolled inward from all four edges toward the middle. In this case, the roller would not have to be of a particularly large diameter, since this inking, as shown in the diagram, is intended only

for the deep bottoms in the plate, into which the soft roller easily penetrates.

The ink is then wiped from the relief (upper) surfaces of the plate with a turpentined rag. Remove the last vestiges of ink with a damp cloth. Now ink a hard roller with a different color and roll it over the plate. Since the roller is hard, it will not squeeze down into the bottoms, therefore it will not damage the film of ink already laid into those areas. The two colors of ink are thus kept apart in their respective places.

The resulting print shows the ink placement in reverse—that is, the last color will appear as if printed on the bottom; the preceding color will seem to have been printed over it; and the intaglio design in black or a contrasting color of ink seems to be printed on top of the color from the relief surfaces.

Combination Printing of Intaglio with Wood or Linoleum Blocks

The intaglio is first etched into the metal plate; then a proof is pulled. While wet, the design is transferred in reverse to the wood or linoleum by laying the wet proof face-down upon the block and burnishing the back of it with a spoon. Or, proof and block may be run through a block-printing press (or the etching press, if it can be adjusted to print from a block). A little talcum sprinkled on the image transferred to the block fixes it so that the block can be cut immediately.

One or more blocks may be used, the process of pulling a proof and transferring the design being repeated for each block. Each block is then cut in relief for a different one of the color elements planned to accompany the intaglio in the print. (If more than one color block is used, block-printing

Illus. 160. Inking the deep-etch or metal graphic plate. The intaglio ink is first applied and wiped. A second color is then rolled on with a soft roller, which gets the ink down into the bottoms. The color is wiped from the relief surfaces, which are then cleaned with a damp cloth. A third color rolled on with a hard roller applies color to the relief areas only. In the print, the soft-roller ink appears superposed on the hard-roller ink. A linear pattern is provided by the intaglio ink.

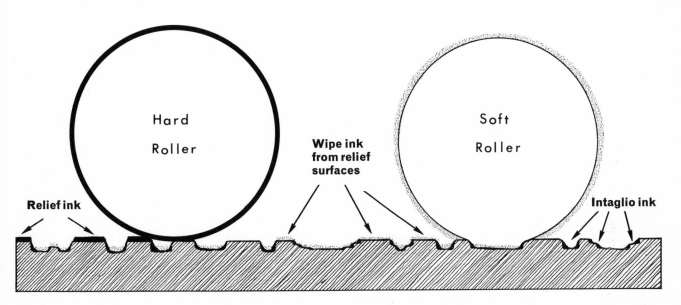

procedures should be used to register the blocks.) The ink is rolled on with a brayer. The paper should be damped for printing from the blocks, so that it will be in the same condition it will have to be in when printing the intaglio design. If the block print is made by burnishing the back of the print paper with a block-printing baren, instead of in a printing press, the damp print paper should be covered with a piece of tough Manila paper to prevent tearing it.

Lay the block prints out separately to dry for a day or two; then redamp them and print the intaglio design over the block-printed color.

To assure register, lay the block print face-up on a piece of stiff cardboard. Place the inked intaglio plate face-down upon it. This method allows you to see what you are doing so that the plate can be registered exactly on the already-printed color image.

Now slip one hand under the cardboard while holding the plate firmly in position with the other. Carefully turn the sandwich of cardboard and plate with paper between over upon the press bed. Remove the cardboard before printing.

Offsetting the Color Design from a Block

The block may be inked as described in the previous section, or several colors may be brushed or rolled on it to produce a multicolor effect, using bristle or sable brushes and rollers of different sizes.

The large roller (Illus. 153) is rolled over the inked block, picking up the colored design on the rubber offset blanket. Since it is not possible to achieve a precise register by this means, the color is planned in advance to fit loosely with the design. You will have to "eyeball" the color on the plate, as an engineer would say. That is, use your eye and your judgment. The result will turn out better than you might think it would. When you feel that you have the roller lined up properly with the previously inked intaglio plate, carefully roll it across. The image picked up from the block by the roller is by this means transferred to the plate. The color image and the intaglio design are printed simultaneously in a single run through the etching press.

As in stencil printing, the block design may also be set off directly upon the printing paper. When the ink is dry, damp the paper and overprint the intaglio upon the block-printed design. A different effect is obtained by printing the intaglio while the ink of the block print is still wet. In this case, the design must be rolled on damp paper which is immediately laid over the intaglio plate on the press bed and printed.

15. MOUNTING THE PRINT FOR DISPLAY

A print may be temporarily matted and hung without benefit of frame, or it may be framed behind glass. Where it is intended to be up on a wall for a considerable length of time, or in a home where the air is full of cooking grease and household dust, the glassed frame is by all means the best way of conserving the print while it is displayed.

The place where the print is to be displayed is an important consideration in the case of a professional exhibit. Museums, galleries, and art organizations have their own rules about the size and color of the mount and how it is to be hung. Therefore, you should approach the individual in charge of the exhibit in regard to these matters and never risk having your print rejected simply because it does not meet a few technical requirements in mounting.

For less formal exhibits, where no particular regulations are formulated, the artist has considerable freedom in choosing the size and color of the mat. Only the canons of good taste impose limitations.

In order to mat a print, you must secure a cardboard called mat board. It is made expressly for this purpose, with a pebbled surface on both its face and its back for smart appearance. One side is white and the other side is either buff or grey. These various tones are available to make the mat board suitable for a wide range of prints.

The entire mount consists of the mat board and a backing board to which the print is attached. Use illustration board for the latter, as its white surface reflects the light passing through the print and reinforces its contrasts. Under no circumstances use a dark-toned strawboard for a backing as it will make the print look dull.

Ordinary, inexpensive mat board and illustration board are satisfactory for temporary mounting. If the mounting is to be permanent, 100 per cent rag board should be used, both in the mat and in the backing. Museum Board, available at art supply stores, is recommended. Whereas Museum Board is more expensive than ordinary mat board, it is your assurance that the mat will not degrade in appearance with time nor cause stains to appear on the margins of the print from chemicals and impurities, as may happen when a print is left in a mount of the cheaper board for an extended period of time.

The mat and the backing board are cut to size. The size, unless specified by a committee in charge of an exhibit, depends on your own taste and feelings, or upon the frame into which it must fit. No print should be jammed into a mount so that it has a crowded look, a result of skimpy margins on the mat. Even a small print should not have any margin less than an inch wide, nor should the largest print have a margin more than 5 or 6 inches in width.

The 5×7-inch print shown in the following illustrations is being mounted to fit an $8\frac{1}{2} \times 11$-inch frame and the mount is therefore cut to this size. The same print might conceivably be mounted to fit into a frame as large as 11×14 inches, but certainly not larger. This kind of balance is something you will have to decide for yourself as no rules exist for it.

Always handle the mat with perfectly clean hands. Light smudges may be cleaned away with a dry-cleaner eraser. If this is not possible, the print will require rematting. There is no possible excuse for hanging a print in a dirty mat.

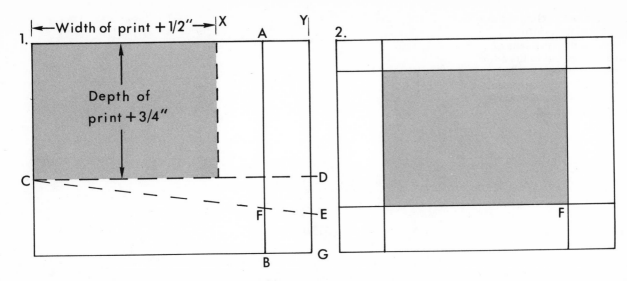

Illus. 161. To locate the print in the optical middle of the mat for good balance, first mark the dimensions of the print on the back of the mat as shown by the shaded area in (1). Mark the points C, X and D. Divide the space X-Y in two and draw the line AB. Divide the space D-G in two, mark the point E and lay a ruler across from C to E. Mark the point F where the ruler crosses the line AB. Using this point (F) as one of the bottom corners of the mat opening, lay out the opening as shown by the shaded area in (2), carrying the outlines to the edges of the mat.

Photography has made certain dimensions popular in this century, and we think of prints in sizes of 6 × 8, 8 × 10, 11 × 14, 14 × 17 and so on. The stock frames carried by art and variety stores are generally obtainable in these sizes. The artist who is equipped to make his own frames has a distinct advantage over those dependent on the general market.

A print that is tall and thin, or one that is perfectly square, certainly presents mounting problems not encountered in the standard sizes. A narrow print naturally calls for narrower margins on the mat than one of plumper dimensions. It is a rare gift to be able to judge the precise size of mat for any given print, and if one has it, he should not be restrained by the obligations of standard frame sizes.

By the same token, a frame that is just right for one print might be an abomination for another. No frame should be so heavy, garish, or unwieldy as to attract attention to itself and away from the print. Whether the frame should be light or dark or in-between is also a matter for personal judgment.

A frame of ⅜-inch to ½-inch width might be called standard for most print sizes. Very large prints with correspondingly larger mats might balance a frame as much as ¾ inch or 1 inch wide.

If you intend to hang a matted print without a frame, you can secure it to the wall with a stick-on mat hanger, available at your art supply store. Stick the hanger to the back of the mat, positioned in the middle laterally and about 3 inches below the top edge. As soon as the glue on it has set, the print is ready to hang on the wall.

An unframed mat should not be allowed to hang for too long a time, however. Without a frame and glass to hold it flat, the mat will warp, particularly if it is hung near a heater.

A simple rule exists for placing a print so that it is optically balanced in the mount. This rule is diagrammed in Illus. 161. The subsequent steps in the correct mounting of a print are continued in Illus. 162 to 167 on the following pages.

After you have gone through the complicated processes involved in producing an intaglio print, it is practically no trouble at all to mount it properly. You will like it better that way and so will your audience.

Illus. 162. Before cutting the mat opening, check its outline against the print by means of the lines carried out to the edge of the mat. This assures that you have not made a mistake and marked the opening either too small or too large.

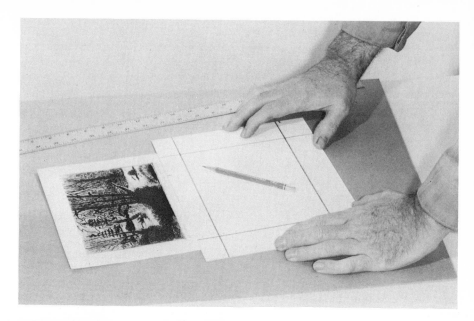

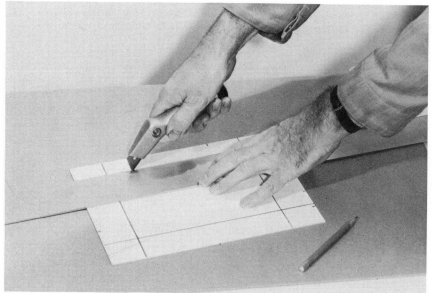

Illus. 163. Use a steel straightedge and a mat-cutting knife to cut the opening. If the straightedge tends to move, clamp it to the table. Lay waste cardboard under the mat to protect the table and cut the edges vertical, not bevelled, which is not only difficult to do but old-fashioned in appearance.

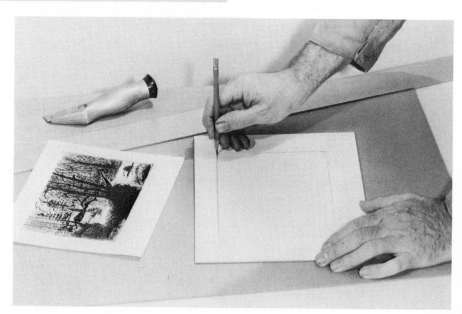

Illus. 164. Lay the mat on the backing board and mark each of the top corners of the opening. Outline on the backing the location of the print.

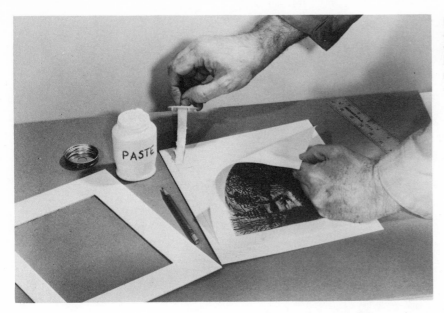

Illus. 165. Paste the two top corners only of the print to the backing with library paste to hold the print in position. When necessary to remove, a knife slipped under each corner quickly frees the print.

Illus. 166. Diagram of the mount shows how the mat is hinged to the backing board with pieces of gummed-paper tape (arrows). If the mat is to be hung without a frame, secure the mat board to the backing with a dab of library paste under each bottom corner.

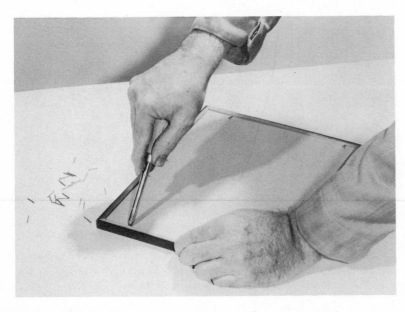

Illus. 167. The best way both to preserve and to display the print is in a frame under glass. Start with a mat cut to fit the frame and do all other work on it in accordance with these dimensions. A brad-pusher (shown) makes it easy to drive $\frac{5}{8}$-inch brads into the frame to hold the mount in.

Illus. 168. MELANCOLIA, engraving by Albrecht Durer (German, 1471-1528). First state, before the figure 9 was changed. National Gallery of Art, Washington, D.C. Rosenwald Collection.

Illus. 169. GYPSIES: L'AVANT-GARDE, etching by Jacques Callot (French, 1592-1635). National Gallery of Art, Washington, D.C., Rosenwald Collection. Use of the *échoppe* is shown in the tapered lines.

Illus. 170. (Right) THE RAT KILLER, Rembrandt (Dutch, 1606-1669), etching. Such genre etchings as this were popular among 17th-century Dutch artists. Plate is 5½ × 4⅞ inches.

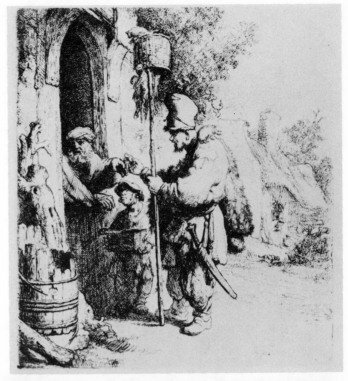

Illus. 171. (Below) THE THREE TREES, etching by Rembrandt, National Gallery of Art, Washington, D.C. Rosenwald Collection. (8¼ × 11 inches.) A perfect demonstration of Rembrandt's superb mastery of light and shadow.

Illus. 172. (Left) **THE FERRY HOUSE**, etching by Joseph Pennell, (American, 1860-1926). National Gallery of Art, Washington, D.C. Gift of Miss Elizabeth Achelis.

Illus. 173. (Below) **EAST BLATCHINGTON**, etching finished in dry point by Sir Muirhead Bone (Scottish, 1876-1953). Compare the artist's style with Rembrandt's landscape style. National Gallery of Art, Washington, D.C. Gift of Miss Elizabeth Achelis.

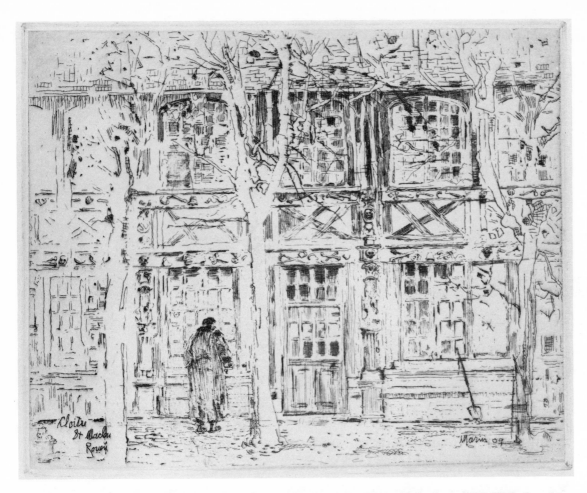

Illus. 174. CLOITRE ST. MACLOU, ROUEN, etching by John Marin (American, 1875-1953). Courtesy of the Art Institute of Chicago.

Illus. 175. LANDSCAPE WITH COTTAGE AND HAYBARN, etching by Rembrandt, National Gallery of Art, Washington, D.C. Gift of R. Horace Gallatin. Plate is $5\frac{1}{8} \times 12\frac{5}{8}$ inches.

Illus. 176. RUINED BARN OVERLOOKING DICKEY PRAIRIE, etching by M. Banister. Plate is 5¾ × 7⅞ inches, copper. Etched in 3 : 5 nitric bath.

Illus. 177. WILSONVILLE FERRY, etching by M. Banister, 6⅛ × 9 inches, copper. 3 : 5 nitric bath. Trees were filled in with the electric engraver. Dark parts of hull and shadow on the water were also deepened with the engraver.

Illus. 178. ENCOUNTER, Intaglio print by Rudy Pozzatti (American, 1925-). Plate is 15½ × 11½ inches. Courtesy of The Los Angeles County Museum of Art. Gift of the Kozlow Gallery.

Illus. 179. GUITAR PLAYER, engraving by
Marcantonio Raimondi (Italian, c. 1480-1530).
National Gallery of Art, Washington, D.C.
Rosenwald Collection.

Illus. 180. THE GATE OF ST. DENIS, soft-ground etching by Thomas Girtin (British, 1775-1802). The Metropolitan
Museum of Art, New York, Harris Brisbane Dick Fund, 1924.

Illus. 181 (Right) DANCING IN THE COUNTRY, soft-ground etching by Pierre Auguste Renoir (French, 1841-1919). National Gallery of Art, Washington, D.C. Rosenwald Collection.

Illus. 182. (Below) FOOTBRIDGE, FIFTH AVENUE, etching and dry point by Martin Lewis (American, 1883-1962). Metropolitan Museum of Art, New York, Harris Brisbane Dick Fund, 1929.

Illus. 183. **THE GUITAR PLAYER,** color print with aquatint and mixed methods including roulette, by François Janinet (French, 1752-1813), after Nicolas Lavreince. National Gallery of Art, Washington, D.C., Widener Collection.

Illus. 184. **LT.-COL. TARLETON,** mezzotint by John Raphael Smith (British, 1752-1812), after Sir Joshua Reynolds. National Gallery of Art, Washington, D.C., Rosenwald Collection.

Illus. 185. TAL PARA QUAL (Birds of a Feather, from Los Caprichos, Plate V). Etching and aquatint by Francisco Goya (Spanish, 1746-1828). National Gallery of Art, Washington, D.C. Rosenwald Collection.

Illus. 186. VEGETABLE MARKET AT PONTOISE, etching and aquatint on zinc by Camille Pissarro (French, 1830-1903.) National Gallery of Art, Washington, D.C. Rosenwald Collection.

Illus. 187. CON RAZON O SIN ELLA (With Reason or Without, from Los Desastres de la Guerra, Plate II), etching with slight aquatint by Goya. National Gallery of Art, Washington, D.C. Rosenwald Collection.

Illus. 188. THE CITY FROM PONT MARIE, soft-ground etching by Thomas Girtin. The Metropolitan Museum of Art, New York. Harris Brisbane Dick Fund, 1929.

Illus. 189. SNAKE CHARMER, soft-ground etching by Rolf Nesch (German-Norwegian, 1893-). Courtesy of The Art Institute of Chicago.

Illus. 190. CARDINAL COISLIN, engraving by Robert Nanteuil (French, 1623-1678). National Gallery of Art, Washington, C.D. Rosenwald Collection.

117

Illus. 191. (Left) WEARY, dry point by James
Abbott McNeill Whistler (American, 1834-1903).
National Gallery of Art, Washington, D.C.,
gift of Myron A. Hofer in memory of his mother,
Jane Arms Hofer.

Illus. 192. (Below) NOCTURNE (One of Venice,
A Series of Twelve Etchings), etching by
Whistler. National Gallery of Art, Washington,
D.C. Gift of Mr. and Mrs. J. Watson Webb, in
memory of Mr. and Mrs. H. O. Havemeyer.
The dark tones were created in the wiping of the
plate, by allowing the surplus ink to remain.

Illus. 193. (Above left) LE PERROQUET, dry point by Mary Cassatt (American, 1844-1926). Metropolitan Museum of Art, New York. Gift of Arthur Sachs, 1916.

Illus. 194. (Above right) AFTERNOON TEA (third and final state). Color print with dry point and aquatint by Mary Cassatt. National Gallery of Art, Washington, D.C. Rosenwald Collection.

Illus. 195. AU LOUVRE: MUSÉE DES ANTIQUES, aquatint by Edgar Degas (French, 1834-1917). Metropolitan Museum of Art, New York, Rogers Fund, 1919.

Illus. 196. (Left) **WOMAN IN WHITE CORSET** (Femme en Corsage Blanc), color aquatint, etching, engraving, roulette, etc., by Georges Rouault (French, 1871-1951). National Gallery of Art, Washington, D.C. Rosenwald Collection.

Illus. 197. (Below) **GOAT'S HEAD**, lift-ground aquatint by Pablo Picasso (Spanish, 1881-). National Gallery of Art, Washington, D.C. Rosenwald Collection.

Illus. 198. **STILL LIFE WITH SPHERE AND CHERRIES,** mezzotint by Yozo Hamaguchi, (Franco-Japanese, 1909-). (14¾ × 13¾ inches.) Los Angeles County Museum of Art, gift of Clifford Odets.

Illus. 199. (Left) **THE TIGHTROPE WALKER,** dry point by Max Beckmann (German, 1884-1950). National Gallery of Art, Washington, D.C. Gift of Heller Foundation.

Illus. 200. (Below) **SOL Y LUNA,** etching by Mauricio Lasansky. Courtesy of The Art Institute of Chicago. The tones consist of soft-ground textures, printed singly and in multiple.

Illus. 201. (Right) **THEME FROM HESIOD'S THEOGONY**, etching by Georges Braque (French, 1882-1963). National Gallery of Art, Washington, D.C. Rosenwald Collection.

Illus. 202. (Below) **BARMBECK BRIDGE** 1932, from the series Hamburger Brücken. Metal graphic print by Rolf Nesch. (17⅝ × 23⅜ inches). Courtesy of Los Angeles County Museum of Art.

123

Illus. 203. PORTRAIT OF LADY ELIZABETH COMPTON, mezzotint by Valentine Green (English, 1739-1813), after Sir Joshua Reynolds. Los Angeles County Museum of Art, Balch Collection.

Illus. 204. FARM, soft-ground etching with aquatint by M. Banister. (5 × 9 inches on zinc.) Soft ground bitten in 1 : 3 nitric bath, aquatint in Dutch bath. Cloud edges faded with litho crayon.

Illus. 205. THE SWAMP, etching, with roulette, by M. Banister. Plate is 5 × 7 inches, zinc. Compare the dark values obtainable by this technique with the soft-ground etching above.

MATERIALS AND TOOLS USED IN VARIOUS INTAGLIO PROCESSES

Plates

Copper and zinc photo-engraving plates, 16-gauge.

Steel plates, 16- or 18-gauge for etching, thinner for electric engraving (see text).

Aluminium (requires special mordant).

Grounding Materials

Prepared ball ground, hard or soft, opaque or transparent.

Liquid ground, hard or soft, opaque or transparent.

Materials for making ground: asphaltum, beeswax, rosin; damar crystals, Singapore No. 1; mutton tallow, petroleum jelly or axle grease for soft ground.

Non-chalking titanium dioxide pigment (white) for laying white grounds; tube of white grease-paint.

Whiting (powdered chalk), for cleaning the plate.

Ammonia, for cleaning the plate.

Turpentine, for cleaning the plate.

Kerosene, for washing ground or ink from the plate.

Benzol, for dissolving asphaltum.

Materials Used in Biting Plates

Bicarbonate of soda (apply to skin to counteract acid burns).

Wax taper or kerosene lamp for smoking the plate.

Acetic acid, 28 per cent, for pre-etching bath.

Nitric acid, CP or AR, 70 per cent.

Hydrochloric acid, CP or AR, 37 per cent.

Potassium chlorate crystals (for Dutch bath).

Iron perchloride crystals (a mordant).

Baumé hydrometer and jar (optional).

Acid-proof thermometer (dairy thermometer with inside scale).

Glass-stoppered or plastic-capped bottles for storing baths.

Feathers or Chinese pencil (brush).

Rubber gloves or finger stalls.

Stop-out varnish (4-lb. cut shellac, see text).

Lampblack powder to thicken stop-out varnish.

Methyl violet to color stop-out varnish.

Stop-out varnish remover; denatured alcohol; or shellac thinner.

Asphaltum varnish.

Brushes, camel's hair or sable, several—round and flat.

1-inch sash brush for painting plate areas with asphaltum.

Plastic apron to protect clothing from acid.

Absorbent cotton for straining acid baths.

Glass or plastic funnel.

Hard rubber, plastic, or Pyrex trays.

Materials Used in Printing

Etching ink, prepared, or dry pigments.

Burnt plate oil, heavy and light.

Raw linseed oil.

Ink slab of marble, slate, glass, or old litho stone.

Palette knife, putty knife, wall scraper (stiff blade).

Wiping compound (optional).

Inking dabber, covered with felt or silk.

Newsprint, one ream, 18 × 24-inch sheets.

Quality print paper, rag; Japanese, etc.

4-mil vinyl plastic sheeting.

Plate glass, $\frac{1}{4}$ × 19 × 24 inches, for damping paper.

Blotters, white, plain, 19 × 24 inches.

Felt press blankets (see text).

Tarlatan, mosquito netting, crinoline, or starched cheesecloth.

Large chalk sticks for chalking hand in hand wipe.

Kerosene, rags or paper towels, for cleaning up.

Tools for Dry Point, Engraving, Mezzotint, and Metal Graphic

Burins as described in text.

Dry points, steel, carbide-tip, and/or diamond.

Dremel Electric Engraver.

Mezzotint rocker, roulettes.

Rocking-pole device (home-made).

Scrapers, burnishers, X-Acto knives, etc. (see text).

Soldering equipment for metal graphic; or metal cement for assembling the plates.

Tools Used in Grounding, Needling, Biting and Printing the Plate

Heater or electric griddle, thermostatically controlled.

Jigger (home-made).

Chamois skin for making dabbers and for cleaning plates.

Leather roller for grounding plates.

Felt- or silk-covered dabber for inking plates.

Etching needles as described in text.

Scraper, triangular; burnisher, bent.

Scotch stone, snake slip, charcoal block.

Plate polish (Brasso, Putz Pomade or similar).

Polishing powders: pumice, tripoli, rouge.

Abrasive papers: Waterproof (wet-or-dry) silicon carbide papers as described in the text; 4/0 emery polishing paper.

6-inch, double-cut file, with handle, for bevelling plates; also single-cut file for fine filing.

Hand grinder with rotary file (optional).

Chasing hammer or 4-ounce-head ball-peen machinist's hammer.

Assorted pin or machine punches, $\frac{1}{8}$-, $\frac{3}{16}$-, and $\frac{1}{4}$-inch point sizes for *repoussage*.

Anvil for use in *repoussage*.

Locking pliers or hand vise for holding hot plates.

Light diffusion screen (home-made).

Polaroid sun glasses.

Etching press.

Shaving brush, tweezers, for cleaning damp paper.

Small brush (badger-hair blender) for brushing off crumbs of ground while needling the plate.

Glass fibre brush for burnishing scratches (optional).

Roulettes (optional).

INDEX

Acid, acetic 30, 45
 Dutch bath 25, 27, 29 ff., 35, 57, 76
 handling of 28, 31
 hydrochloric 27, 28
 nitric 25, 27, 29 ff., 34, 70, 76
Acid fumes 28, 32
Adjusting the press 40
Alcohol 22, 31, 74
Aluminium, foil 10
 plates 7
Ammonia 9
Anvil 62
Apron, plastic 32
Aquatint 72–77
 box 47
 color 95
 correcting 76
 grounding with rosin 73 ff.
 lift bath 78
 lift-ground solution 77
 liquid ground 77
 salt 77
 sandpaper 77
 spirit ground 78
Arkansas stone 61, 81, 84
Asphaltum 11, 17
Asphaltum varnish 25, 95
Bag, rosin 72
Ball ground, hard 11, 22
 soft 11, 12, 67
Banister, M. 58, 69, 110, 125
Baths, acid 25, 27 ff., 34, 57, 70, 76, 97
Baumé hydrometer 27, 28, 29
Beckmann, Max 122
Beeswax 11
Belt rag 47
Bevel, plate edges 33, 99
Bite, creeping 76
 foul 25, 31, 52, 57, 67
Blankets, etching press 39, 52
 care of 40, 55
 dimensions 40
Block printing 100
Blotters 37 ff., 52, 54
Bone black 42
Bone, Muirhead 108
Braque, Georges 123
Brayer—see Roller, rubber
Bridge, for drawing on soft ground 69
Brush, badger-hair 23
 shaving 53
Bubbling 31
 timing by 34
Buffer sheet 52
Burin 8, 25, 57, 80
Burnisher 8, 61, 76, 91
Burnt plate oil 43 ff., 94
Burnt sienna 42
Burnt umber 43, 52
Burr 7, 70, 82, 84, 89
Calipers 62
Callot, Jacques 106
Carbide point 84
Carbon black 42
Carborundum 45, 62
Cassatt, Mary 119
Chalk, powdered 9
Chalking hand 47
Chamois 10, 15
Charcoal block 33, 60 ff.
Cleaning, dry ink 52
 hands 94
 ink slab 55
 the dabber 10
 the leather roller 10
 the plate 61
Clips, pick-up 52
Cobalt linoleate 54
Color printing 95–101
 aquatint 95
 deep etch and metal graphic 100
 inks 94
 linear with colored background 96
 relief with aquatint 95
 relief with blocks 100
 relief with stencils 96
 two or more plates 96
 wet ink over dry 98
 wet-on-wet 96
Conditioning etching needle 22
Copper plates 4 ff., 27 ff.
 steel-facing 86
Corrections, aquatint 76
 dry point 87
 in the bath 35
 on etched plate 61
 soft ground 70
 with liquid ground 12

Cotman, J. S. 67
Creeping bite 76
Crevé 24, 62, 78
 correcting 25
 roughening 25
Cross-hatching 25, 34, 87
Cushion blanket 40
Cut-outs 78
Cutting
 plates 7
 mats 102–105
Dabber
 grounding 10, 14 ff., 58, 60
 inking 15, 45, 55
Dabbing, the ground 14 ff., 57, 67
 ink 47
Damar crystals 12
Damping papers 38 ff.
"Dark manner" 25
Decorative felt 40
Deep etch 78, 100
Degas, Edgar 119
Diamond point 84
Diffusing screen 23, 82
Drawing 19
 for soft ground 67 ff.
 frame 69
 in stages 34
 in the bath 35
 on the plate 17, 19, 82
 on white ground 17
 preliminary 19
 transfer to plate 17, 19 ff., 67, 83, 86
 using a mirror 21
 with dry point 85
Drawcutter 8
Drier 70
Drying the plate 34, 70
Dry point 84–87
 as guide for engraving 83
 for correcting etched line 25, 57, 70
Dürer, Albrecht 106
Dusting rosin on the plate 73
Dutch bath 25, 27, 29 ff., 35, 57, 76
Échoppe 23
Edition printing 53
Emery paper 8, 33, 61 ff., 82
Engraver, electric 86
Engraving 4, 80–83
Etching the plate, aquatint 76
 definition 4
 hard ground 30 ff.
 soft ground 70
Etching blankets 39 ff.
Etching ink 42 ff.
Etching log 32
Etching needles 23
Etching presses 36 ff.
 adjusting 40
Etching trays 30
Etching with stopping out 34, 75
Fading out, aquatint 75
 etching 34, 35
Feathering the plate 35, 76
Felt, decorative 40
 fine 39
 orthopedic 40
 woven 40
Filing, bevel 33
 plate edge 33
Finger stalls 31
Finishing the print 54
Fire extinguisher 17
Flattening prints 54
Flour of sulphur 60
Formulae, ball ground, hard 11
 ball ground, soft 67
 Dutch baths 28
 ink 42
Foul bite 25, 31, 52, 57, 67
Frame, drawing 69
Framing print 102–105
Frankfort black 42
Fronting blanket 39
Fume hood 26, 32
Fumes, acid 28, 32
Gallery of plates 106–125
Gelatin roller 100
Girtin, Thomas 67, 112, 117
Gloves, rubber 31
Goya, Francisco 72, 75, 116
Green, Valentine 124
Griddle, electric 10, 73
Grinding pigments 42 ff.

Ground, aquatint 72 ff., 97
 ball 10, 67
 burned 16
 drawing directly on 17
 irregular 60
 liquid 12, 22, 77
 mezzotint 87
 patching 22
 pick-up 78
 rebiting 57
 removing 31
 smoking 15 ff.
 soft 11, 12, 67
 spirit 78
 transparent 11, 12, 57, 97
 white 17
Grounding, temperature for 10
 with aquatint box 74
 with dabber 14 ff., 60, 67
 with liquid 12, 22, 77
 with roller 10, 12 ff., 57, 67
Gum arabic 77, 83
Hamaguchi, Yozo 121
Hammer, repoussage 62
Hand wipe 47
Heater 9 ff., 13, 45 ff., 57, 73
Hopfer, Daniel 5
Hydrochloric acid 27, 28
Hydrometer, Baumé 27, 28, 29
India stone 61, 81
Ink, cleaning 52, 55
 color 94
 etching 42 ff.
 grinding (mulling) 42 ff.
 slab 43, 55
 storage 45, 55
Inking the plate, dry point 87
 etched 45 ff.
 in color—see Color printing
 metal graphic 93
 mezzotint 92
 with stencils 96
Intaglio 4
Iron perchloride 28, 76
Iron plate 5
Ivory black 42
Janinet, François 114
Japanese papers 37
Jigger 10, 45 ff., 73
Kerosene 17, 47, 55
Kerosene lamp 15
Laid paper 37, 69
Lalanne, Maxime 34
Lamp, kerosene 15
Lampblack, pigment 42
 for thickening 25, 34, 75
Lasansky, Mauricio 122
Leather roller 10, 12, 57, 67
Lewis, Martin 113
Lift bath 78
Lift-ground aquatint 77
Linen tester 31, 35
Linoleum blocks 100
Linseed oil, raw 42 ff., 54, 92, 95
Liquid ground 12, 22, 77
Lithographic pencil 75, 82, 86
Lithography 4
Log, etching 32
Magnifier 24, 31, 35, 60, 74
Makeready 52
Margins, prints with 54
Marin, John 109
Mat cutting 102–105
Materials and tools, list of 126–127
Metal graphic 92 ff., 100
Metals 7
Mezzotint 89–93
Mezzotint rocker 25, 89
 for correcting crevé 25
Mixed media 4, 5
Mounting the print 102–105
Muller 43
Mulling ink 43 ff.
Multiple lining tool 80
Nanteuil, Robert 117
Needles, dry point 84
 etching 23
Needling the plate
 etching 24 ff.
 dry point 85
Nesch, Rolf 92, 117, 123
Newsprint 38 ff., 51
Nitric acid 25, 27 29 ff., 34, 70, 76
Numbering editions 55
Offset printing 101
Oilstones—see Stones, sharpening
Oils, burnt plate 43 ff.
 machine 8, 61, 81, 84, 89
 raw linseed 42 ff., 54, 92, 95

Orthopedic felt 40
Overbitten plate 61
Pad, wiping 47 ff.
Paper, brushing 53
 damping 38 ff.
 Japanese 37
Patching ground 22
Pencil, for drawing on soft ground 67, 69
Pennell, Joseph 108
Photo-engraving plates 7
Picasso, Pablo 120
Pick-up clips 52
Pick-up ground 78
Pigments, ink, dry 42
 grinding 42 ff.
Piranesi, Giovanni Battista 59
Pissarro, Camille 116
Planography—see Lithography
Plastic apron 32
Plastic, dry point on 86
Plate mark 33, 52
Plates, bevelling 33, 99
 cleaning 8
 cutting 7
 etching 27 ff., 34
 polishing 62
 steel-facing 86
 (also see—grounding, inking, printing)
Plier, locking 15
Points, carbide 84
 diamond 84
 échoppe 23
 for dry point 84
 for etching 23
 steel 84
Polaroid sunglasses 24, 82
Polishing the bevel 33
 the plate 62
 the scraper 61
Potassium chlorate 28
Poupée, à la 95
Pozzatti, Rudy 111
Press, etching 36 ff., 51 ff.
 adjusting 40
 pressure, on needle 24, 30
 on litho pencil 75
 on soft ground 67 ff.
Printing, à la poupée 95
 color 94–101
 dry point 86
 etched plate 51–55
 metal graphic 93
 mezzotint 92
 relief 4, 54, 95
 soft ground 70
 wet-on-wet 97
 wet-over-dry 98
 with blocks 100
 with stencils 96
Proofs, trial 51
Pumice 33, 82
Punches 62
Pusher blanket 40
Putty knife 43
Pyrex muller 43
Raimondi, Marcantonio 112
Register, for printing color 96, 100
 guide 99
Regrounding and rebiting 57 ff., 71
Reneedling 31
Relief, design 95
 blocks 100
 printing 4, 54, 95 ff., 100
Rembrandt 4, 5, 17, 20, 25, 57, 84, 89, 107, 109
Renoir, Pierre Auguste 113
Repoussage 62
Retroussage 49
Reverse image 17, 21, 67
Rijn, Rembrandt van—see Rembrandt
Rocker, mezzotint 25, 89
Rocking pattern 90
Rocking-pole device 90
Roller, gelatin 100
 large 96
 leather 10, 12, 57, 67
 rubber 20, 95, 101
Rolling the ground 12 ff., 57
Rosin 11, 22, 72 ff.
Rosin bag 72
Rouault, Georges 120
Roulette
 barrel 89
 drum 88
 mimeograph 23, 25, 89
Safety precautions 17, 28, 29, 31
Salt aquatint 77
Sandpaper aquatint 77

Saw, band 8, 92
 bench 7
 jigsaw 7, 92
 radial-arm 7
Scotch stone 33, 62, 76
Scraper 61, 91
 scratches on plate 8, 62
Screen, diffusing 23, 82
Seghers, Hercules 5
Sharpening
 stones for 61, 81, 84
 the burin 81
 the needle 84
 scraper 61
Shaving brush 53
Shellac 22
Siegen, Ludwig von 89
Sized paper 37
Sizing catcher 39, 52
Smith, John Raphael 115
Smoke hood 16
Smoking the ground 15 ff.
Snake slip 33, 62
Soft ground 67–71
 correcting 70
 drawing for 67 ff.
 etching 70
 printing 70
 texture 71
Spirit ground 78
Sponge, engraving 82
Stages, drawing in 34
States 56
Steel, dry point 84
 facing 86
 plates 4, 7, 27, 86
Stencils 96
Stones, sharpening 61, 81, 84
Stop-out varnish 22, 24, 25, 31, 34, 54, 75
 removing 31
Stopping out, aquatint 75
 etching with 34
 for color printing 97
 for deep etch 78
 soft ground 70
Stops, for holding paper 100
Storage, acid 29
 ground 12
 ground dabber 15
 ink 45, 55
 ink dabber 55
 leather roller 12
 plates 17, 52
 volatile fluids 17
Styli 23
Sulphur, flour of 60
Tableau paper 37
Tapers, wax 15
Tarlatan 47
Temperature of Dutch bath 28
Temperature of plate for
 grounding 10
 inking 45
 printing 51
 rosin 73
Timing the etch 30, 34
Tracing 17, 19, 67, 83, 86
Transferring a drawing 17, 19 ff., 67, 83, 86
Transparent ground 11, 12, 57, 97
Trays, etching 30
Turner, Joseph M. W. 65
Turpentine 9, 10, 17, 22, 24, 31, 82, 97
Underbitten plate 57, 76
Varnish, asphaltum 25, 95
 stop-out 22, 24, 25, 31, 34, 54, 75
Vine black 42
Waterleaf paper 37, 54
Wax tapers 15
Wet-on-wet color printing 97
Wet-over-dry color printing 98
Whistler, James Abbott McNeill 35, 118
White ground 17
Whiting 9
Wiping compound 42
Wiping pads 47 ff.
Wiping the plate 47 ff.
Wood blocks 100
Woven felt 40
Zinc plates 4, 7, 27 ff., 70, 86